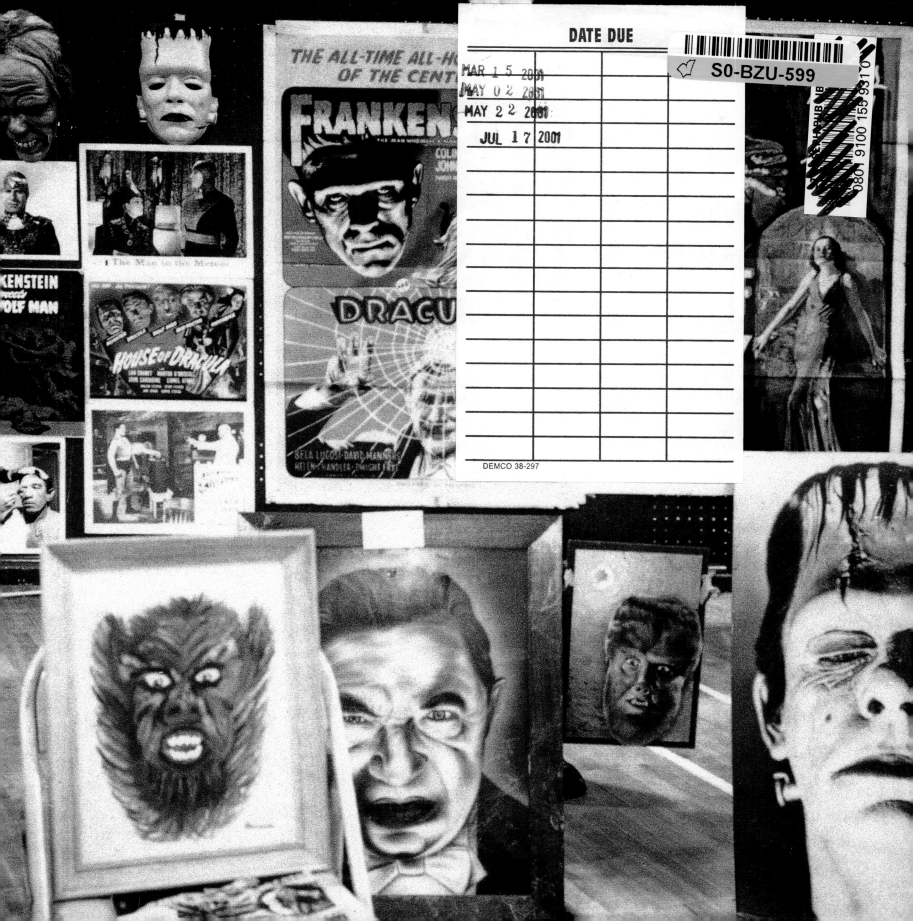

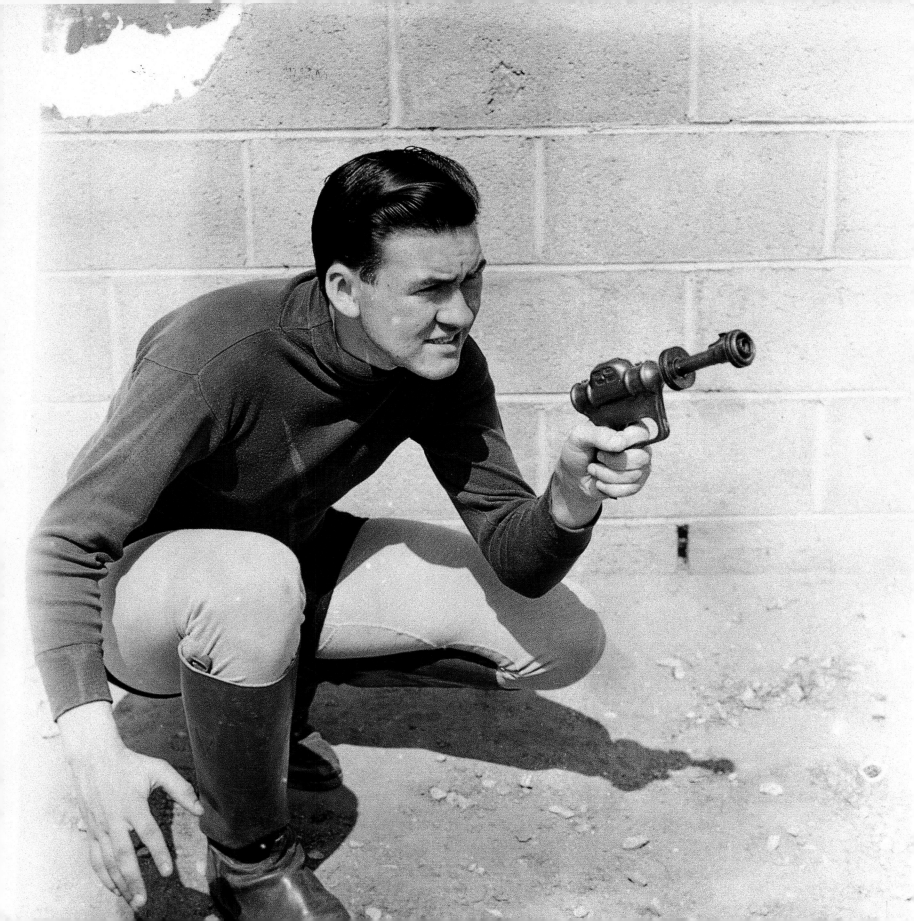

IT CAME FROM BOB'S BASEMENT!

EXPLORING THE SCIENCE FICTION AND MONSTER MOVIE ARCHIVE OF BOB BURNS

CHRONICLE BOOKS
SAN FRANCISCO

B **BURNS**

with **JOHN MICHLIG**

introduction
by
DENNIS MUREN

ACKNOWLEDGMENTS

With apologies to the many individuals that I've surely left out, thanks to the following for their contributions to the museum and this book:

Wah Chang; Phil Kelison; Mrs. Zsoka Pal; Jackie Blaisdell; Walter Koenig; Gene Warren; Gene Warren Jr.; Forrest J. Ackerman; Jim Danforth; Ray Harryhausen; James Cameron; Dennis Muren; Ben Burtt; Chris Walas; Rick Baker; Doug Beswick; Bob Skotak; Dennis Skotak; Dorothy Fontana; "Bob Burns and Friends" Halloween Crew; Bill Malone; Lynn Barker; Marc Richards; Dave Daniels; Don Glut; Greg Jein; Lou Zutavern; Joe Viskocil; Ron Lizorty; Kevyne Baar; Jan Henderson; Marc Belich; Mike Stein; Steve Smith; Bill Harrison; Jeff Preston; John, Joyce, and Jesse Meyer; Steve Neil; John Goodwin; David Schecter; Katy Mayne; Greg Nicotero; Henry Alvarez; Frank Deitz; Don Coleman; Steve Stockbarger; Dan Roebuck; Jim McPherson; Taylor White; Chuck Williams; Chuck McSorley; Carole Bauman; Bob Cauler; Lee Staton; Ron Miller; John Gilbert; Raven Hood; Steve Wang; Ben Chapman; Tom Woodruff Jr.; and Alec Gillis.

And especially to John Michlig, who came up with the idea for this book and put it all together.

A NOTE ON THE CREDITS

The authors, and Bob Burns especially, wish to thank all of the people who have donated items and memorabilia to Bob's collection over the years. Because of their generosity, the wonderful stories of how these items were created and used to shape our collective memories through film will not be lost like so much of movie-making history.

Further, because it is not Bob's intention to violate any of the rights of these generous donors, the creators of the items, or the owners of the rights to the films in which these items were used, the authors wish to acknowledge that they claim no exclusive rights in the underlying artistic works embodied in the items and memorabilia shown in this book. Whatever copyright rights still exist in the photographs, movie stills, posters, props, etc. shown in the book are the property of their respective owners.

Where possible, the authors have attempted to accurately credit the owners of such property throughout the book, but because of the number of items involved, and perhaps more importantly, the passage of time, mistakes or omissions may occur. Because the authors believe that publication of this book can only help to increase the interest in these classic movies and memorabilia, the authors hope that the respective owners of any copyright rights of these properties, whether correctly credited or not, will see this book for what it is—a small attempt to preserve a piece of movie history—a history of which those owners, and Bob, are integral parts.

Copyright (c) 2000 by JOHN MICHLIG and BOB BURNS.

Library of Congress Cataloging-in-Publication Data available.

ISBN 0-8118-2572-8

Printed in Hong Kong.

Design by:
JON SUEDA
Lettering by:
JON SUEDA & LEE SHELVERTON
Prop photography by:
DAVID HALLMAN & JIM BUNTE
Other photography by:
BETSY ANNAS

Distributed in Canada by
RAINCOAST BOOKS
9050 Shaughnessy Street
Vancouver, British Columbia V6P 6E5

10 9 8 7 6 5 4 3 2 1

CHRONICLE BOOKS LLC
85 Second Street
San Francisco, California 94105

www.chroniclebooks.com

Dedicated to the memory of special people who shared with me special things:

DAVID ALLEN, ROY BARCROFT, ELLIS BERMAN,
PAUL BLAISDELL, CHESLEY BONESTELL,
LIONEL COMPORT, MIKE MINOR, CHRIS MUELLER,
WILLIS O'BRIEN, GEORGE PAL, JACK PIERCE,
HANS SALTER, TOM SCHERMAN, DAVID SHARPE,
GLENN STRANGE, MY FOLKS,
AND MY GRANDFATHER.

ENTS

PREFACE

by Dennis Muren

The years before the 1970s were an unrewarding time for those of us interested in the heritage and history of fantasy films. Not only were science fiction and horror films, with a few exceptions, considered "lowbrow" entertainment, but Hollywood studios took little if any interest in preserving any of the left-over props and art created for these movies. When a project wrapped, everything was just tossed out or taken home by somebody and put into a garage or attic. These props were tools, and when their utility was exhausted they fell into the same category as used paper cups would. This went on for decades, and many handcrafted works of art created for classic films were lost forever. As young film fans, my friends and I began to take for granted that we'd never get to see "in person" the fantastic objects that transfixed us on movie and television screens. We were "movie geeks," a small, unrecognized minority who wanted to know the nuts and bolts of visual effects.

As time went on, however, more and more people became interested in science fiction and horror films and filmmaking. With the release of *Star Wars*, in particular, interest really picked up and a lot of people wanted to get into films and know how they were made. Suddenly the public at large was curious about what made those spaceships look so real and how giant monsters could trample cities. The studios began to think seriously about preserving the work of their craftsmen, and they mourned the stuff that was lost forever due to lack of foresight.

How fortunate we all are that Bob Burns had been busily running around Hollywood rescuing our favorite spaceships, costumes, ray guns, and monster masks from oblivion! Bob made himself known in the entertainment community as a guy willing to give up living space to display a rubber corpse or a pair of Frankenstein's boots; consequently, a lot of amazing stuff that was headed to the incinerator made a left turn in the direction of what is now known as "Bob's basement," being preserved for posterity rather than becoming Southern California landfill. Undoubtedly many of the people who contributed items to his collection felt relieved to find a home for pieces they simply had no room for. And Bob not only collected the items, but the personal stories connected to them.

And how fortunate for Bob to have in his wife, Kathy, a partner with an equal love for films! Bob will be the first to tell you that it's only through her encouragement and constant shared enthusiasm that his collection exists in the first place. Both veterans of the entertainment industry—Bob was a film editor, and Kathy worked at a production company—they're a great team and special people to a huge menagerie of friends like myself who love to gather at their place to talk about movies and hatch schemes. From the minute I first walked into Bob and Kathy's house I knew there was something about them that was very special. There was movie stuff everywhere and original artwork on the walls from wonderful fantasy and sci-fi films, work that had been done by famous illustrators like Chesley

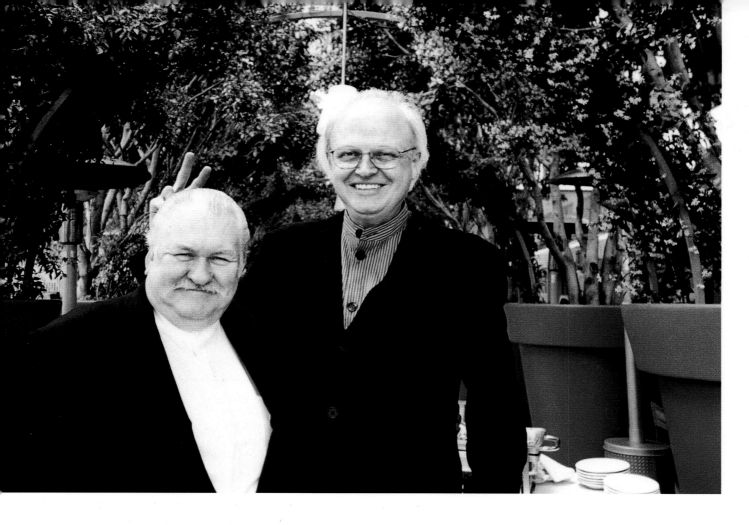

Bonestell, and paintings by people who weren't so famous, like their good friend Mike Minor. Tom Scherman had built beautiful models of the sub from *20,000 Leagues Under the Sea*. Bob and Kathy have incredible art, incredible models, and incredible enthusiasm. Over the years they've become sounding boards and cheerleaders for a great many film industry professionals, offering encouragement to many of us as we started out in the field and unabashed excitement when we showed them what we were working on. Mostly, they made us believe in ourselves.

One of the schemes hatched at Bob's house was the annual Halloween show. Starting in 1969, Bob would come up with the money to fund an extravagant live re-creation of a scene from a famous sci-fi or horror movie with a little plot—beginning, middle, end—lasting for three to five minutes. It was his way of giving something fun to the community of Burbank, and my friends and I had a blast working on the scenes. The themes were conceived by Bob, incorporating props from his collection, and we did a

different scenario each year: *The Exorcist, War of the Worlds*, and *Alien*, to name a few. The shows were a melting pot of the collective imaginations and talents of aspiring filmmakers. A dozen of us would spend a few weekends beforehand building the sets and coming up with music cues, lighting effects, and the like, culminating in the big Halloween night. For the viewers who walked through our setup, the experience was like being inside a movie—there was no screen between the viewer and the monster or alien we'd unleash. Our first show was so popular that it drew fifteen hundred people and we had to add a second night; there was a line all the way down the street and around the corner, and the road was jammed with cars stopping to see what was going on. We ran the shows from about 5 P.M. until 10 or 10:30 P.M. nonstop, with hundreds of people going through, seeing this little scene. I was for the most part hidden behind the set, doing the lighting cues. Tom Scherman would be running around pulling

cables or doing whatever was needed. Mike Minor, who did the set design, would be making sure everything was just right. Bob and Kathy would be out there making sure the whole thing didn't fall apart. Hollywood VIPs would invariably show up and stay for hours, perhaps surprised to rediscover the sense of wonder that brought them to the business in the first place.

Seeing a famous prop close up triggers that same sense of wonder. These props are a part of history that we can embrace by just looking at them. For people like me, seeing Bob's old props and artwork is a connection to the long heritage of visual-effects artists. For young people, Bob's collection helps them understand that these items were actually made by real people and that the possibility exists that they someday could build these same kinds of props and work on these same types of movies. More than one modern visual-effects craftsperson has been inspired to enter the vocation by a visit to "Bob's basement" and his acknowledgment of their talent when they showed him a sample of their work.

It's a lot more difficult for Bob to collect props from modern movies than when he began collecting, because so many of the props are computer generated and no physical model is ever made. It's not very interesting to look at a CD-ROM or tape cassette that has one of your favorite scenes on it. Today we can get the model, the creatures, the background, roto-mattes, all the lighting, the whole deal, on a piece of magnetic media, but there is nothing else tangible to keep. That

makes Bob's collection even more valuable, because it reminds people of the handcraftsmanship that used to go into the work.

And that's really what it was: craftsmanship. The techniques that had been handed down for thousands of years were updated as the tools changed. Our newest tool, the computer, may well have severed that line of hand skills and eliminated much of the tactile aspect of creating props and effects. Bob's collection—though still growing and threatening to burst his house at the seams—may represent the last physical connections we as fans have to our favorite films.

This book contains a lot of photographs of Bob's objects, but it really ought to have a good photograph of his brain, too. That brain has retained so many wonderful stories about the people he has met, worked with, or counted as his friends, and Bob gets his greatest satisfaction from spreading the word about artists who have created the most indelible images ever filmed. Over the decades, visitors to his collection have been treated to an oral history of geniuses like Mike Minor, Rick Baker, Paul Blaisdell, Chris Walas, and Tom Scherman, just to name a few, in addition to better-known names like George Lucas, Glenn Strange, George Pal, and even Ed Wood Jr. Thankfully, someone has strapped him down long enough to commit to paper some of his storehouse of stories—though, since Bob seems to have met everyone and remembered everything, one volume is hardly adequate. I hope he's working right now on the next book!

Thanks, Bob, for watching over—and sharing—these treasures.
—Dennis Muren

Dennis Muren encounters the Metaluna Mutant (Bob Burns) while setting up Bob's 1969 "This Island Earth" Halloween show.

A CHILD IN THE LAND OF DREAMS

ONE OF MY EARLIEST MEMORIES of childhood in Muskogee, Oklahoma, is of the day my grandfather bought me two wooden Superman figures at a hardware store. Today's toy collectors would have considered my grandfather and me real pioneers;

we noticed that among the crowd of jointed Supermen in the display there were two different versions with distinctly different "S" logos and cape colors, so we decided we'd better get both kinds. Somehow, I was already thinking like a collector.

My grandfather and I were very close; he lived with us, and as an only child I became the focus of his affection. He indulged my interest in superheroes, spacemen, monsters—anything in the realm of the fantastic—in ways my father would never dream of. Many evenings Grandpa and I would turn out all the lights and listen to our huge console radio accompanied by the eerie red glow of our gas heater. The adventures of the great radio heroes—Superman, Buck Rogers, Flash Gordon, Dick Tracy, The Shadow—came alive for us.

My mania for all things heroic led me to send away for pretty much every radio or breakfast-cereal premium offered, from decoder rings to special-agent badges. No sooner had the breathless announcer begun his description of the latest Earth-preserving ray gun or science-defying code-breaker than I'd begin busily scribbling my return address on a note with 10 cents taped to it. I'd beg my mom to buy boxes and boxes of horrid cereal in order to accumulate proof-of-purchase boxtops (the key was finding ways to secretly dispose of the tasteless nuggets so mom would get the impression that I loved the stuff). Every outgoing envelope initiated another period of insane waiting and fixation on the mailbox. I was in a perpetual state of anticipation.

Fortunately, my parents were movie fans and I grew up in an era when it was quite common to go out to the theater two or three times a week. It also helped that the local movie house, the Major, was

"refrigerated"; on a 98-degree day, even a mediocre-to-bad flick can look pretty good in a chilled theater.

I especially enjoyed the Republic "cliffhanger" serials: *Spy Smasher, The Crimson Ghost, Perils of Nyoka*, and countless others. I became very familiar with the cast of stock "heavies" and heroes that would appear in each production. It was understood by us kids that the guy getting smacked around by Captain Marvel on a particular Saturday afternoon would probably turn up on the receiving end of Rocket Man's fists of fury the very next week. It was almost comforting to see familiar faces return time and time again in everything from westerns to sci-fi potboilers, smashed by the forces of Good every time.

My grandfather died in 1941, when I was six years old—a crushing blow for me, as he was my very best buddy. My dad was also deeply affected by the loss. When Uncle Jess called from California inviting him to come west and take advantage of the booming World War II job market, my dad left Muskogee without regrets. My uncle was right about opportunities on the West Coast; Dad landed a job at the Lockheed plant, and my mother and I followed him a year later.

One of the first things I noticed once we got to our new home was that Burbank had a mind-boggling *five* theaters to choose from for Saturday-afternoon entertainment. In Muskogee the Major was the only game in town, but now I could make an entire day of watching movies, seeing a few cool serials at one theater and then walking up the block to catch the latest horror flick.

After seeing a particularly intense afternoon double feature of *Frankenstein* and *Frankenstein Meets the Wolf Man*, I decided to figure out how they made Lon Chaney Jr. look so scary. Monster fan magazines

previous page: **Superman jointed wood-and-composition figures by Ideal Toy Company purchased in 1939.** (13" tall)

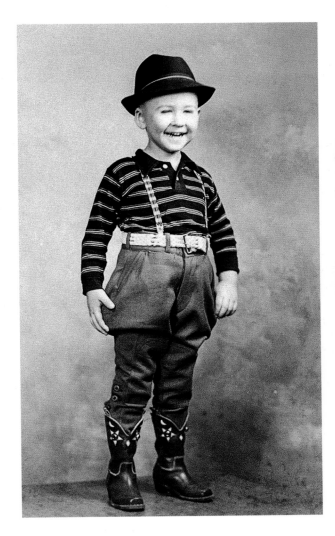 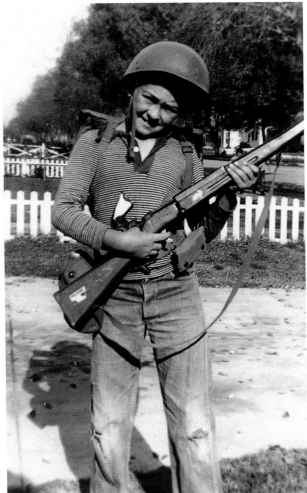

left: **Bob Burns at three, in 1938.**

right: **Bob plays soldier with his Uncle Melvin's helmet at age ten, about the time he visited the set of *The Purple Monster Strikes* (1945).**

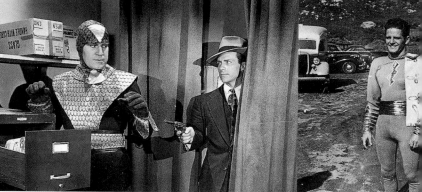

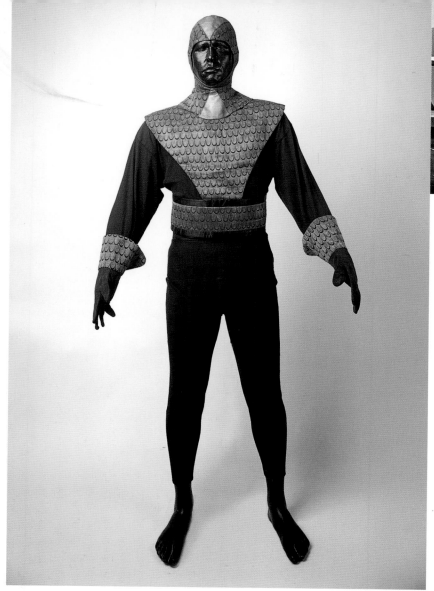

above: **Roy Barcroft's** *The Purple Monster Strikes* (1945) uniform, also used in 1952's **Commando Cody** serial *Radar Men From the Moon*. Roy had a pouch sewn inside the sash where he could store his cigarettes.

above center: **Roy Barcroft and Dennis Moore in** *The Purple Monster Strikes* (1945).

didn't exist yet, so I relied on sketches I made while the memory of the Wolf Man was fresh in my head. Using white glue and sections of my mom's hairpieces—which were, after all, perfect raw material for creating facial fur—I transformed myself into a vision of lupine terror. Well, at least my mom was horrified.

It was around this time that I discovered something amazing about our new hometown. I was playing in my front yard when a car pulled up and out came a man instantly recognizable to me as the heavy in so many Saturday-afternoon Republic serials. I stood there, dumbstruck, as the guy who battled Roy Rogers, went toe-to-toe with Gene Autry, and slugged it out with Zorro walked up to my neighbor's front porch.

When he left, I sprinted next door to ask about my neighbors' visitor. It turned out that their daughter, Joyce, was secretary to Roy Barcroft, one of the screen's great villains. She asked if I'd like to meet him next time he stopped by. I managed to shout "OK!" in the calmest voice I could muster under the circumstances.

A few days later, Roy was standing in my house saying, "Hi, Bob." I was thrilled to death! "I'm working on a new serial," he said. "Would you like to come on the set with me?" That same week, Roy picked me up and we made the short trip to Republic Studios in Studio City—I had no idea the movies were made right in my backyard—and I was able to spend the entire day watching cast and crew work on a fight scene on an office set for *The Purple Monster Strikes*.

Right away one of my illusions was blown. Roy got into his Purple Monster suit and came onstage, followed by another actor, Fred Graham, who was dressed the same. "Who's that guy?" I asked. That's

above right: **Master stuntman David Sharpe, who choreographed and performed in hundreds of onscreen fights, made each Republic battle a thrilling trademark centerpiece. Republic took to hiring actors on the basis of their physical resemblance to Sharpe, since he would double them for stunts and fisticuffs.**

pages 17 and 18: **Captain Marvel tunic worn by stuntman David Sharpe in the Republic** *Captain Marvel* **serials (1941).**
(36" from neckline to bottom of cape)

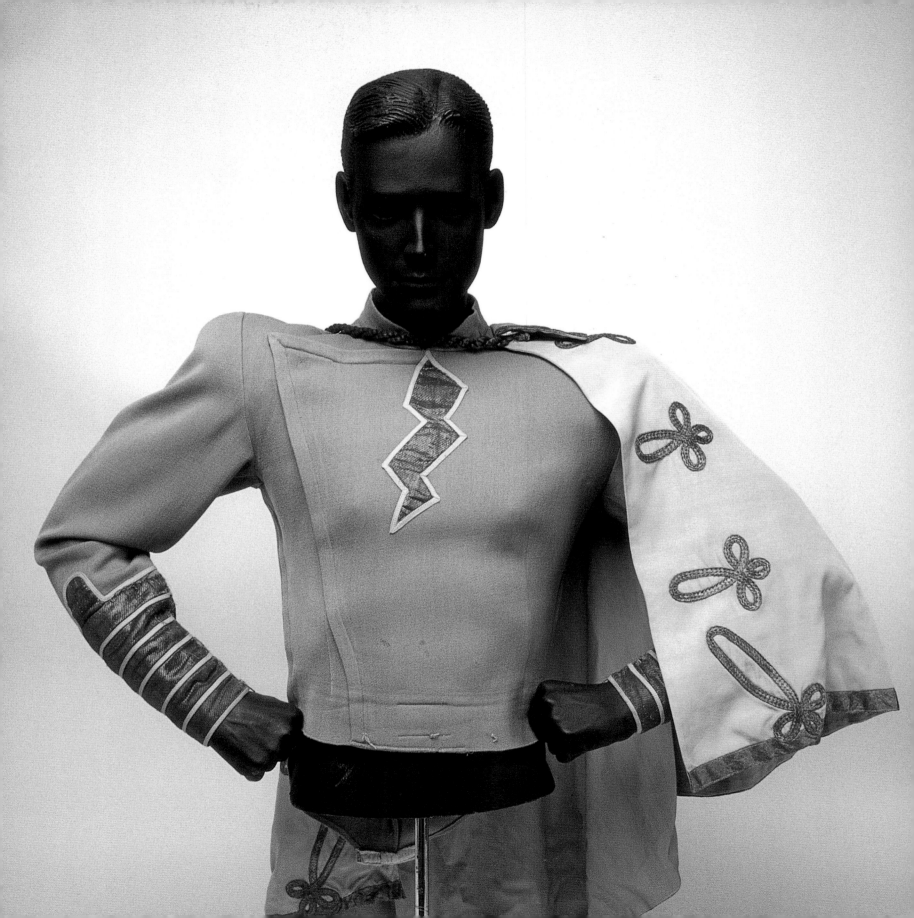

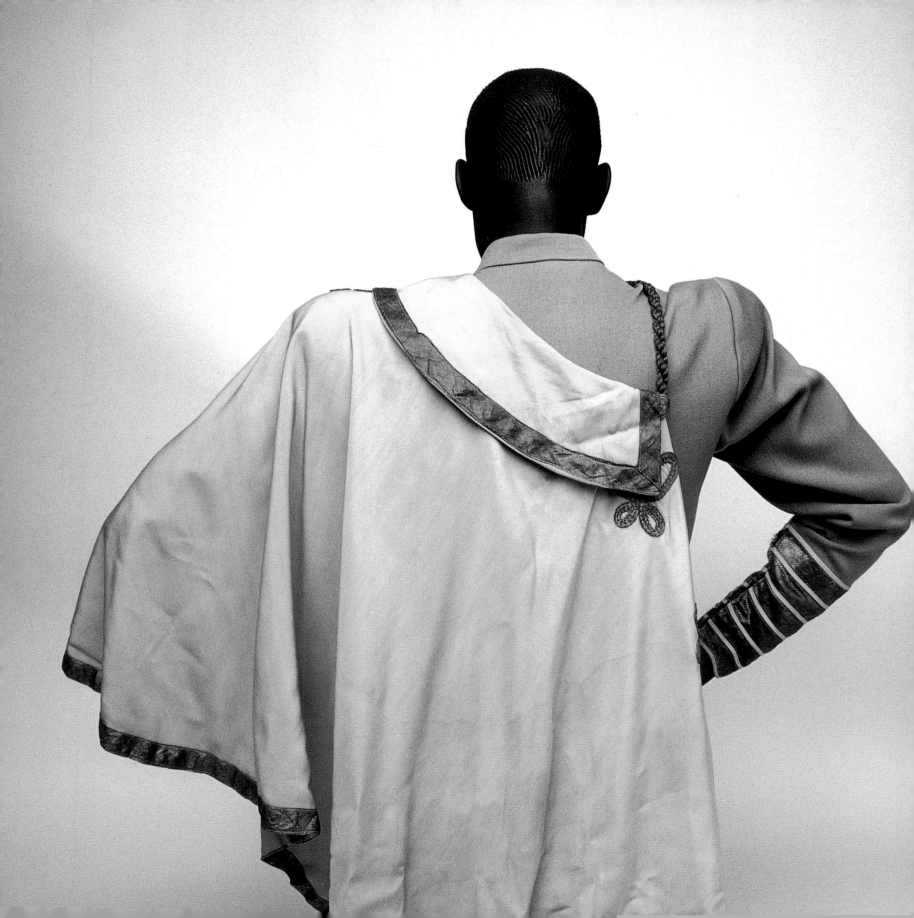

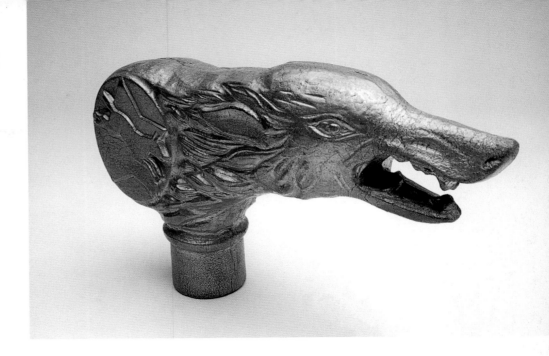

when Roy explained to me the concept of stuntmen—a devastating revelation. So it wasn't really Crash Corrigan or Buster Crabbe or Tom Mix leaping from balconies and crashing through strategically placed wooden crates? We had been duped all this time? It took quite a while to accept that harsh reality.

That didn't make my day on the set any less thrilling, though. The crew was set up for a master shot, which, according to the time-tested and efficient Republic shooting system, meant that two or three cameras were in place to capture the action as stunt stand-ins destroyed the set. This was well-organized chaos; Republic's ace serial director, Bill Witney, conceived the idea of carefully choreographing battles, and intricate fights became Republic's trademark.

A stunt coordinator worked out specific moves for everyone involved in the melee, and, when the director called "action," the stunt performers quickly made wreckage of everything in sight, grappling and launching themselves with seemingly reckless abandon. After we returned from lunch break, the set had been completely re-dressed with duplicate chairs and vases. Roy and his co-star, Dennis Moore, stepped in and enacted the fight scene again, skipping the dangerous leaps and falls that had been captured during the morning shoot. The battle was shot in bits and pieces; there was not an ounce of wasted motion. The crew obviously had the procedure down to a science and the entire sequence was finished that day. I went home with stars in my eyes.

As incredible as it was to see a movie being shot, it was even more exciting when *The Purple Monster Strikes* premiered at the Magnolia Theater, right down the street from my house. When I saw that familiar set and the fight unspool on the big screen, my heart pounded like a jackhammer—I was there! I saw that scene shot! Suddenly there seemed to be a bridge between my humdrum life and the exciting, wonderful fantasy world of movies.

I began to see that living in Burbank would offer many such connections. My friend and classmate Sonny Berman and I would hang around his father's shop after school, watching him work. Ellis Berman was a special-effects technician who had worked on movies like *The Ghost of Frankenstein* and *The Wolf*

Man. Fortunately, he was also a patient and accommodating man who withstood my near-incessant questions about the films he'd been involved with and how he created the masks and props.

Ellis had some monster-movie photos in his shop, and Sonny told me they were from the studio publicity departments. I began my collection of stills and publicity shots that evening by writing to Universal's press office—they sent me two photos of Boris Karloff made up as the Frankenstein monster—and my collection has grown steadily since. Because many of the studios didn't bother to maintain their own library of stills, my collection has become quite a resource for people involved in projects concerning science-fiction and monster movie history.

Ellis Berman also set me on the road to creating my prop collection. He had on a shelf in his office the silver wolf's-head cane ornament that Sir John Talbot used to slay his son, Larry, the tragic carrier of the werewolf curse in *The Wolf Man*. Ellis had created the prop, and I spent many, many afternoons quietly staring at it. One day he said to me, "You really like that thing, don't you?" Like it? I loved that cane head; it was a real, physical object that had actually been used in one of my favorite movies. "It's yours. Go ahead and take it," he said. I thought I would burst as I took it home to put it in a place of honor. Thus began my lifelong occupation as custodian of treasures from sci-fi and monster movies.

In 1948, Ellis Berman invited me to a location shoot in Palmdale for *Unknown Island*, a low-budget film being produced by a little studio ambitiously called Film Classics. Over the preceding weeks I'd watched Ellis construct "Ceratosaur" dinosaur costumes for the movie, and he knew I'd get a kick out of seeing the suits in action.

The three suits Berman created were made of canvas covered with latex, and the stuntman in each costume could move the head and operate the mouth by manipulating rods and wires. The little arms could do little more than wiggle as the stuntmen lumbered blindly about; there were no eyeholes. These stiff, awkward contraptions were probably the most uncomfortable monster suits ever made.

Palmdale in those days was an undeveloped desert area, and the mercury crept up over 100 degrees on the day I watched filming. I was in shirtsleeves and sweating buckets; the guys in the unventilated dinosaur costumes were broiling. Whenever they needed to rest—which was often—the "Ceratosaurs" had to lean against a crew member in a manner that looked for all the world like some sort of cross-species mating ritual. The exhaustion was so bad that, as they filmed a scene where actor Barton MacLane lobs hand grenades at the dinosaurs, one of the stuntmen fainted dead away. The penny-pinching director never even considered a retake, and the fall can actually be seen in the final print.

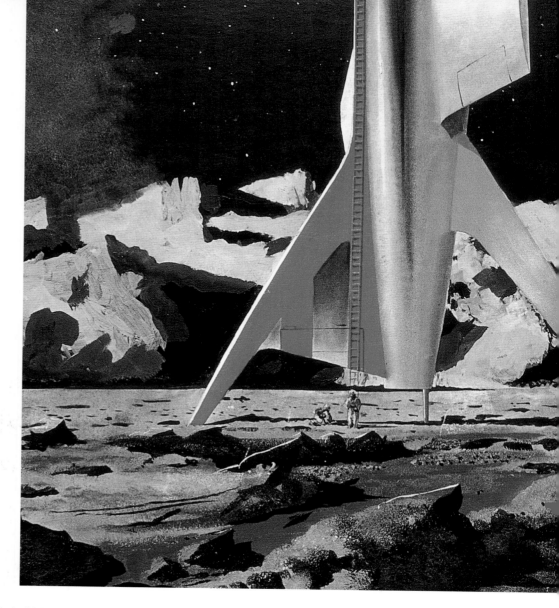

I'd soon discover that not all film studios were so stingy. In 1949, another schoolmate of mine, knowing of my interest in science fiction, told me his dad was a grip on the *Destination Moon* production and that I could come with him after school to visit the set. What a break!

This was an experience much, much different from the Palmdale shoot. *Destination Moon* was Hollywood's ambitious first attempt at an adult space-travel movie—it was written by science fiction author Robert Heinlein, and celebrated astronomical artist Chesley Bonestell had been commissioned to create designs and paintings for state-of-the-art authenticity—so the studio went to enormous expense to make sure everything that appeared onscreen looked plausible. We entered the largest soundstage at General Service Studios and I was immediately chilled to my toes with excitement—and chilled *literally* as well, since the entire building was refrigerated to the extent that crew members were walking around in overcoats. The actors wore bulky red, yellow, and blue spacesuits padded with insulation to give the impression that they were inflated with oxygen, and the helmets had no holes through which built-up body heat could escape. They fried in their costumes under the big, powerful lights needed for Technicolor while everyone on the periphery of the set shivered.

I was dressed for a typical 75-degree California day but too busy taking it all in to feel cold. The set was breathtaking and completely enveloping. We stood on the edge of an utterly convincing moonscape, from sand and rocks on the ground to a starry cyclorama above—nothing like the sterile blue-screen stages used today where everything is added in post-production and the actors have to imagine their surroundings. I was even able to meet director George Pal, who greeted us warmly and made me feel welcome. He would later become a dear friend.

Everyone on the set looked very busy, so I tried not to ask too many questions, but I was able to learn that each individual "star" on the huge cyclorama above the landscape was actually an automobile headlight bulb, and that every single bulb—they were countless in number—had to be fitted with a small green gel to avoid red auras when photographed.

That little tidbit of information made a strong impression. It occurred to me that even an unskilled guy like myself could do the kind of grunt work generated by a production of this size. Though I couldn't create pieces of prop art like Ellis Berman, I could surely tote around a ladder and screw in tiny lightbulbs all day if it meant being part of this incredible dream factory.

That experience was the final straw—I had to get involved with fantasy moviemaking even if it meant making movies in my own backyard.

above: **Concept painting created circa 1949 by Chesley Bonestell and used by George Pal to sell the *Destination Moon* (1950) movie. The design was eventually used in *Flight to Mars* (1952).** (14" x 16")

right: **Intricate *Destination Moon* (1950) gantry, featuring welded-together "girders" and threads for finer details. Reproduction ship by Lou Zutavern.** (48" tall)

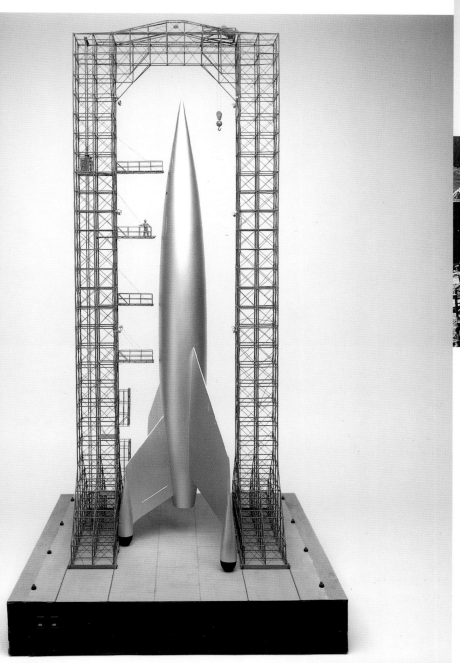

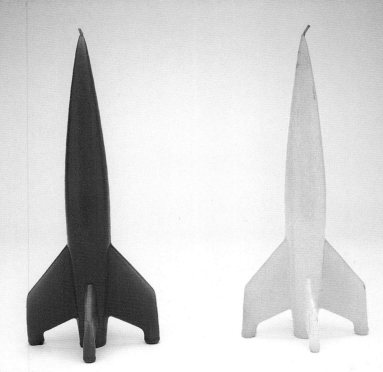

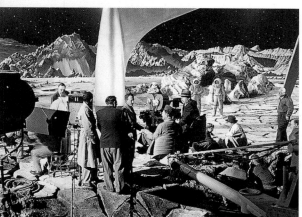

top: **Candles created for *Destination Moon* press party.** (9" tall)

above: **The refrigerated set of *Destination Moon*.**

Destination Moon (1950) panoramic moonscape by Chesley Bonestell, signed by the artist, with light-equipped starfield, a gift from Mrs. George Pal. (13'4" long, 2'4" high)

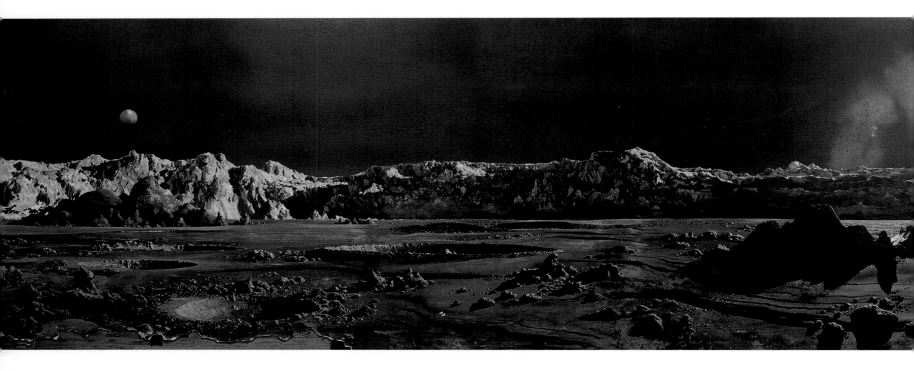

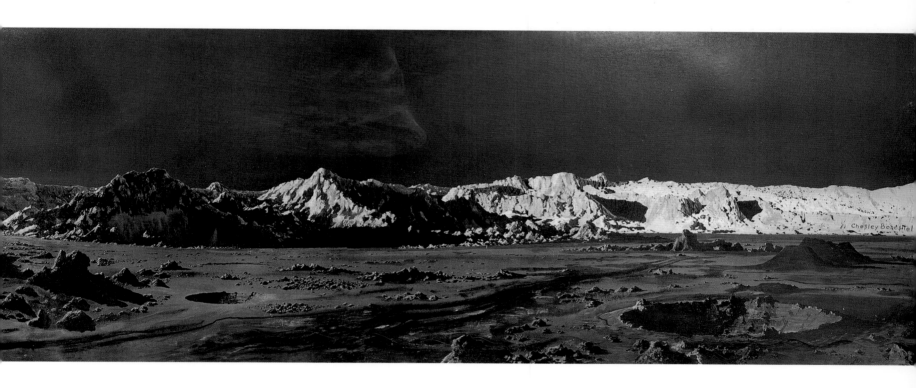

COSTUMES

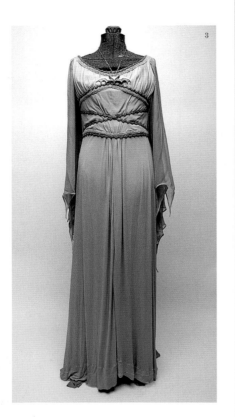

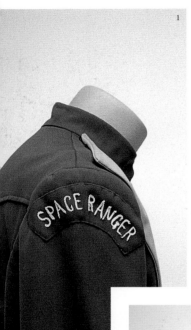

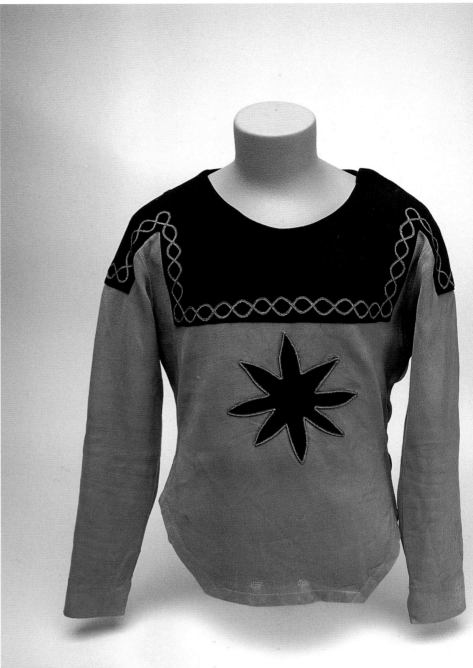

1 & 2 *Rocky Jones Space Ranger* (1954) uniform top. (24" tall)

3 Lily's dress from "The Munsters" (1964-66) includes a reproduction pendant made from the original mold.

4 *Flash Gordon* (1940) tunic. (24" tall)

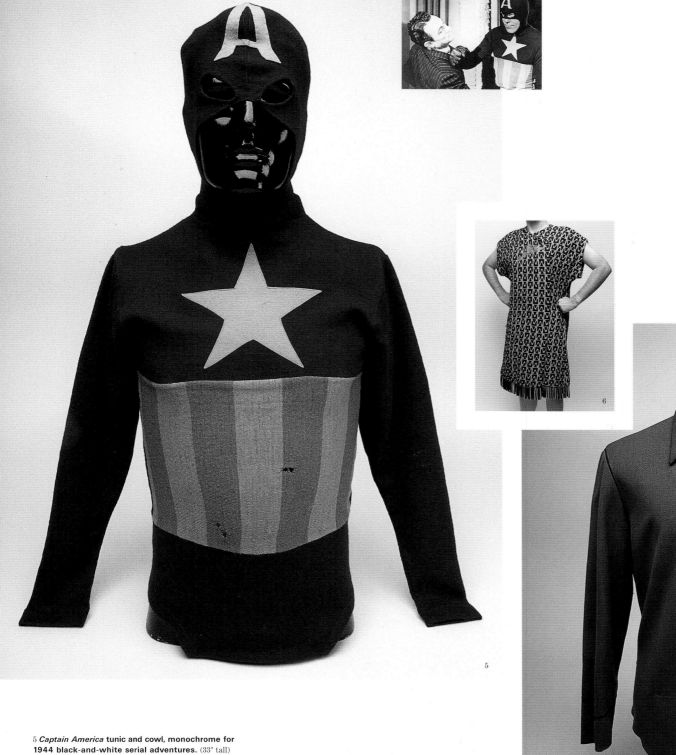

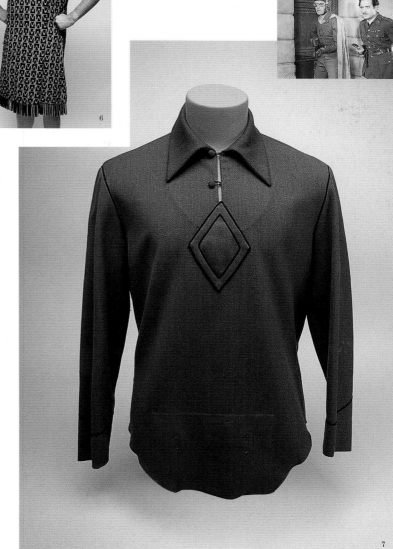

5 *Captain America* tunic and cowl, monochrome for
1944 black-and-white serial adventures. (33" tall)

6 **Guard tunic from** *The Mole People* **(1956).**

7 **Republic** *Spy Smasher* **(1942) tunic.** (30" tall)

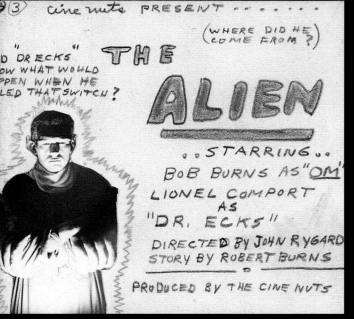

③ cine nuts PRESENT

(WHERE DID HE COME FROM?)

"D DRECKS" OW WHAT WOULD PPEN WHEN HE LED THAT SWITCH?

THE ALIEN

.. STARRING ..

BOB BURNS AS "OM"

LIONEL COMPORT AS "DR. ECKS"

DIRECTED BY JOHN RYGARD STORY BY ROBERT BURNS

PRODUCED BY THE CINE NUTS

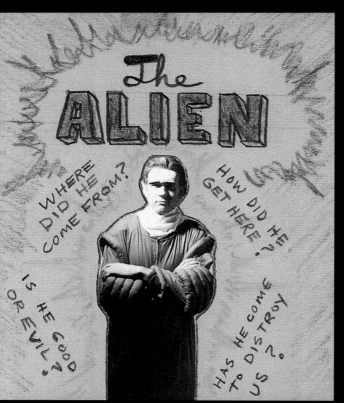

The ALIEN

WHERE DID HE COME FROM?

HOW DID HE GET HERE?

IS HE GOOD OR EVIL.

HAS HE COME TO DISTROY US?

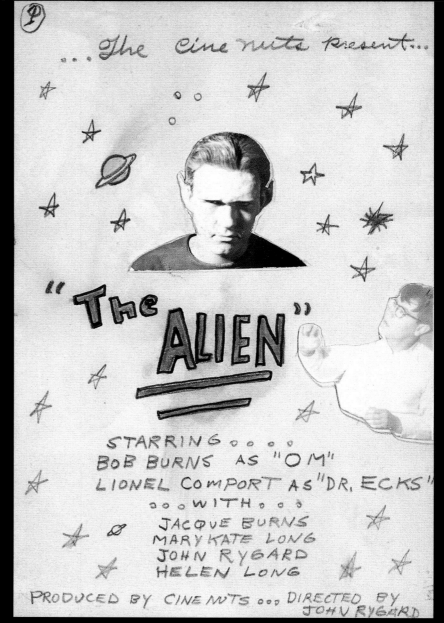

④ . . . The cine nuts Present . . .

"The ALIEN"

STARRING

BOB BURNS AS "OM"

LIONEL COMPORT AS "DR. ECKS"

. . . WITH . . .

JACQUE BURNS
MARY KATE LONG
JOHN RYGARD
HELEN LONG

PRODUCED BY CINE NUTS . . . DIRECTED BY JOHN RYGARD

WHEN WE FIRST MET, Lionel Comport surely had no idea that his acquaintance with me would lead to spending hours with lettuce on his face.

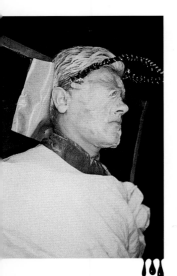

Lionel Comport endures Bob's lettuce-and-spirit-gum makeup.

previous page: **Handmade promotional material for *The Alien*.**

Lionel came to my junior high from a Catholic school, and as a gangly, bespectacled new kid he was the target of older bullies. I was picked on quite a bit as well, so I more or less took him under my wing—though, at over six feet tall, Lionel became my bodyguard of sorts as we entered high school. Like many people in Burbank, he was peripherally involved with film production; his father owned and operated the Movie Ranch, a "zoo" of domesticated animals that studios would rent for scenes that called for chickens, cows, horses, sheep, and the like.

Though he didn't necessarily share my mania for filmmaking and science fiction, Lionel was game for anything fun. My parents were part of a camera club in which they would get together and write a story, then film it using each other as cast and crew. I decided Lionel and I could be auteurs and use my dad's camera to make a fun science-fiction type of movie, complete with special effects. I came up with a story called *The Alien*, wherein a scientist named Dr. Ecks uses a "teleporter" to accidentally transport a strange being from another dimension into his laboratory; I played "Om," the alien, and Lionel portrayed the scientist. I wore makeup to exaggerate my brow and point my ears, and we created some simple visual effects right in the camera.

The first film was so much fun that we made a movie called *The Monster* very soon afterward. This effort was very much in the *Ghost of Frankenstein* mode, and I created a makeup for Lionel using the best materials I had access to—in this case, lettuce glued on with spirit gum and covered with grease-paint. To say that he was a patient and tolerant friend is the understatement of all time. In exchange for his lettuce-induced agony, Lionel got to destroy the set for the film's climax. I'm sure he was able to derive a measure of satisfaction—or revenge—through that!

It was around this time that I met the most important person in my life, Kathy Patterson. She sat in front of me in a summer-school typing class—I was in it to graduate early; Kathy attended because she was bored—and I made an impression on her when the teacher told us to "throw the carriage." For some reason, mine detached from the typewriter and sailed across the room. It looked like schtick, but I honestly had no intention of causing a calamity. My fellow pupils laughed; the teacher did not.

Not long afterward, a girlfriend of Kathy's invited her to someone's house for the "world premiere" of our movies, *The Alien* and *The Monster*. Kathy decided to attend, under the impression that I was the guy in her typing class with a sense of humor.

Perhaps emboldened by the fact that we'd just screened our masterworks, I went ahead and asked her out that day to Bob's Big Boy—and she accepted. She was fourteen and I was eighteen; by the time she was sixteen we were engaged, and we married two years later. I knew I had to move fast before she realized the truth about that carriage return.

Besides getting me a date, the little movies I'd made with Lionel won us sufficient notoriety for the Monterey Avenue School PTA to ask us to prepare a short safety presentation for their Founder's Day meeting. Naturally, I figured out a way to bring the science fiction element into our skit. I immediately envisioned a courageous space traveler as our protagonist, and all I needed was a sufficiently stalwart-sounding name. Although plenty of kids called me "Flash Burns"—a play on the civil defense atomic bomb propaganda of the day, "beware of flash burns"—I didn't think that moniker was mysterious enough. I ended up using a name I'd written on one of my many doodles years earlier: Major Mars.

right: **Storyboards for *The Monster*.**

Trailer For "The Monster"

① Fade in on smoke effect.

② Fade from smoke to first title. (Look Out.)

③ " " " " Second " . (its Coming.)

④ " " " " Third " . (The Monster.)

⑤ Show sillowett of Monster with fire + smoke in front of Lens. Monster blotts out scene with hand.

⑥ Fade from smoke to : (Don't Miss).

⑦ " " " " (The Monster).

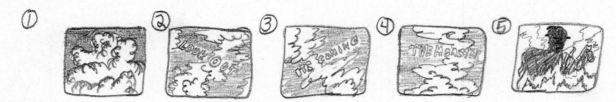

NOTE: Lionel wears weather mask on his face.

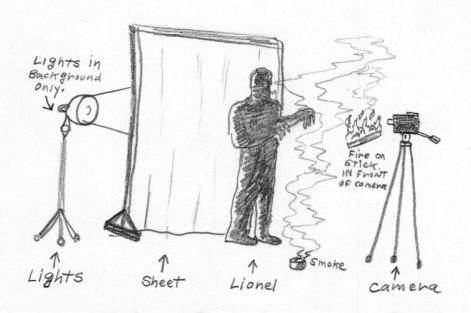

Lights Sheet Lionel smoke camera

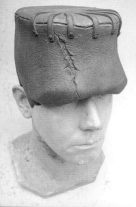

top: **Head appliance for** *Abbott and Costello Meet Frankenstein* **kept for many years as a souvenir by Glenn Strange.**

center: **Bob in uniform as a CBS page.**

bottom: **Flyer for Bob's ill-fated appearance as the Mummy.**

A few years previous, my aunt and I had built a red spacesuit based on the ones I saw while visiting the *Destination Moon* set. She did a great job; I wore the suit as the title character in *The Alien*, and I pressed the costume into service again for Major Mars. A toy Space Patrol bubble helmet, a face-concealing surplus-store gas mask, and mukluk snow boots completed the outfit. Lionel again played a scientist, and we delivered a tight five-minute skit outlining the overwhelming benefits of pedestrian safety—which went over well, if I do say so myself.

My next performing opportunity came when a coworker at CBS, where I was an usher, introduced me to the manager of the Fox Theater in Venice, California. He wanted to add a "spook show" element to his midnight horror-movie programs and I gladly volunteered to lumber up and down the aisle in a Don Post Frankenstein mask, illuminated by a strobelike "lightning" reel projected on the movie screen—a cheap effect, but sufficiently scary to a crowd of teens and preteens jacked up on soda and candy bars.

My Frankenstein performance was a mere shadow of the elaborate spook shows of the 1940s and early 1950s. Lionel and I were constantly on the lookout for a garish newspaper notice that announced the engagement of another midnight spook show at the local theater. The ads were great: "All New Triple Terror Show!" "Teeming with Screaming Thrills!" "In Person and ON A RAMPAGE!" Who could resist? The theaters were always jam-packed when a spook show was booked, even if the movie accompanying it was awful. Large productions traveled a nationwide circuit, and some operators even "bicycled" more than one unit between towns.

The classic spook show was hosted by a "Ghostmaster," usually with a great name like "Ray-Mond," "Dr. Ogre Banshee," or "Dr. Zomb." A few magic tricks and short skits led to the climax of the evening, which was the terrifying blackout. At a significant moment—usually just as a "monster" broke

loose and looked as though he was headed for the audience—the theater would be thrown into total darkness as all kinds of spooky phosphorous manifestations appeared all around the stunned assembly. The monster would make his exit into the wings, and lights-out lasted only a minute at most, but it was a giddily terrifying eternity for a crowd that was *certain* a ghoul was loose among them.

A decade after my Frankenstein stint I got a first-hand look at exactly why spook shows are now extinct. As a favor for a friend, I dressed as the mummy for a matinee show at an inner-city theater. When it came time for me to head out into the audience, the lighting guy missed his cue and didn't plunge the theater into darkness until I was actually in the crowd, surrounded. All around me I heard, "Get that mummy!" "Pound the mummy!" I was rescued by a neighborhood tough to whom the theater manager had paid ten dollars in advance to "protect the mummy at all costs" (or at least ten dollars' worth). The lights never went back on; somehow the power failed and a full-scale riot ensued in the lingering darkness. The theater was destroyed.

Fortunately, I had no such close calls in 1952 at the Fox. In fact, after a few performances as Frankenstein I suggested to the manager that we bring my character, Major Mars, to the popular Saturday matinees. TV hadn't yet taken over, and parents could still drop their kids off at the local theater and know they'd be there, safe and entertained, for three or four hours. You'd have cartoons, serial chapters, and a space opera or horror flick on the program—the whole thing. The manager agreed that a live host would fit right in.

Boots worn by Glenn Strange in *Abbott and Costello Meet Frankenstein* **(1948). Glenn also used the boots on personal appearances.** (each 16" long)

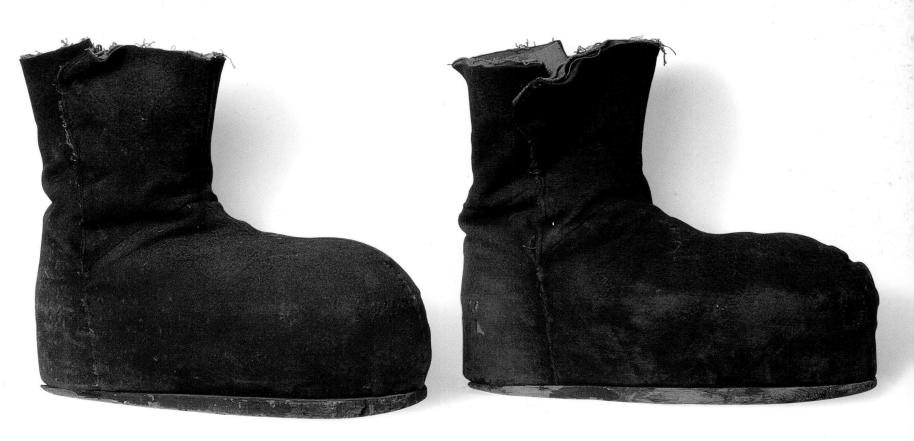

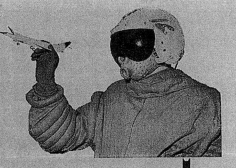

CALLING All BOYS And GIRLS
TO JOIN THE BIG **FREE**
REVELL
MAJOR MARS CLUB

— MEETS AT THIS THEATRE EVERY —

SATURDAY JUNIOR
MATINEE SHOW
STARTING 12 NOON
SATURDAY JUNE 4

MAJOR MARS **IN PERSON** ON OUR STAGE	**ACTION FEATURE** ON OUR SCREEN Plus LOTS OF COLOR **CARTOONS**

PRIZES — CONTESTS

BIG **REVELL** PLASTIC KITS
FOR CONSTRUCTING AIRPLANES AND OTHER TOYS!
GIVEN AWAY FREE
AT EVERY CLUB MATINEE
FUN FOR ALL...PRIZES FOR MANY!

JOIN THE CLUB TODAY AND BE AT THIS THEATRE EVERY SAT. MATINEE

MAJOR MARS, Care of FOX THEATRE
PLEASE ENROLL ME AS A REGULAR MEMBER IN YOUR CLUB.

NAME

STREET

CITY .. ZONE

AGE MY NEXT BIRTHDAY WILL BE

PLEASE PRINT PLAINLY AND HAVE IT FULLY FILLED OUT BEFORE BRINGING IT TO ABOVE SHOW

FOX
THEATRE
620 LINCOLN VENICE

FILL OUT THIS MEMBERSHIP APPLICATION AND BRING IT WITH YOU WHEN YOU ATTEND THIS BIG MATINEE SHOW AT THIS THEATRE

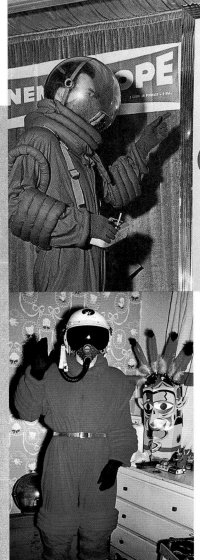

left: **Flyer advertising an appearance by Major Mars.**

opposite top: **Bob "Major Mars" Burns and a poster touting one of his very first appearances.**

opposite bottom: **The Major with upgraded Air Force headgear.**

So, starting in 1952, each Saturday afternoon saw me onstage at the Fox as the mighty and mysterious Major Mars. After two performances I was able to upgrade my headgear to an Air Force helmet that my uncle had sent me, but other than that my Major Mars outfit and schtick remained more or less constant for the remainder of my run. We usually started with a movie or serial chapter; then I would come onstage with a microphone and tell space stories. There was no script—I've never worked well with scripts—and I would basically make up the dialogue on the spot. I believe in audience participation, so I'd always make sure to build in a component for the kids to take part. I'd say, "Today I'm going to tell you about my experiences fighting the Martians on Venus, so here's what I'm gonna do: When I say that I fire my ray gun, it goes Bzzzzzt—and I want all of you kids to do that. When I say my ship takes off, it goes BGGGGGSSSSHHH—you all come in on that." And

when I pointed my ray gun or activated the rockets, the theater would go nuts.

I started augmenting my stories with contests in which kids could win small prizes, including gift certificates from local merchants and free passes to next week's show. I kept each game as simple as possible—eating crackers and trying to be the first to whistle, for example—because I realized how important it was to give kids a chance to come out on top. The littlest kid who couldn't swing a bat could be the big winner in a race to pop a balloon on Saturday afternoon in front of all of his or her peers.

My weekly Major Mars appearances, already popular, gained an even larger following after an executive from the Revell Model Kit Company attended a show with his kids. Captivated by the size and enthusiasm of the crowd, he met with the theater manager and proposed that Major Mars give away model kits that were a tie-in to Revell—a great promotion for the local model company and a substantial boost for the Fox Theater box office. Soon, hundreds of kids carried Official Revell-Major Mars Club membership cards in their back pockets—and I was able to amass a pretty nice collection of models.

I retired the Major Mars character after two years of Saturday afternoons in the helmet and spacesuit. Kids were starting to stay home with the TV, and I was simply running out of steam. It also didn't help that very few new kid-oriented films were being produced in the mid-1950s.

Was this the end of Major Mars? Had the stalwart defender of intergalactic goodness finally been vanquished? If you know your Republic serials, you'll also know to stay tuned.

IT'S FUNNY how the course of your entire life can be shaped by seemingly inconsequential decisions and chance events.

Just such an episode occurred for Kathy and me around 1954 or 1955. We attended a meeting of the local science fiction club to hear the featured speaker, Ray Bradbury. He had just finished the screenplay for *Moby Dick* and was going to discuss the process of working on that rather ill-fated film (which I loved). During a break in the presentation, Kathy and I somehow started talking with the couple seated next to us, Paul and Jackie Blaisdell.

During this chance encounter, all four of us clicked really well. Paul, it turned out, was a technical illustrator who was doing science fiction artwork for some of the magazines I regularly read, such as *Spaceway*, *Other Worlds*, and *The Magazine of Fantasy and Science Fiction*. He also liked to write science fiction stories—my kind of guy!

But the kicker was yet to come. As our conversation developed, Paul mentioned that he'd recently been contacted to create a monster for a movie about to be shot. If I had been intrigued before, I was enraptured at that point! When we parted ways at the end of the event, Paul asked us to come up sometime to their house in Topanga Canyon, where he'd show us the little alien he'd built for the project. A couple of weekends later—after what I considered a polite interlude—I gave him a call and we did just that.

Paul's inaugural movie project came to him by way of his art agent, Forrest Ackerman. Paul and Jackie, also a very talented artist, were commissioned to put together a miniature monster for an American Releasing Corporation picture directed by Roger Corman. "All he has to do is point a ray gun and fall over when he 'dies,'" Paul related to me. "Doesn't seem too complicated." What neither of us knew at the time was how "interesting" it could be to work for Roger Corman and American Releasing Corporation (ARC).

ARC cofounder James Nicholson had an uncanny knack for dreaming up provocative titles. True to their normal modus operandi, ARC had pre-sold to exhibitors a film entitled *The Beast with 1,000,000 Eyes*, complete with poster art and ad blurbs, before a single frame had been shot. Corman and his partners were particularly pleased with this project because the screenplay called for a monster that was an energy-based nonentity—in other words, a way to exploit the emerging science-fiction movie craze with no expensive special-effects bills. When the finished film was shown to potential exhibitors, however, they were not at all pleased by the experience of sitting through seventy-eight minutes of inane plot with no sign of a monster anywhere. ARC's advance promotional artwork had led them to expect something pretty slick, and they were damned if they'd buy a movie with "beast" in the title but not on the screen.

Corman contacted Forrest Ackerman, whose byline he had seen in numerous science fiction magazines, to plumb his contacts in the business for someone who could create a creature. Perhaps forgetting for a moment whom he was dealing with, Ackerman first suggested "Dynamation" animator Ray Harryhausen. The notion of paying the man who brought life to Mighty Joe Young and *The Beast from 20,000 Fathoms* was, of course, ludicrous to budget-strapped Corman. Ackerman's second suggestion was Jacques Fresco, who had created effects for the 1953 film *Project Moon Base*. Alas, his asking price of $1,000 was beyond Corman's reach. Finally,

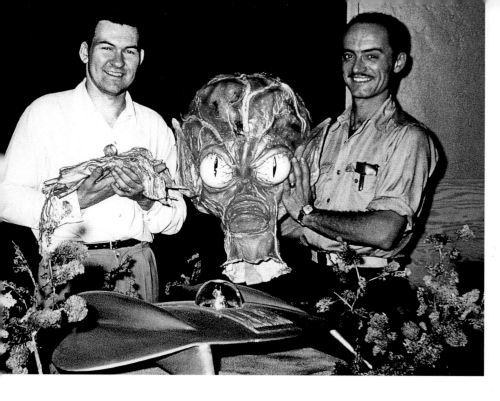

left: **Bob Burns and Paul Blaisdell** pose with props from *Invasion of the Saucer Men* (1957).

below right: **The Blaisdells' first movie monster, "Little Hercules,"** from *The Beast with 1,000,000 Eyes* (1955).

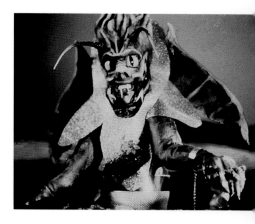

Ackerman cut to the quick and asked just how much Corman was willing to spend to salvage his movie. "I'm willing to go as high as $200," he answered. Ackerman knew that no professional would touch that measly paycheck.

However, Paul Blaisdell was a talented artist with no experience in motion-picture work, so Ackerman correctly surmised that he might take the assignment on a lark. After asking for and getting a copy of the script, Paul agreed to do the job if he could get an additional $200 for materials. Corman really had no choice if he wanted to save his investment, so Paul had a whopping $400 to work with—minus Ackerman's ten-percent agent's commission.

"We figured for a couple of kids who had grown up in the '30s when everyone was making model airplanes and kites and puppets, the assignment couldn't be all that bad," Paul said. "The script didn't indicate anything complicated." Of course, this was before Paul learned that what you saw in an ARC script usually had very little to do with what would actually be filmed.

Since Corman gave Paul complete discretion over the look of the alien, he quickly decided that a literal million-eyed creature was out of the question. It would be plausible, however, that the "nonentity" Beast could see, hear, and interact with other characters through an alien slave body. Working first with sketches and finally sculpting the extraterrestrial in

modeling clay, Paul Blaisdell's very first contribution to movies was born: an eighteen-inch hand puppet he nicknamed "Little Hercules." The alien featured a large "exposed brain" head and batlike wings. Manacled wrists illustrated its slave status and a jeweled pendant accessorized its uniform.

Little surprises began early. Paul was also asked to create a rocketship airlock door built to the same scale as Little Hercules, and then an entire miniature ship for the film's new conclusion. He delivered a meticulously created egg-shaped craft—only to find that the film's second-unit crew had already constructed a full-size ship section in the desert for insert shots. The amalgamation of auto mufflers, an airplane nose cone, and garbage cans did not resemble Paul's model, so he had to create a new miniature.

Actual filming of Paul's handiwork was another headache. Paul was told to report to a studio owned by Lou Place, de facto director of the film. Upon arriving with his miniatures, it was obvious that "studio" was a stretch; they would be working in Place's garage. Compounding the problem with cramped quarters was the fact that the shooting space was filled with expendable bodies. The film's crew were all impressed with Paul's work and wanted to make sure they were involved in some way with the shots of Little Hercules and the miniature spacecraft. Paul

Marty the Mutant menaces the heroine on this *Day the World Ended* (1956) promotional insert.

found that he could barely manipulate his puppet in the small space provided by the director's hurried and harried setup, and his suggestion of retakes to allow for experimentation was dismissed with a laugh. The entire filming process took about ten minutes—Place was under enormous pressure, as Corman was in a hurry to get his cobbled-together flick in the can and into the hands of his exhibitors. Paul left the shoot with misgivings, but assumed "these guys must know what they're doing."

The Blaisdells barely had time to catch their breath before Corman—no doubt pleased with the amount and quality of their work for a mere $400— threw another assignment at them. ARC felt that exploiting the country's apprehensions about atomic testing in the USSR could put some money into their pockets, and James Nicholson knew he had a can't-miss title: *Day the World Ended*. There was, of course, no script, but that had never stopped ARC before and it certainly wouldn't now.

Though the project was still a bargain-basement production by mainstream Hollywood standards, ARC planned a budget several times that of their previous science fiction effort. For his part, Paul felt gratified that he was solicited for help on *Day the World Ended* at the very outset of the picture's production, even to the point of helping screenwriter Lou Rusoff resolve some story issues in his tale of seven survivors struggling in a ravaged wasteland following World War III. Rusoff, the brother-in-law of ARC founder Samuel Z. Arkoff, was responsible for writing most of the studio's original output.

I was surprised at how calmly Paul related another piece of news: In this film, he would not only construct a life-size mutant man-beast, he would actually portray the monster. He was very nonchalant about it: "Well, Bob, it's just cheaper and easier for me to tailor a suit to my own dimensions. And anyway, no real actor wants to go onscreen swaddled in a creature-suit." Despite his indifference, I was thrilled for him.

Though he was working in a milieu wherein screenwriters, producers, and directors alike gave very little thought to the logical implications of what went onscreen, Paul liked to think through the "science" of the creatures he designed. He sketched concept after concept for the new creature—in this case, attempting to account for various radioactivity and mutation issues—and submitted each permutation to the ARC brain trust of Roger Corman, Lou Rusoff, Sam Arkoff, James Nicholson, and producer Alex Gordon.

To illustrate the "capable hands" upon which Paul's artistic vision depended, it should be noted that producer Gordon met James Nicholson when he tried—unsuccessfully—to sell Nicholson a script called *The Atomic Monster*, written by his roommate at the time, none other than the illustrious Edward D. Wood Jr. (The script was eventually produced as *Bride of the Monster*.)

As the Blaisdells' new project started up, Kathy and I accompanied them to a press screening of *The Beast with 1,000,000 Eyes*. There, our education continued. The picture was, of course, fairly dreadful. Wooden acting, stilted dialogue—par for the course in a low-budget ARC product. The real shock came when Paul's alien appeared for the first time. Attempting to camouflage director Place's completely inappropriate camera angles, someone had superimposed a spiral effect and huge floating eyeball over Little Herc's scenes. The obscured scenes played so quickly that none of Paul's details—the wrist manacles, ray gun, bat wings, etc.—could be discerned. When I glanced over at Paul as the movie unspooled, he kept looking straight at the screen.

We watched the credits in silence. Lou Place's name was nowhere to be found—we later learned that he'd had it removed from the project. (Paul didn't have to worry about prideful actions like that, since his name was also nowhere to be found.) The house lights came up and we were all the way out on the street before I could muster any kind of small talk.

"That was a disaster," Paul finally said, shaking his head. Kathy and I did our best to reassure him: "You came in at the end of the process. Things will be different on your next project now that you're involved

Wax test casting for Paul Blaisdell's beast in *Beast with 1,000,000 Eyes* (1955). (5" tall, 2 ½" thick)

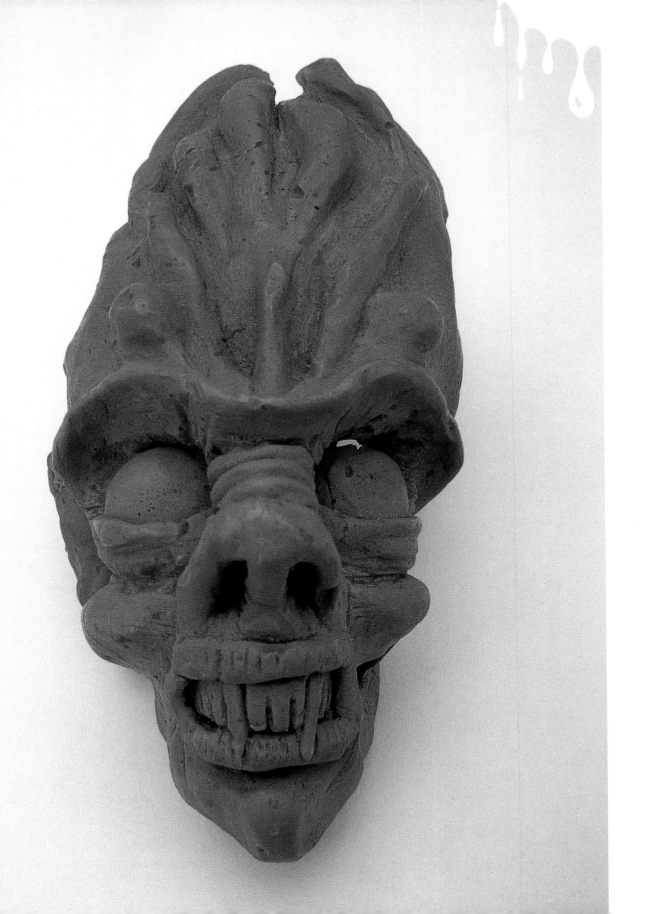

early on." Both Paul and Jackie looked unconvinced. The balance of that particular evening was filled with awkward silences.

Paul and Jackie gamely continued work on their mutant monster costume for *Day the World Ended* and resolved to do whatever they could—from their admittedly very low position on the pecking order—to prevent poor choices from being made this time around. Budget considerations were restrictive enough without the added indignity of carelessness.

Day the World Ended would be directed by Roger Corman himself, and Paul soon found that even though Corman hadn't directed many features before, his vision was written in stone. On one particular shooting day, Corman called over Paul and his star, Richard Denning, to explain a scene wherein Denning would fire a gun at the monster from a few feet away. The monster—this time nicknamed "Marty the Mutant"—would use his superhuman strength and speed to snatch the bullets out of the air.

Paul saw his chance. "I think we're in danger of appearing ridiculous," he said as politely as he could. "It's going to look sort of silly—I'll look like I'm swatting flies." Corman's answer was succinct: "I'm the director." Unsaid, but explicitly understood, was an additional admonishment: "And you're just a guy in a rubber suit who should feel lucky to have the work." The scene was filmed Corman's way and included in the movie. Rent the videotape and you'll see Paul dutifully swatting flies.

The Corman touch also produced some inspired visuals, though at the expense of Paul. I was on location at Griffith Park when a fit of Corman's spontaneity resulted in Paul lying flat on his back with a fog-machine hose snaking up the leg of his costume while sprinklers steadily doused him with "rain." The just-hatched idea was that the monster's death scene would culminate in his "disintegration."

In fact, the slowly escaping white fog created a fairly effective visual. Unfortunately for Paul, the smoke was so thick inside the suit that he couldn't see out of his small peephole, and the foam rubber that made up 90 percent of the outfit was becoming laden with water to the point that he couldn't get up to take a clear breath. He raised his arm to alert the crew, but the movements looked enough like monster death throes that Corman shouted encouragement

from his position behind the camera. It wasn't until Jackie recognized Paul's distress that the crew rushed into action and helped him to a sitting position—whereupon rivers of water shot out of the openings in his legs.

When *Day the World Ended* was ready for release, ARC's Arkoff and Nicholson decided to send Marty the Mutant on tour as an attraction for the lobbies of theaters showing the film. The suit would be shipped from city to city and worn by some unfortunate local usher who risked dismemberment at the hands of moviegoers anxious to wiggle Marty's antennae or snatch off a scale. After Marty's first such appearance, Paul received a package in the mail containing the tattered remains of his costume, which he dutifully patched up and sent back out into the world. He was supposed to get it back regularly for further repairs, but the last we heard of Marty, he was on his way to Hong Kong, never to return. Lost or not, ARC wrung additional mileage from the character by splicing footage of him into another of their flicks, *Teenage Caveman*.

During this period, Paul and Jackie began to work almost constantly for ARC productions. In September 1955, Nicholson and Arkoff moved their offices to Sunset Boulevard in Los Angeles and unveiled a new name to reflect what they hoped would be an ambitious new direction: American International Pictures.

At the same time, Kathy and I became closer and closer friends with the Blaisdells. We found ourselves making the trip to their place more and more. AIP's assembly-line production slate meant there was very little—if any—hiatus between projects, so the Blaisdells always seemed to have a new monster of some sort inhabiting their home workshop. Though the help we provided consisted mainly of fetching a fresh glass of lemonade or holding pieces steady as they were glued together, Kathy and I loved being around the "creature-making" process. The days flew past quickly when we were together, and each visit ended with Paul saying, "See you guys next weekend."

It was natural, then, for me to tag along with Paul on his movie gigs. My job at CBS allowed for taking

Bob's display at the 1963 Hobby and Gadget Show of Burbank netted him a "Best Presentation" ribbon and his name on the "Sweepstakes" trophy.

Paul and Jackie compare their She-Creature mask to the artwork for the film.

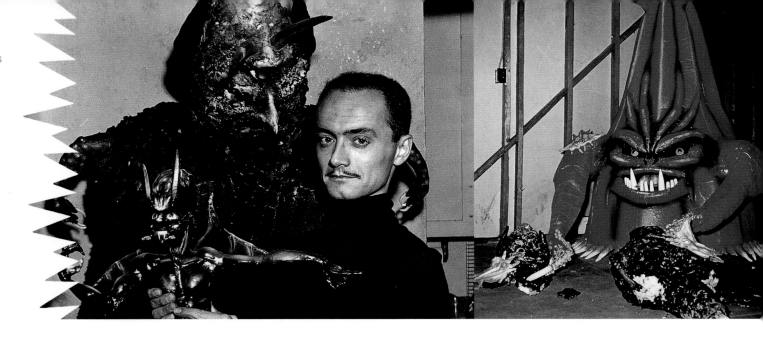

vacation time in one-day increments, so when he invited me to come with him to the set of his next assignment, *It Conquered the World*, I jumped at the chance to get involved with the process. I would act as Paul's unpaid assistant, helping with repairs and touch-ups on his various creations.

For this film, Paul was told by Nicholson to "make something that no one had seen before, something really different." He certainly delivered with "Beulah," a giant crab-armed, cucumber-shaped monstrosity. Beulah was built so Paul could operate it from inside, controlling arm and facial movements.

Once again, Paul thought out the details when building his monster. "The writer wanted some kind of creature that was pretty invulnerable and came from the planet Venus," Paul later explained. "At that time the belief about the physiognomy of Venus was that it was hot, humid, conducive to plant life but not well suited to animal life." With that in mind, Beulah was conceived as a giant piece of intelligent vegetation equipped with small, telekinetically controlled creatures that it could send out to handle the "hands-on" terrorizing and conquering details. According to the script Beulah itself would remain stationary in a dark cave, ambulatory for only a short scene that showed it slowly wading, partially concealed, through underbrush.

Again, director Roger Corman's budget-minded, spontaneous style conflicted with Paul's intent. On the day the crew was set up in Bronson Canyon to shoot the film's climax, which would feature a confrontation with Beulah inside its cave hideaway, Corman suddenly decided that the monster would exit the cave and make its final stand in the light of day.

Paul was beside himself. "I have casters on the monster so I can move it from setup to setup—those tiny wheels aren't made for on-camera moves," he explained. "And I made the creature to inhabit the shadows. It'll look ridiculous in the light of day!"

Legend has it that Corman issued a characteristic edict along the lines of "I paid for a monster, so by God we're going to see it!" Paul's more diplomatic recollection of that afternoon: the gas-fueled generator, which powered the lights, had gone dry and no one wanted to waste time refilling it. Corman went full speed ahead, and the onscreen result—a seven-foot scowling cucumber creeping over uneven ground in broad daylight—lives on as one of the goofiest moments in film history.

It Conquered the World had barely wrapped when Paul was invited to create a new creature, this time a member of the fairer sex.

For *The She-Creature*, Paul was charged with designing and building another full-size monster outfit. In preproduction meetings, everyone and his brother had a concept they wanted Paul to include in his visualization of the creature, and he nodded studiously as they shared their grand visions. He knew by now, though, that most grand flashes of brilliance lobbed at him over a conference table would be forgotten the minute the meeting adjourned—and, worse, most of

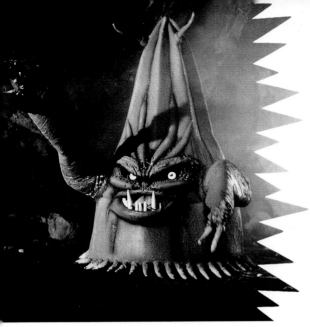

far left: **Paul with "Marty the Mutant" of** *Day the World Ended* **(1956).**

center:**"Beulah" of** *It Conquered the World* **(1956) before production began. The tattered remains of "Marty the Mutant" are in its clutches.**

left: **"Beulah" in action on the set.**

Rubber "remote mind-control creature" from *It Conquered the World* **(1956), created by Paul Blaisdell. Restored by Jim McPherson.**
(12" wingspan, 13" long)

the suggested details that he implemented would be second-guessed in the light of day. Paul wisely stuck to the script for his inspiration.

The "She-Creature" costume, dubbed "Cuddles," took eight weeks to complete. This monster would be called upon to do things no previous AIP monster had had to do, so Paul made the costume suitably flexible and resilient. In fact, Cuddles would prove durable enough to appear in three subsequent AIP features.

I accompanied Paul and Jackie to the shoot to help out with suiting up and minor repairs on the *She-Creature* costume. The director this time out was Eddie Cahn, a seasoned veteran who always came fully prepared and well versed in the shooting script. With an ever-present pipe clenched between his teeth, Cahn would be up and pointing to another spot on the ground for the camera while the echo of the previous scene's "Cut!" still hung in the air. He took immense pride in the number of setups he could accomplish in a single shooting day. Also, it was Cahn's suggestion that Cuddles be given a long tail, and he sent Paul back to the shop to endow the She-Creature with, as he put it, "bigger boobs." Thus was born Hollywood's first voluptuous monster.

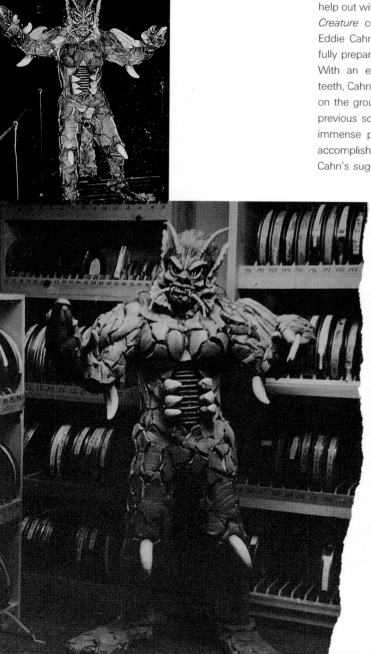

The AIP crew by this time was a well-oiled machine and accustomed to working together. I watched, amazed, as they'd tear through forty setups in a single day. Often Cahn would have to be asked to repeat an instruction—the combination of his pipe-clenched teeth and English accent often made him unintelligible—but, other than that, the five days that Paul and I spent on the set were remarkably stress-free. It was fun watching Paul, who was fast and furious with the off-camera quips, give actress Marla English a case of the giggles when he loomed over her as Cuddles.

above: **On the night Paul Blaisdell finished his She-Creature creation and tried it on, Bob commemorated the occasion with 35mm shots, some in 3D, taken around Paul's property. Soon after this picture was shot they took a walk down one of Topanga Canyon's desolate roads while in costume, waiting for the headlights of an unsuspecting motorist—giving someone quite a story that night.**

left: **Bob ready for his cue at CBS.**

While Paul was a bit disappointed that Cahn's sprintlike production style precluded the exploitation of some of his costume's ingenious features, he couldn't be happier that, in this case, his director stuck to the script and didn't spring any on-set surprises on him. Still, five days in a seventy-two-pound outfit—plus nightly repairs after each day's shooting—wore Paul to a frazzle. When the film wrapped, he was ready to relax.

The speed with which AIP could package a feature was astounding. Within a couple of weeks, *The She-Creature* was released on a double bill with *It Conquered the World*. Paul and Jackie had just barely been able to dry out the seawater-drenched Cuddles costume when James Nicholson asked him to appear on an L.A. television show—not as himself, but in character as the She-Creature.

Too pooped to take on the extracurricular activity but loath to let down Nicholson, Paul turned to me. "Bob, I just can't stomach lumbering around in that damn suit anymore. It feels like we just finished filming yesterday. Do you want to go in my place?"

After watching from the sidelines for so long, I felt like the coach had tapped me to go in for the quarterback—of course I'd step in!

There were actually two shows on which the She-Creature was to appear, "Quinn's Corner" and "Campus Club," and both were taped in the CBS building where I worked. In the film library–dressing room, Lionel Comport acted as my assistant and made sure I got my head screwed on right and all my zippers secure. We caused a stir when walking down the hall in search of a soda machine.

"Quinn's Corner" was a breeze. We opened with the host, Louis Quinn (who would later be well known as Roscoe on "77 Sunset Strip"), sitting at his desk welcoming the viewing audience, unaware of my approach as the She-Creature. After his surprise, we discussed the pros and cons of horror films and monster-hood. He sympathized with the fact that the monster rarely comes out on top.

"Campus Club" was a different situation entirely. Hosted by Gene Norman, this live show had an in-studio audience of school kids that he wanted to surprise with an appearance by the She-Creature. They were surprised all right—as soon as I stepped

out onto the set I saw a wall of kids rushing toward me, anxious to see the monster up close. I was sure they'd drive me right through the backdrop, scales and all!

Norman quickly restored order and the show got down to fun and games. Cuddles joined a marshmallow-eating contest, and, as a tribute to my eating skill as much as to Paul's flexible costume design, I won first prize—a pair of tickets to a showing of *The She-Creature*. I indignantly growled and gave them to the runner-up.

When all was said and done I had been in the suit for over four hours, drenched with sweat and three pounds lighter as a result. It probably would have been a miserable experience for Paul, but I loved it. In fact, I asked him if I could have Cuddles for an extra day or so to show the outfit to a neighbor who'd asked to see it. At about 9 P.M. I suited up and began the short walk to his house. On the way there, I came around a corner and ran smack dab into a little girl who looked to be all of seven years old. Before I could say anything, she let out a screech and ran back the way she came. She was so shaken that she tripped over a curb and chipped her two front teeth on the sidewalk. I yanked off the mask as quickly as I could and approached her gingerly, all the while thinking, "Uh-oh—lawsuit city!" I helped her home and her parents, well acquainted by now with the fact that I had "weird friends in show biz," answered the door without batting an eye. I apologized profusely, but the mother told me not to worry about it.

"She's been defying us lately, sneaking out of her room at night," she explained. "We told her that if she kept it up, one day she was going to run into the devil."

The most fun I had working with Paul began when James Nicholson suggested to Blaisdell that they create something evocative of the old sci-fi pulps they both had treasured as kids.

"I'd just love to do a picture with one of those classic Martians," Nicholson explained. "You know, the kind with the enormous head and little tiny body, and he doesn't worry about a thing; you just look like you're going to hurt him and he points a finger at you and goes BRZZT—and you've had it!"

Paul knew exactly what he meant, and the two spent quite a bit of time brainstorming ideas for visu-als. Nicholson, as usual, had a great title already dreamed up: *Invasion of the Saucer Men*.

Of course, AIP's budget precluded swarms of beady-eyed aliens making landfall on a major U.S. city, so Nicholson and Blaisdell agreed that Paul and Jackie would create four extraterrestrials and two flying saucers, plus various head and claw close-up gags. Paul felt that the job was not only manageable but had the potential for real fun.

His mood was dampened early, however, when he presented his first *Saucer Men* heads to Nicholson and co-producer Robert J. Gurney Jr. The fruition of Nicholson and Blaisdell's idea of classic pulp-magazine aliens didn't sit well with Gurney; he stated forcefully that the heads were way too big and therefore unusable. Nicholson didn't fight Gurney's opinion, so Paul went back to the workshop and "shrunk" the Martians' craniums by slicing a wedge from the rear of each head and meticulously pulling the opening closed.

Eddie Cahn helmed the seven-day shoot, 98 percent of which took place on a very large soundstage complete with police station, café, and farmer's house. Despite its low budget, *Invasion of the Saucer Men* exudes a polished sheen due in large part to the fact that all of the "outdoor" night scenes were simulated on the realistically designed stage, avoiding the cheap-looking "day-for-night" location footage that mars many productions (including *I Was a Teenage Werewolf*, the picture that shared a double bill with *Saucer Men*).

My big-screen debut was made possible after Paul demonstrated his "hypodermic fingernail" creation on me for a reluctant Lyn Osborne, whose character gets zapped by a Saucer Man. The aliens, you see, were equipped with retractable needles in their hands that delivered knockout doses of alcohol. "Doesn't hurt a bit, does it, Bob?" Paul asked. I shook my head, but Osborne, unconvinced, said, "Fine, then *you* do it." Eddie Cahn simply shrugged his shoulders and told us we'd have to deal with it during insert shooting. My neck would work just as well as Osborne's.

Paul, Jackie, and I were to complete all of the "insert" *and* miniature special-effects sequences, including my stand-in stint, in a single day. There

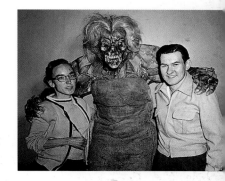

Jackie Blaisdell and Bob pose with Paul in costume as the title character of *Voodoo Woman*. (1957)

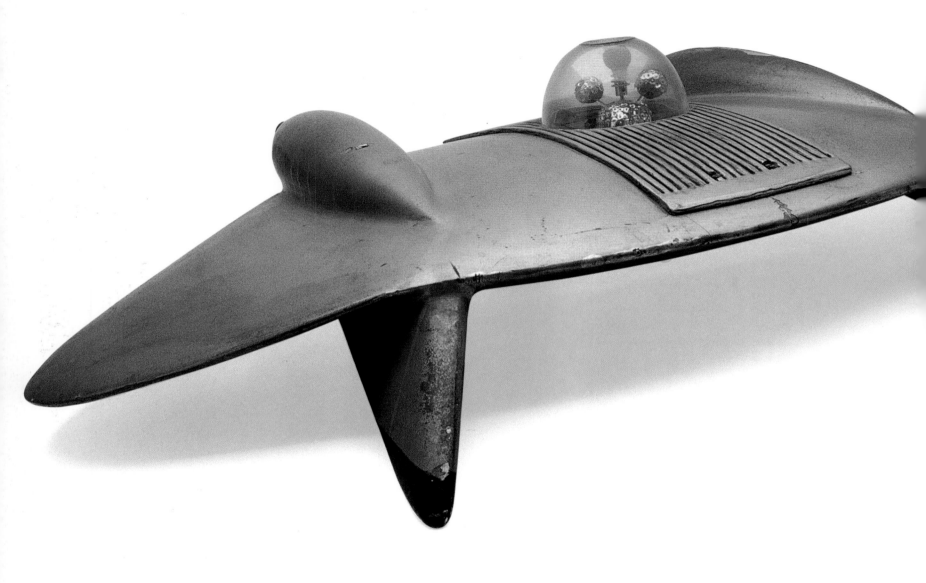

above: *Invasion of the Saucer Men* space vehicle created
by **Paul Blaisdell**, built of white pine and painted with
**100 coats of paint. Its internal motorized flashing mechanism
is still operational.** (30" across, 24" wide)

right: **Paul Blaisdell's ready-to-explode cardboard ship
in repose on slapped-together landscape by "Mr. X".**

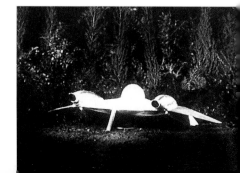

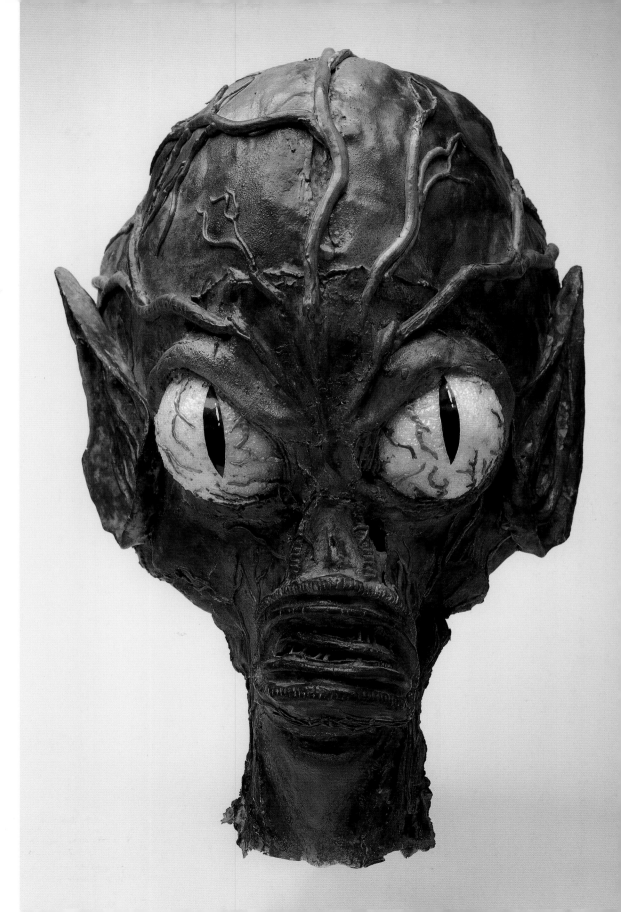

The Saucer Man head Bob wore in
Invasion of the Saucer Men, reconstructed
by Jim McPherson. (23" tall)

were no dailies (screenings of the previous day's shooting) and no chance for retakes—whatever we got in one session was what would go in the final film.

For miniature shots of the Saucer Man spacecraft that Paul built, a fishpole-and-wire setup made for convincing fly-bys and landings that Paul practiced for days leading up to the shoot. Unfortunately, the designated special-effects man, whom I'll refer to for propriety's sake as "Mr. X," decided that Paul should limit himself to building props and monsters; Mr. X, as arbitrarily titled "special-effects" person, would be the pilot. (Paul's title on *Saucer Men* was "technical effects.") Not only that, Mr. X discarded Paul's carefully prepared miniature landing site—a "union problem," he explained—for something he created himself right in front of us: a chunk of plywood with brush and dirt (he pulled ferns from right outside the stage door) stapled and glued onto it.

As the shot was being set up, cameraman Howard Anderson, who shared the "special effects" title in the film's credits, noticed how clumsily Mr. X was handling the spacecraft via Paul's wire-and-pole setup. Anderson wisely decided to overcrank the film to slow the image down, thereby smoothing the craft's trajectory a bit. The resultant slow-motion footage concealed Mr. X's clumsy maneuvering, but, unfortunately, also ruined the strobe effect Paul built into the spaceship via rotating mirrors in its dome.

Paul had created a cardboard model of the Martian spaceship for its onscreen explosive destruction, adding extra details to the interior—computer consoles and other electronic gadgets—that would briefly expose themselves during a controlled blast. We watched as Mr. X loaded the ship with gunpowder and more gunpowder, and more gunpowder, until Paul had to step in and warn him that there was simply too much in there. Of course, Mr. X refused to listen, and I followed Paul's lead as he prepared a plywood "fort" in the corner of the studio for us to hide in. Predictably, the explosion blew model parts—and Paul's details—past the camera with far too much velocity for them to be seen. In fact, we never were able to locate all of the model's pieces in the studio. When Mr. X finally got tired and left the studio, Paul, Jackie, and I got the rest of our shots done with the invaluable assistance of cameraman Anderson.

One of the more elaborate setups we were able to do without interference involved a Saucer Man's encounter with a bull that resulted in a bloodily gouged eye for the unfortunate Martian. To get the shot, Paul positioned himself behind a Saucer Man head with a Hershey's Syrup–filled grease gun mounted in the eye. As I rammed a pole-mounted prop bull head into the Martian's orb, he let loose a gush of simulated blood—a gory success!

Outdoor shots of the bull attempting to throw a bronco-busting Saucer Man dummy had been done earlier at Lionel Comport's Movie Ranch using his Brahma bull—not a match for the in-studio prop, but who would notice?—made suitably ornery by use of a rodeo "bucking burr." To film the bull succumbing to a Martian injection, the animal was actually drugged; you can see his eyes roll in the film. In 1957, the ASPCA wasn't a factor in most film production.

In a fit of self-awareness nearly unheard of in the world of low-budget filmmaking, James Nicholson and Eddie Cahn decided in midstream that *Invasion of the Saucer Men* would actually play better if they approached it with a sense of humor. After all, two of the stars—rubber-faced Lyn Osborne and impressionist Frank Gorshin—were comedic talents who could easily deliver laughs. Added narration by Osborne, who also gave voice to the Saucer Men, started and ended the film with a perfect tongue-in-cheek attitude. Paul was charged with creating cartoonish illustrations for the main titles, and he ended up contributing far more by crafting an entire book containing the titles, the cover of which is finally closed at the end of the picture by—surprise!—a Saucer Man hypo-hand.

Paul and I were disappointed to see that a great many of his best effects sequences were trimmed from the final edit—our "eye goring" scene was deemed too graphic, for example, and minimized—but the end result was a science-fiction/monster/teen flick with a sense of humor, which, in that era, was

below left: A promotional still of the Saucer Men.

below center: An on-set still created before the aliens' head shrinking operation.

below right: Director Eddie Cahn, pipe clenched in his teeth, supervises the violent demise of a Saucer Man.

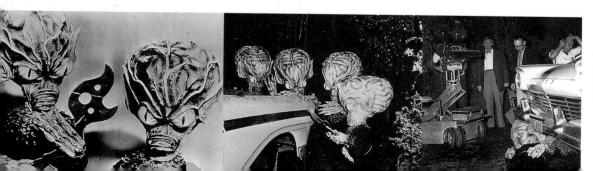

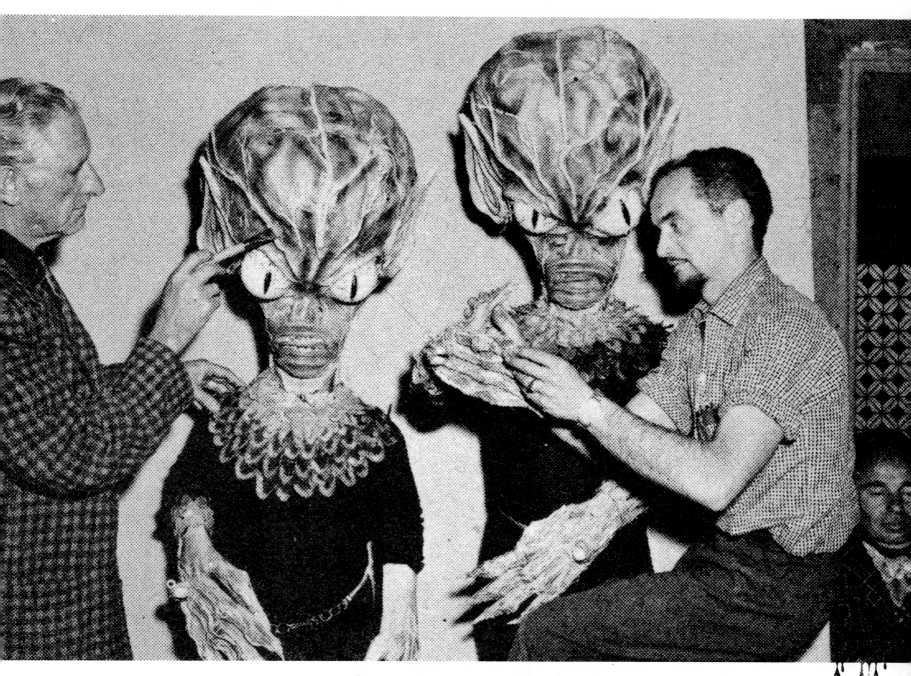

Makeup man Carlie Taylor and Paul Blaisdell put finishing touches on the Saucer Men.

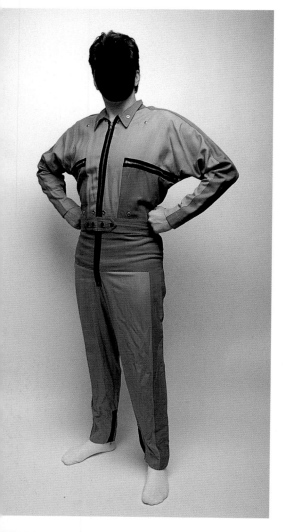

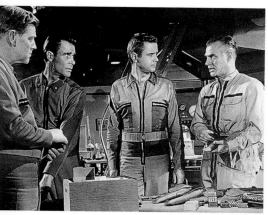

above and left: **Flight costumes from**
It! The Terror from Beyond Space (1958).

very rare indeed. Paired with *I Was a Teenage Werewolf*, the double bill did enormous business, and *Invasion of the Saucer Men* remains a cult favorite to this day.

Spurred on to a great extent by promises made by AIP that the small paydays Paul faced on the "front end" of his movie work would be taken care of in the form of royalties and larger checks as the company grew, the Blaisdells (Jackie began to get her deserved film credit by now) continued to toil on films like *Attack of the Puppet People, Earth vs. the Spider*, and, in a roundabout manner, *How to Make a Monster*. The last film's storyline purports to show AIP "behind the scenes," complete with footage of "studio tours." In reality, American International Pictures didn't own a single soundstage, much less a studio complex; they rented all of the stages and locations they used. Paul's contribution was limited to the presence of some of his creations in the film's fiery finale. In the background you can see the heads for the She Creature and the Saucer Men, as well as the remains of Beulah from *It Conquered the World*.

The last movie that I helped Paul with was *It! The Terror from Beyond Space*, a film many say influenced *Alien* in terms of atmosphere and plot. Independent producer Robert E. Kent set up the project at United Artists, and he brought the AIP team of Eddie Cahn and Paul into the production.

The movie faced a bit of a problem right at the outset, and that problem's name was Ray "Crash" Corrigan. A veteran of the Saturday afternoon serials in the 1930s and 1940s, Crash had also portrayed many gorilla roles in features like *Captive Wild Woman* and *Dr. Renault's Secret*. By the late 1950s, though, Corrigan's tendency to hit the bottle at all hours of the day made him almost unemployable. United Artists was set on using him, however, so Paul was hired to create an "It" suit tailored to the very large actor. Corrigan refused to make the trip to Paul's workshop to get measured, instead sending over a pair of his long johns to work with. Paul protested to

no avail; United Artists wanted Crash Corrigan's name on the credits to give *It!* a promotional bump, so Paul would have to work around his behavior.

It should come as no surprise, then, that Robert Kent ended up making a frantic call to the Blaisdells on the day Corrigan first tried on the suit.

"Is something wrong?" Paul asked.

"Just get down here," was the terse reply.

Upon arrival at the producer's office, Paul and Jackie were met with the sight of Crash standing in the middle of the room clad in the scaly bodysuit they'd created. Lane "Shotgun" Britton, the film's makeup artist, was dusting the area around his eyes. Everything looked good until he tried to pull on the mask, which only *barely* covered his substantial head. His bulbous chin escaped through the mouth hole.

Paul was crestfallen, all but certain he'd be asked to redo the mask overnight despite his earlier warnings. But then Kent suggested, of all things, that they paint Corrigan's chin.

Lane Britton jumped in: "What if we put some makeup on his chin and make it look like a tongue?" Without hesitation, he began applying greasepaint to Corrigan's jowl. Paul had to hand it to Britton—the effect was pretty darn effective. All that was needed was a touch-up around the eyes and a row of lower teeth, and "It" looked ready to terrorize the galaxy. Another job done.

Days later I got a call from Paul, sounding about as irritated as I'd ever heard him.

"They want me down on the set tomorrow," he growled. "They can't figure out the suit and they want me to deal with it and make repairs. Wanna meet Jackie and me at the studio gate and tag along?" Why not?

Paul arrived on the *It!* set with a chip on his shoulder. A few days earlier he'd been there to make sure a specially crafted separate monster armpiece he had made for Corrigan had reached the set safely. Having been the man behind the mask so many times before, Paul empathized with Corrigan's desire to stay out of the entire uncomfortable contraption as much as possible, so he fabricated the armpiece as a considerate—and uncompensated—"extra" for Crash

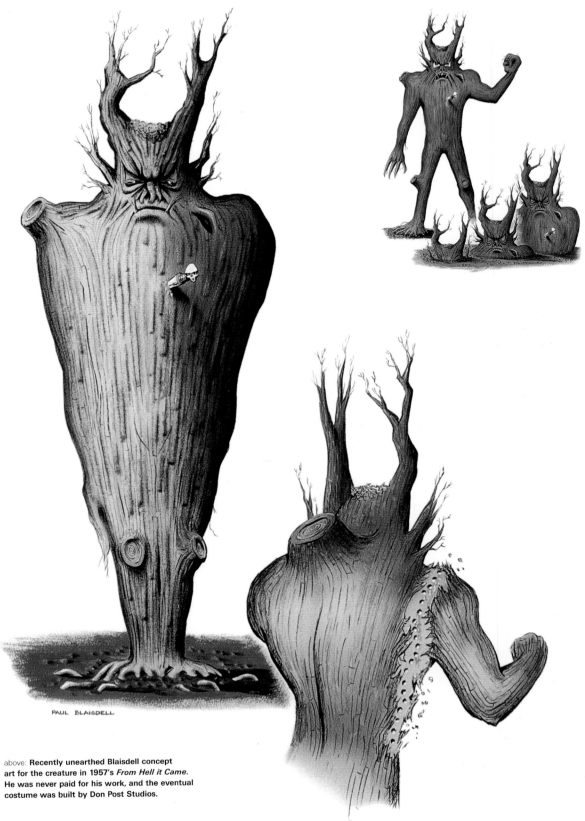

below: *It!* mask (left) from original mold shows how Blaisdell's design looked before alteration to fit Crash Corrigan. Duplication of mask (right) as it finally appeared in the film. (16" tall)

bottom: Head and ear plaster molds for *It! The Terror from Beyond Space* (1958).

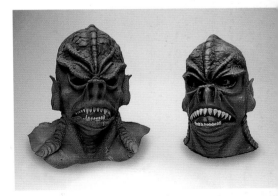

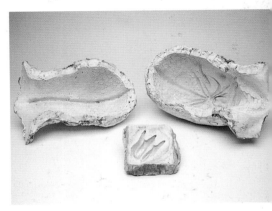

PAUL BLAISDELL

above: Recently unearthed Blaisdell concept art for the creature in 1957's *From Hell it Came*. He was never paid for his work, and the eventual costume was built by Don Post Studios.

to wear in the many scenes where the rest of him would not appear on camera. On that day the assistant director looked at Paul the same way he would have regarded a worm on the sidewalk. "Who the hell are you?" he snapped. Then the A.D. proceeded to chew Paul out for no particular reason. After that experience, Paul was inclined to stay clear of the shooting and leave the "pros" to their work.

However, it was not in Paul's nature to be vindictive and hurt a project he was involved with, so we dutifully reported to the wardrobe person and the Blaisdells effected repairs on the costume, tattered by Corrigan's energetic thrashings on the cramped set. I tried to be their inconspicuous assistant.

It should be noted that, whatever his faults, Corrigan was a wonderful, good-natured person to be around. Despite his unwillingness to trek out to Paul's place for fittings, for example, he was a generous and earnest performer when on the set. Paul, for one, really liked spending time with Crash between shots. The problem was that he was basically playing one of his gorilla roles for *It!* despite Eddie Cahn's directions to the contrary. Corrigan lumbered across the set as if he were in a jungle, and no amount of prodding and reminding could get him to change his style.

Also, he hated to put the mask on and would plead to do scenes without it. There's a scene in the final cut of the film where the monster is seen as a shadow on a passageway wall, and you can plainly see, above the monstrous contours of the "It" suit, Corrigan's very human profile. During another scene, Corrigan's mask works loose from the latex around the eyeholes and he is clearly lowering his head so he can see. "Lift your head! We can't see your damned face!" Cahn yelled from off camera. Corrigan reached up with a monstrous paw and obtusely pushed the mask back on his head to realign the eyeholes. And, yes, that's in the film as well.

The atmosphere on the set was very, very negative—nothing at all like the camaraderie we enjoyed on AIP productions. I was able to make small talk with veteran actor Dabbs Greer, whom I'd seen in countless TV and movie appearances, but the situation was so uncomfortable that I went back only one more time with Paul.

It was up to Eddie Cahn to salvage the film. Paul later told me that Eddie had decided to simply shoot around Corrigan in order to stay on schedule and avoid additional miscues that could have ended up onscreen. The final product is actually much more effective as a result; showing the monster in brief glimpses made for a very creepy atmosphere and eerie sense of suspense. That formula—as well as the basic plot of *It!*, for that matter—was to be followed in 1979's incredible *Alien*.

As the 1950s faded, Paul, Jackie, Kathy, and I continued to enjoy weekends in Topanga, where we made 16mm "home horror movies," recorded radio spoofs, and just plain had fun. Paul, meanwhile, concentrated on his artwork while waiting for the long-promised call from AIP that would mean, finally, a decent budget and a nice paycheck.

It was about that time I got my call from Uncle Sam.

Interplanetary teleportation controller created by Blaisdell for *Not of This Earth* (1957). Behind the red disc is one of Bob's Marx playset figures, which displays in silhouette when illuminated from within. (13" tall)

WAH MING CHANG: GENIUS

During our marathon one-day effects shoot for *Invasion of the Saucer Men*, an effects artist named Wah Ming Chang was using the same studio to create a shot of a large, drooling scorpion head for animation pioneer Willis O'Brien's last film, *The Black Scorpion*. He'd forgotten an ear syringe needed in order to make his monster "drool." Paul had two, so he gave Wah one to keep.

Wah was and is an extremely humble person despite his prodigious talents. I met him again in the late 1960s while doing a CBS segment on Project Unlimited, the effects company he ran along with partners Gene Warren and Tim Barr. I was amazed at what I learned about his background; at an age when most kids were just learning to color inside the lines, child prodigy Wah was having his artwork exhibited in major galleries. At age sixteen he was designing sets for the Hollywood Bowl. Wah eventually became known as a master of nearly all manner of artistic expression, whether it be drawing, painting, sculpture, or conceptual design. In his early twenties he created intricate articulated models for Disney animators to use as guides on films like *Bambi* and *Pinocchio.* He built the miniature Time Machine prop used in the film of the same name, and he shared the 1960 Oscar for the effects on that film with Warren and Barr. The impossibly beautiful headdress Elizabeth Taylor wears during her entrance into Rome in *Cleopatra* is Wah's handiwork.

Wah also did groundbreaking work for TV's "The Outer Limits" and "Star Trek." For the latter, he created familiar sci-fi aliens like the Salt Monster, the Talosians, Gorn, Balok, and Tribbles. He designed and built now-classic Trek hardware like the Communicator, the Tricorder, Spock's Vulcan Harp, and the Romulan Warship, and he manufactured Phasers and other intricate props used on the series. He is so prolific that, to this day, I *still* discover something else he has created every time I talk to him.

And Wah accomplished so much while challenged with polio, which struck him when he was twenty-three years old. He has been an inspiration to me as long as I've known him, and he remains a treasured friend to this day. He is currently very excited about what his new computer can do, constantly encouraging me to follow his lead into the digital frontier.

Four wax faces created by Wah for his short film entitled *The Three Little Dwarfs.* (1 ¹⁄₂" x 2" each)

Elf figure with leather suit created for *The Wonderful World of the Brothers Grimm* **(1962).** (12" long)

NO KNOCK ON WOOD

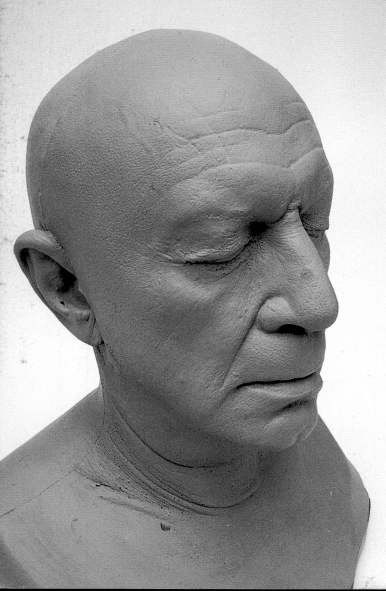

I met Ed Wood, appropriately enough, at a monster-themed party. He was just about to begin *Grave Robbers from Outer Space*, and I found nothing particularly memorable about our short conversation beyond the fact that he was a very enthusiastic and positive individual; I liked him right away, even though he was in full fund-raising mode for his film. His colorful entourage definitely left an impression, especially Vampira (Maila Nurmi). Everyone was welcome in Ed's world, and I imagine some of my friends and I would have participated in the circus were we not so wary of some of his fringe-dwelling friends.

I dropped by the set of *Grave Robbers* on the day Ed was shooting his cemetery material. The floor was covered with grass mats that shifted and slid as they were walked on, and I watched as cardboard "tombstones" wiggled and tipped over when actors brushed up close to them. Through it all Ed bounded about, a virtual dynamo, encouraging his actors and keeping things moving along at a brisk pace. His cheerfulness was downright infectious, and I could see how Ed's troupe of actors could get caught up in his vision.

Kathy and I were invited to an advance screening of *Grave Robbers*, renamed *Plan 9 from Outer Space*, held at a little theater in a shabby part of town. The mood there was very festive and upbeat, and Criswell, the "psychic" who narrates the film, opened the evening by introducing all of the principals in the room.

Undaunted by the death of his film's star, Bela

Lugosi, weeks before production, Ed built his film around existing stock footage he'd already shot of Bela. Tom Mason, the chiropractor who doubled—poorly—for Lugosi in the movie, got up to thank the "late, great Bela Lugosi" for giving him a chance to make his screen debut, and Ed got onstage to dedicate the film to his departed friend.

Kathy and I sat right next to giant Tor Johnson and his family. Tor was enjoying himself immensely, laughing at his appearances onscreen and saying out loud in his thick Swedish accent, "That's good! That's good!"

The last time I saw Ed was in the late 1970s. He had called and said there was something he had to see me about—too secret to talk about on the phone. I told him to swing by CBS, where I was working, the next day. When he arrived, the security guard at the front desk was very leery about letting him in; he was looking the worse for wear and obviously drunk. He greeted me with his usual ebullience and an invitation to help finance his latest film project, the details of which he could not share because he was afraid someone would steal the idea. He was living out of his car but still clung to his conviction that his big hit was right around the corner. I bought him a cup of coffee and gave him all I had in my pockets, about $50, which undoubtedly financed a continuation of his bender. I heard he died very soon afterward.

In the end Ed was a guy with drive, ambition, and passion. There were people who thought he was merely a con man, but I don't buy that for a second. A con man drives around in a big car and pays the mortgage on his mansion with other people's money. In Ed's case—at least until alcohol took over late in his life—every penny he had went toward his dream, and, unlike most of his effete detractors, he actually went ahead and *completed films*. Ed was a good-hearted man who had all that it takes to be a great filmmaker, except two things: taste and talent.

Flash forward. My friend Chuck McSorley worked as propmaster for Tim Burton's 1994 biopic, *Ed Wood*, and he brought me to the set one day. Burton had heard that I'd met Ed and asked me to watch Johnny Depp's characterization and answer whatever questions he might have. Watching Depp, I felt as though I were seeing the ghost of Ed Wood—that exuberant dervish you see

in Burton's film is exactly the way I remember Ed. I ended up spending three days on the set as an informal adviser.

During the shoot, a production assistant called me at home to ask if it would be OK for Depp to bring a friend over to see my collection. A little girl with an inoperable brain tumor was being granted her dream—meeting Johnny Depp—by the Make-A-Wish Foundation, and Depp wanted to visit my collection with her. The little girl and her family arrived first in a limo, and Depp pulled up soon after in a black Porsche. I was very touched by the attention he showered on these people. He went from item to item with the little girl and enthused with her about the props and the movies they had appeared in. I gave her a rubber "bullet hit" from *Terminator 2* and she wore it proudly taped to her shirt all day.

The little girl's father was videotaping and took me aside. "It'll be a long, long time before I can watch this tape, but you and Johnny have made an incredible memory here today. This is something none of us will ever forget." I was very choked up; all I'd done that afternoon was welcome visitors to my collection, which I often enjoy as much as (or more than) the visitors themselves. Depp, however, had paid for an extra day's lodging and limo for the entire family so they could come over, and, better than that, gave generously of himself during the entire visit. By the time they left to have dinner together, I'm certain that little girl felt as though she were hanging out with a new pal. In fact, Depp had her jump into his Porsche so they could drive to the restaurant together.

I couldn't have been more impressed.

right: **Two of Ed Wood's saucers—store-bought Lindberg kits—created for** *Plan 9 from Outer Space*. **The remnants of a square piece Wood glued to the bottom of one model in an effort to crudely match his saucer exterior set can be seen at right.**

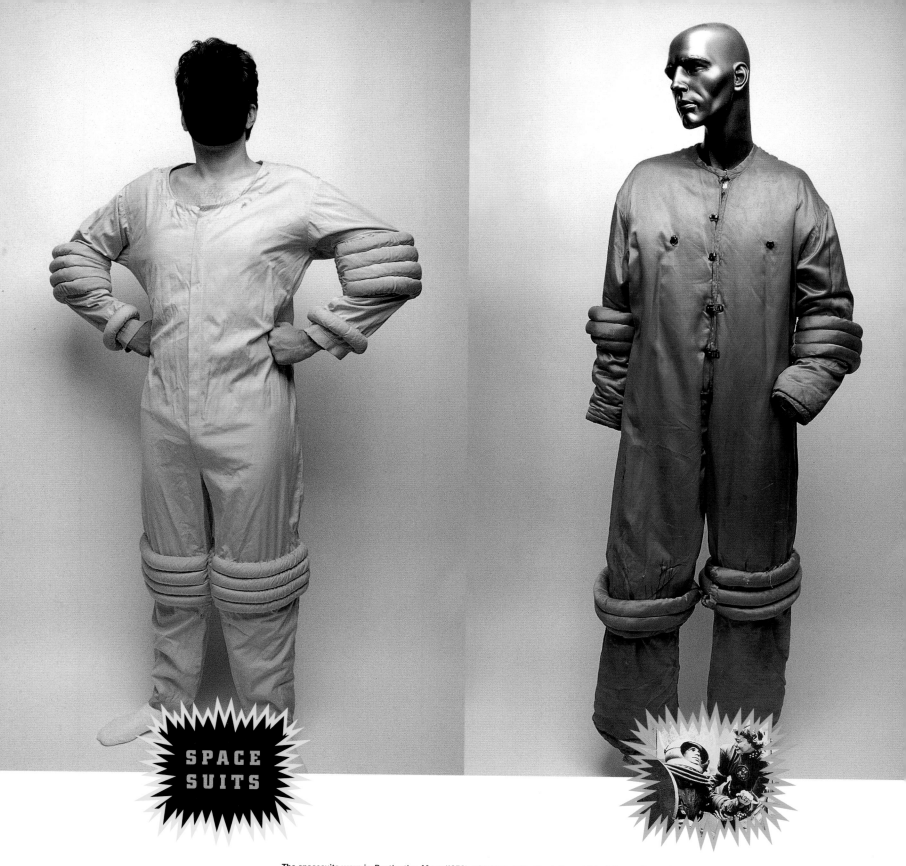

SPACE SUITS

The spacesuits worn in *Destination Moon* (1950), with their distinctive bellows joints, influenced an entire generation of astro-wear, including the suits worn in the

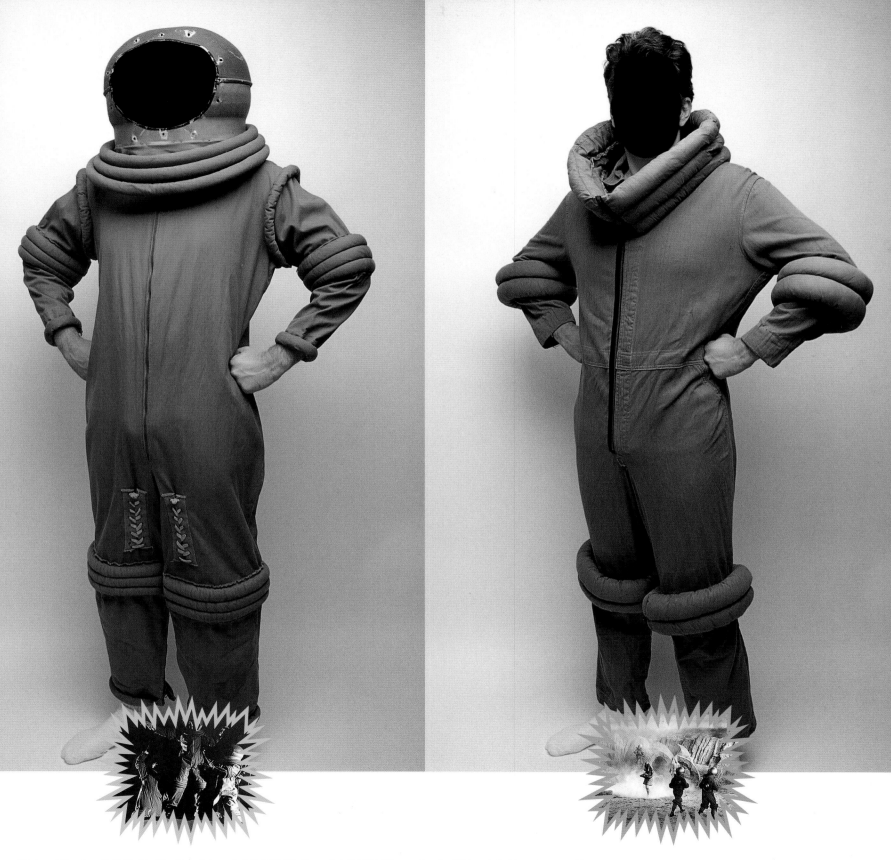

TV shows "Time Tunnel" (1966–67), "Tom Corbett Space Cadet" (1950–56), "Space Patrol" (1950–55), as well as the 1964 movie *Robinson Crusoe on Mars*.

THE ARMY
THE MAGAZINE BUSINESS
AND OTHER
CREEP SHOWS

IF YOU HAD TO BE DRAFTED, 1958 was a good time for it since we were between conflicts. However, I can say this about my military career: No enemy has ever done as much damage—and in such variety—as I did in the short period of my hitch. Severed limbs, sucking chest wounds, chemical burns—I inflicted them all.

After getting my notice I was sent to Fort Ord, California, for boot camp, then on to Fort Leonard, Missouri, for my first assignment. I was excited to see on a bulletin board that they needed a film editor there; in typical Army fashion, however, I was assigned to and trained in Medical Supply. Next it was off to Fort Sam Houston in Texas, where I was to spend the remainder of my tour sorting bandages and medicine bottles for the infirmary. After basic training we were allowed to rent a house or apartment offbase, so Kathy and I were able to live together during my hitch.

I wasn't at Fort Sam Houston long before I got caught doodling monsters and aliens while in one of my medical supply classes. Instead of chewing me out, the sergeant asked if I could do some drawings for his six-year-old son's birthday. This sergeant was even nice enough to have Kathy and me over for dinner so his son could thank me for the pictures. That's when things started looking up.

"Bob, you're wasting your time and talents in Medical Supply," he said. "We have a division called Training Aids that is responsible for making parade floats and props for training films. I know the captain there and I can get you in." I thanked him but really didn't expect anything.

Lo and behold, the sergeant was true to his word. Within weeks I was transferred to Training Aids, and as luck would have it they were just beginning a

new initiative designed to make the instruction for medical trainees more effective. Up until that point simulation exercises consisted of attaching a tag to a soldier playing the casualty: "This man has a gut wound," or "This man has a bullet wound in his thigh." Then the trainee would dress the "wound" as if conducting a real procedure. The U.S. Army was finding that this did nothing to prepare medical personnel for the sorts of horrific injuries they would encounter during a battle. Then someone in the division came across a brochure describing a new program being used in Canada called Simulated Casualty Wounds. You could even order ready-made "wound" appliances and recipes for "blood" from the organization that put out the brochure.

It was a great idea. The problem was that the "wounds" they sent were not very good. Since I had picked up some professional makeup experience from Paul Blaisdell, I was tapped to sculpt and cast better appliances for us. The wounds had to look absolutely real—and be approved by the Surgeon General—so I needed to use rubber, latex, air pumps for "squirting arteries," and buckets and buckets of blood (I improved that recipe as well). I didn't have camera angles to help me, and everything had to *feel* as real as it looked, so the job was a very challenging one compared to movie work.

The focus of my job was Operation Blow-Up, the casualty simulation exercise that we ran every month or so. I had between twenty-five and thirty people

top: **Dressed for service to Uncle Sam.**

bottom: **Bob in footage from Army training film with smoking "phosphorus burn" created with makeup and dry ice, a realistic effect that thrilled the Surgeon General.**

right: **Bob is cast as model for one of the world's first CPR dummies, and then experiences the eerie sensation of demonstrating lifesaving techniques on "himself."**

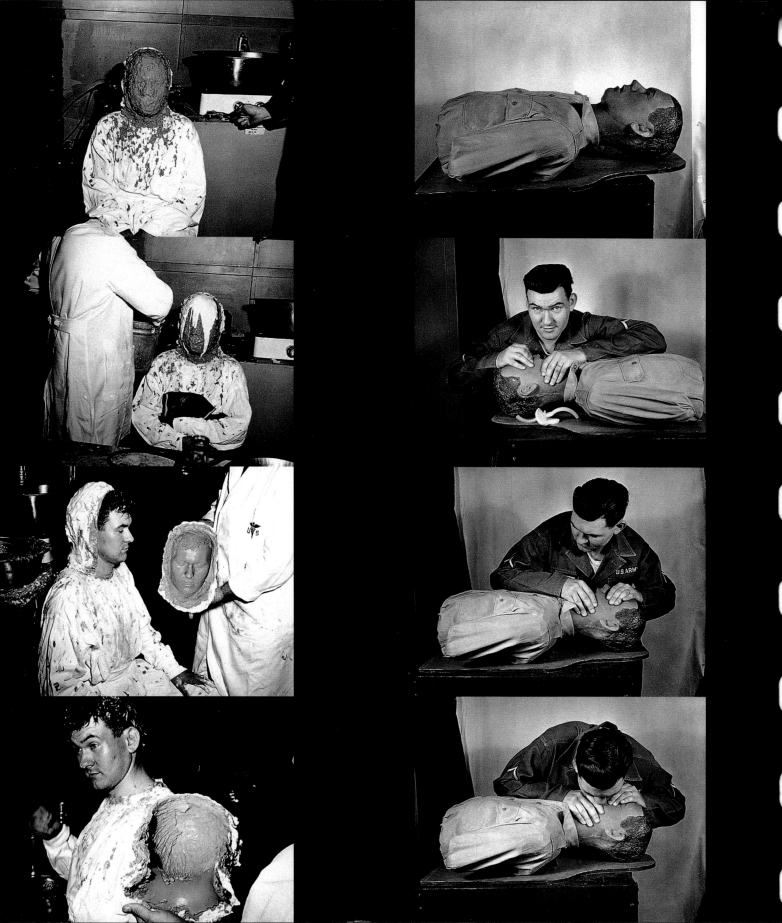

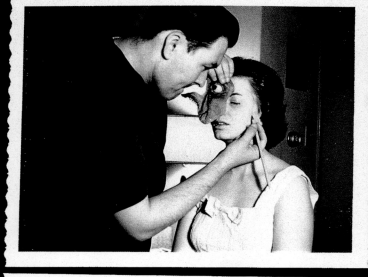
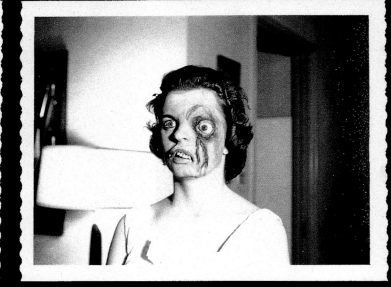
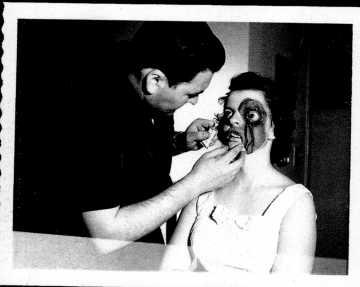
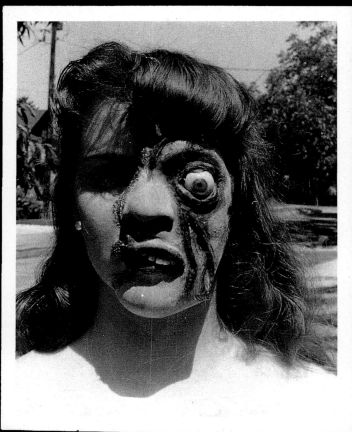
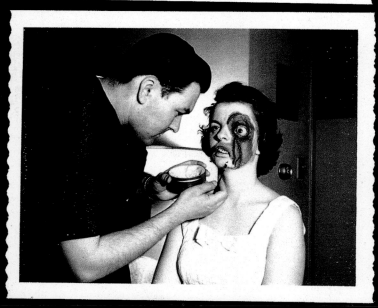

under me whom I would train to do the various makeups on more than one hundred casualties out in the desert. If it was a belly wound, we'd make a fake compartment that contained "organs" that the trainees had to stuff back in. Ear syringes made blood squirt, and my famous oatmeal-and-glycerin "vomit" was a real crowd pleaser. If we didn't get at least one trainee at each session to faint or produce real vomit, we weren't doing our jobs.

So there I was, PFC Robert Burns, Assistant Makeup Chief in the U.S. Army. I couldn't believe my good fortune.

Not everything was rosy, of course. My sergeant at Training Aids was a sadistic Army lifer who hated draftees—and I was the only person under his command who was there "by government invitation." He made no bones about it: I would be his scapegoat and personal slave, on and off duty.

I seriously needed a diversion before I'd snap and end up court-martialed.

One night Kathy and I were at home watching "Shock Theater" on the local channel 5, KENS-TV. The host was Joe Alston, who introduced each film while sitting on a haunted-house set. Other than the host wearing a cape and homburg cap, it was a pretty nondescript setup. At the midpoint of the show, Joe would appear and intone in an Orson Welles-like voice, "How do you like it so far?"

I looked at Kathy and said, "Geez, that's so boring. We could really do something with a setup like that. You and I could give them a monster every week if they would pay for materials—when they show *The Mummy*, I could appear in musty bandages. When they show *Frankenstein*, I could dress as the monster." Kathy got the phone book and goaded me on until I called the station.

As was the case at most small affiliates in those days, Joe Alston was the jack-of-all-trades at KENS-TV; he was the station announcer, did all of the voice-overs and live commercials, hosted a kiddy show called "Captain Gus," and, finally, donned a cape for "Shock Theater." He liked our idea right away, and, upon our first meeting, Kathy and I were happy to find that he was a gregarious, fun person.

I had a life-cast of my head that had been made for one of the world's first CPR dummies (and, believe

me, it was unnerving giving demonstrations on that dummy), so I would build masks using that bust as a "blank" for my face, in the same way I had seen Paul do it. We made the first version of what would be known as "The Mad Mummy" during this period; I made the mask and Kathy created the tattered, "aged" bodysuit. We'd make Kathy into the Bride of Frankenstein, I'd be the Wolf Man—the sky was the limit. On weeks when there was no real "monster" featured in the movie, I'd do an Igor-type makeup and function as a demented assistant. Joe was energized by the new possibilities that presented themselves now that he had someone to play against. As time went on the skits became longer and more elaborate, and ratings for KENS-TV went through the roof. When producer William Castle came to town to promote his new thriller, *The Tingler*, the manager of the Texas Theater in San Antonio contacted KENS-TV to see if we could send someone from the "Shock Theater" cast of characters to meet him at the airport. Castle was well known as a master showman and famous for his promotional gimmicks. His 1958 film *Macabre* offered a life insurance policy to those who felt they might "die of fright," and *The House on Haunted Hill* featured a breakthrough he called "Emergo," which consisted of an inflated skeleton that would soar from the screen over the theater seats at an appropriate point in the film.

I knew Castle, of all people, would enjoy an elaborate welcoming party. First of all, we'd need a "dignitary" to be present, so I made up Kathy as the horrific "Miss Shock," complete with beauty pageant sash. I created a special "skeleton key" out of spare bones I'd accumulated while repairing skeletons on the base, so we were able to present the "Shock Theater Key to the City," made of real human bones— an especially ironic gift to the man who was known for promoting good-natured frauds. When Castle deboarded his plane and saw our motley crew gathered under a banner reading "Welcome King of Horror Makers," he was so tickled that he invited us to his hotel to have pictures taken—always the promoter. I was quite surprised by how down-to-earth this Hollywood producer was; he said, "I'll send you some stills," and he actually followed through.

Castle invited us to come to the theater the next morning to help set up the "Percepto" illusion for *The Tingler*, which consisted of vibrating boxes placed

Joe Alston discusses a prop with Bob, who is in ghoul makeup.

left: **"Miss Shock" Makeup**

under about thirteen seats scattered throughout the venue. At the preordained time, a switch was thrown in the projection booth and pandemonium ensued— even people sitting in the nonvibrating seats were sure they felt the "Tingler" climbing up their spines. It was pure William Castle.

When I was finally emancipated from the Army, I quickly hooked up again with Paul Blaisdell. We'd been corresponding all along, and he had sent me periodic "care packages" with pictures and drawings from his latest projects. He'd been moving away from film work, however. The "you're part of the family" promise that he had gotten from the management at AIP turned out to be smoke and mirrors. While the double bill of *I Was a Teenage Werewolf* and *Invasion of the Saucer Men* generated AIP's first million-dollar box office total, the bean counters at the studio were still asking Paul to take pay cuts to create effects for dreck like *Attack of the Giant Leeches*. He turned them down; he had to, because taking less and less money for assignments would have been career suicide.

One job I'm certain Paul wished he'd walked away from was *The Ghost of Dragstrip Hollow*, a very, very bad "beach party" movie. James Nicholson, with all good intentions, offered Paul an intriguing proposition: a chance to finally appear out of costume and speak a few lines of dialogue. When Paul saw the script, however, he was disappointed to find that it was yet another monster role. Nicholson pressed Paul to take the part. "But the monster's not a monster—it's you!" he offered. Finally, Paul relented, reasoning that it might be fun to parody himself.

Soon afterward, Sam Arkoff called. "Paul, I want you to know everything is 'go' on *Dragstrip Hollow*." Wonderful.

"So," Paul inquired, "how much time do I get to create this monster?"

"Nobody told you?" Arkoff asked. Paul knew what was coming. "We thought we could save some time and money if you just used the She-Creature outfit again." So, a slightly modified "Cuddles" made her fourth screen appearance at the end of *The Ghost of Dragstrip Hollow*.

And what an ending it was! À la "Scooby Doo," Paul is unmasked as the "monster" that spent the duration of the movie nonlethally menacing the cast

of teenagers. To this day it's painful to recall the lines Lou Rusoff wrote for Paul's unmasking scene:

> Of course you've seen me before. I scared you to death—to death—in *Day the World Ended*! You shivered when you saw me in *The She-Creature*! Oh the shame of it, the indignity, they didn't use me in *Horrors of the Black Museum* after my years of faithful service. They just discarded me.

At the time, Paul looked at the role as good-natured parody, and he certainly had a sense of humor about himself. Later he realized that those lines were brutally prophetic; AIP really had discarded him. He felt as though his work were destined to be forgotten.

If Paul was bitter, he didn't let it ruin our reunion. We got together very soon after my release from Uncle Sam's captivity and picked up where we had left off. One weekend I brought some of my monster magazines to the Blaisdells' to show Paul published stills of "Beulah" from *It Conquered the World*. We were sitting around paging through Forrest Ackerman's *Famous Monsters of Filmland* (Paul contributed an article to, and I shot photos for, its debut in February 1958) and a host of imitators and also-rans of varying quality—*Castle of Frankenstein, Monster Parade, Monster Party*, etc.

Blaisdell was unimpressed. "Hell, Bob, we could do better than this stuff. Some of this is really awful." I couldn't disagree. While *Famous Monsters of Filmland* had a style all its own that made even the shallowest articles entertaining, the same could not be said about the copycats that had jumped in to take advantage of the monster craze. They were basically teen-idol magazines that substituted ghouls for heartthrobs. The layouts were sloppy and the articles were poorly researched (if they were indeed researched at all).

"We'd have a lot to offer a magazine that wanted to show readers how things are actually done in the monster movies and moviemaking in general," I said. "Aren't people curious about that sort of thing? Like finding out how Jack Pierce did Karloff's makeup?"

"Or how 'Cuddles' got her voluptuous figure?" Paul added, tongue in cheek. We tossed around our unschooled opinions for the balance of the evening, neither of us thinking the other was very serious.

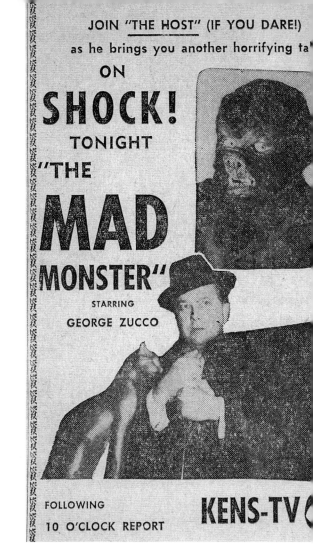

An ad for "Shock Theater" featuring Bob in werewolf makeup and Joe Alston in his trademark cape and homburg cap.

However, I went to bed that night still contemplating the ideas we'd discussed. I called Paul the next day.

"Were you completely joking last night about wanting to do a magazine?" I asked. Paul admitted that he was actually only half-kidding—he'd thought about it a bit more after I'd left. "Well," I continued, "as long as you were half-kidding, that means you could be half-serious—so let's talk about it some more."

What excited us most was the opportunity to show what goes on behind the scenes on a creature-feature production. That doesn't seem like such a breakthrough idea—nowadays countless magazines, books, and television specials devote themselves to the minutiae of film production—but back in the late

Bob and the "Shock Theater" crew constructed elaborate sets and miniatures to complement the featured movie. The house and hand at upper right were made for showing of *King Kong*; the pod person at right starred in skits during *Invasion of the Body Snatchers*.

Peter Lorre James Dean Abraham Lincoln Laurence Olivier Lon Chaney Jr. Boris Karloff Ludwig von Beethoven Clark Gable

Life masks were created by makeup departments in order to conduct different makeup experiments without discomfort to the actors. They were often hung on the walls of makeup workshops as "prestige" objects. Also in the group are the death masks of Lincoln and Beethoven.

1950s and early 1960s, special-effects artists held their techniques close to the vest. And, other than rare exceptions like Jack Pierce and Lon Chaney, makeup and technical artists labored in obscurity. We were certain that others shared our fascination with the mechanics of film production and would gobble up a magazine that addressed those topics.

We also decided our magazine would differentiate itself from others on the rack by confining humor to certain sections while remaining fairly serious in articles and features that warranted greater depth. It rankled us a bit when we contributed an article and photos to the first issue of Ackerman's *Famous Monsters of Filmland*, only to see Paul's text rewritten in "Ackermanese"—horror-flavored puns and wordplay throughout. Still, Ackerman's pervasive humor made

and distributor. One of the more interesting tips he got was to choose someone in the middle of the country, since shipping costs would be the same to both coasts. He was given a few contacts in Iowa and began making inquiries until settling upon a company that was willing to make a deal. That's where our downfall began.

Paul was acting as publisher and business manager, though he knew little more than I about publishing or business. His phone meetings with the printer revealed that launching a national magazine was going to mean an enormous investment from both of us. Start-up costs, the printer explained, would be huge, but he would be willing to "do a deal" on the printing and production in exchange for an ownership stake in the magazine. The numbers he

and had pretty much settled on *Fantastic Films*. The printer was unimpressed. "You have to put 'monster' in the title or it won't sell," he told Paul—and he was probably right. Finally, we ended up with *Fantastic Monsters of the Films*, which was routinely shortened to *FanMo* by our readers.

Paul had no desire to be an editor, so we paid writers Ron Haydock and Jim Harmon to act as editor and associate editor respectively, and Haydock artificially fattened our writers' roster by using pseudonyms. My masthead title was "research editor," since I planned to spend much of my time digging out images for the layouts from my considerable collection of stills, and Paul called himself "editorial director."

Full color was what we needed to make a real impact, but it was financially impossible. However,

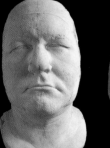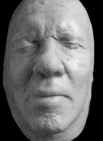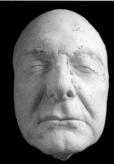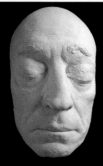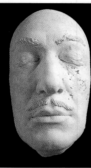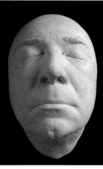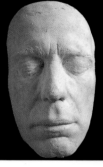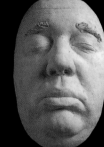

Bob Burns | Bob Burns ("the Arkansas Traveler," Bob's namesake) | Ray "Crash" Corrigan | Buster Keaton | Vincent Price | Bela Lugosi | Humphrey Bogart | Charles Laughton

his product distinctive and uniquely entertaining. Our magazine—which we were now calling *The Devil's Workshop*—would carve its niche by taking a more sober tack.

After a few late-night caffeine-fueled bull sessions, our little fantasy began to become reality. We brainstormed the names and themes of our sections and departments, and Paul drew up sample page layouts. I contacted a writer I knew, Ron Haydock, to talk about getting some articles created. We also decided to go after stories by some of the top names in the science fiction genre, such as Robert Bloch, Isaac Asimov, and Ray Bradbury.

We were babes in the woods, but we moved forward nonetheless. Haydock doubled our writing corps by bringing in a friend, Jim Harmon. Through his contacts at magazines for which he'd created artwork, Paul got some advice on securing a printer

and other potential printers were throwing around made it clear that even if Paul and I sank every cent between us into the project—I had $6,000 in savings and Paul had $14,000—we would need at least that much *more* to launch. The printer made an offer: He'd swallow certain fees and expenses if we'd cede to him a 51-percent share of the magazine in order to make it worth his while. This would be his first national publication and he was willing to assume some risk to broaden his business.

In hindsight it's easy to see how naive we were, but at the time there seemed to be no other way to make our project a reality. I emptied my bank account and gave a check to Paul; he added his savings and paid the printer. We were in the magazine business.

Our new partner added his proverbial two cents immediately. We'd already decided *The Devil's Workshop* was too limiting a name for the magazine

Paul's art and design background brought some unique tinting effects that gave our pages a much more expensive look—which was important, because our cover price would have to be a hefty 50 cents, a bit higher than the typical horror-movie mag. I had the idea of including in our first issue a full-color fold-out pinup à la *Playboy*'s "Playmate of the Month." Paul thought a shot of Karloff as the Frankenstein monster would be perfect, but, try as we might, we couldn't locate a color photo from the production of the 1931 film. We decided to use a shot of Paul in the She-Creature costume that I'd taken the evening he finished building it, so he got a bit of well-deserved self-promotion in spite of himself.

The cover shot of issue #1, a startling color photo of Christopher Lee in Hammer Films' *Horror of Dracula*, was made possible by an opportune film break years

before when the movie was screened on my Army base. I grabbed a frame and had it enlarged, making our cover image truly one-of-a-kind—that is, until *Castle of Frankenstein* magazine lifted our picture for the cover of its eighth issue.

Not all of our photos worked out so well. Mere days before deadline, Paul received from the photo lab a fuzzy, nearly unusable enlargement of my She-Creature slide. He was beside himself; the lab had had ample time to deliver a quality shot, and now we were stuck at the eleventh hour with a large color blob. After issuing some choice invective, Paul got out his airbrush and paints and quickly laid in details that had been lost to the photo agency's shoddy work. He had to settle for a far less-than-perfect final result, but the printer got our materials on time and the magazine

Our euphoria at seeing the fruit of our work was tempered by little flaws that populated the pages of our first issue. Paul was given assurances by the printer that the problems would be fixed, but our second issue appeared with as many blemishes as the first. Paul kept the long-distance wires to Iowa hot with his complaints. By issue #3 we were upgraded from newsprint to slick pages, which mollified us for the time being. Besides, we were getting great feedback from our readers and it appeared that we had nowhere to go but up. Paul was creating a distinctive look for our covers by hand-tinting black-and-white photos of monsters that we featured in tight close-up. We sold copies of our short films and inexpensive novelties—"secret skull rings" and rubber spiders, for instance—in our "Shock Shop" ads at the back of the

call from producer Jim Sullivan to help out with different props and effects they wanted on the show. By the time Bob Guy left and was replaced by Lietta Harvey—an attractive actress who transformed into the grotesque Ghoulita—I had become the effects person for "Jeepers Creepers Theater." I stayed with them for well over a year, until Lietta left the show.

Unfortunately, our venture as magazine publishers didn't last that long.

Although we were pleased with the attention *Fantastic Monsters of the Films* was getting from a growing readership, it became apparent that our printer in Iowa was letting the quality of the production and printing slip into shoddiness. Ink streaks, splotchy photos, blank spaces, and wrinkled paper were just some of the problems for which he was

was soon on press.

We began to get response almost immediately after *Fantastic Monsters of the Films* # 1 hit the newsstands. Letters came in from all over the country, mainly wanting to know when our next issue would be out. There were so many positive letters regarding our fold-out photo that we decided to make the pinup a regular feature. Readers were captivated by Paul's visual touches; the duotone pages and hand-tinted poster really left an impression. We began to feel that we had the right idea and fell to work on subsequent issues with a song in our hearts. I contacted Vincent Price through his agent, and he agreed to write a piece for us gratis. I knew Kirk Alyn, the original movie Superman, through my friend Glenn Strange, and I was surprised when he agreed to write a piece detailing his days in the red-white-and-blue regalia.

magazine. Before long readers could even join our Fantastic Monsters Club for three dollars, which got them a giant membership card, an 8"-by-10" photo from *Invasion of the Saucer Men*, a subscription to the club bulletin, and a year's subscription to *FanMo*. The publishing business seemed like it was going to be pretty fun.

On assignment for *FanMo*, I contacted the staff of "Jeepers Creepers Theater" at Channel 13, KCOP-TV of Los Angeles, for a story on their version of the "Shock Theater" schtick I'd been doing in Texas. During our conversation I mentioned that I had a mummy costume, and Bob Guy, who played horror host Jeepers, said, "Why don't we get you on the show?" After a meeting with his producer we retired to the local bar and worked up a few loose routines for my appearance as "The Mad Mummy," and we ended up with a fun article for the fourth issue of *FanMo* besides. After that I would periodically get a

constantly making excuses. Paul had just about had enough.

We got a shock when we unbundled issue #7 to find in the masthead a name we'd never seen before: "Jiro Tomiyama—Art and Production." It turned out that our printer, in order to save money on his end, was forgoing the normal production team he'd hired to do the setup of the magazine based on Paul's sketched layouts. He'd brought in Jiro to handle the whole job alone. Not surprisingly, issue #7 looked awful. Our hands were tied, however. "Maybe he'll get better with time," Paul said through gritted teeth.

The next issue of *FanMo* was to be a Karloff tribute edition, and I'd already sent off to Iowa a large packet of rare stills, including one-of-a-kind images that had been given to me by the man who designed and applied Karloff's Frankenstein makeup, Jack Pierce. We eagerly awaited the brown-lines, hoping

The complete run of *Fantastic Monsters* covers

that broke my friend's back. He'd been jilted by AIP, and now his latest venture had fallen victim to a setup. Furthermore, his former agent, Forrest Ackerman, nurtured a grudge against Paul and me for daring to publish a monster magazine that he felt competed with his own *Famous Monsters of Filmland*. While Paul's distinctive creations graced the pages and covers of *Famous Monsters*, his name was never mentioned.

Disgusted with every aspect of the entertainment business, Paul's normally positive outlook dissolved. He decided to shun anything or anyone related to what he perceived as a detrimental "show business" culture. Our conversations and visits grew scarce, culminating in a phone call in which Paul frankly admitted that he no longer felt comfortable with me since I was "heavily involved in the whole Hollywood thing." Those would be the last words between us for many years. Paul and Jackie, already hermitlike when we met them, retreated into near-total seclusion at their Topanga hideaway. They never worked on another film or television project, and Kathy and I lost our best friends—a blow far more devastating to me than any financial damage we incurred as a result of the insurance scam.

If there is a positive side to the experience, it's the fact that I learned later that *FanMo* actually made an impression on its readers during its short life. Among those influenced by our publication were the Skotak brothers, Robert and Dennis, whom I met when they came out to L.A. to seek their fortune in movie visual effects. The multitalented Skotaks have gone on to create visual effects for some of the biggest films ever made, including *The Abyss, Aliens, Terminator 2,* and *Titanic*. They are dear, dear friends, and they make me feel as though *Fantastic Monsters of the Movies* was a success despite the magazine's tragic fate.

for the best. Weeks went by without a word from the printer. Paul tried to call and was sickened to find that the printer's phone had been disconnected. He called together Jim Harmon, Ron Haydock, and me to break the news; despite his best efforts, it looked like our printer and "Jiro Tomiyama" were gone, and along with them a priceless cache of pressbooks, lobby cards, stills, and photos from our personal collections.

As time went on, we discovered that there had been a fire at the printer's building—arson. The addition of our nationally distributed magazine to his client list had enabled the printer to increase his insurance protection, and he'd disappeared after collecting. *Fantastic Monsters of the Films* was up in smoke.

We were all devastated, but no one took it harder than Paul. While we'd both sunk our savings into the venture and I'd lost a huge amount of one-of-a-kind stills from my collection, this was the straw

DENNIS SKOTAK RECALLS FANMO'S INFLUENCE

Growing up, we were fledgling/aspiring/hopeful filmmaking kids working in 8mm (pre-super 8mm!). It's hard to imagine now, but it was impossible to find out anything anywhere about our area of fixation—science fiction films and visual and makeup effects. It was a pre-video, pre-computer, pre-media era; there were no behind-the-scenes publications then. No *Cinefex, Starlog*, etc. We were starved for information.

Then along came *Fantastic Monsters*. Each issue gave us film previews, fiction, behind-the-scenes tidbits, the "Mad Mummy," and loads of special effects stills—almost all from Bob Burns's collection—for us to marvel over and study. Its inspired innovations were many: 3D photos, "Cinemascope" picture layouts, color fantasy pinups, interior color, and forward-looking design, many of which were direct influences on our own publication, *Fantascene*, twelve years later.

A big vacuum in our teen careers was quickly and entertainingly filled. Not that there weren't other publications, such as *Famous Monsters* and *Spacemen*, but this was the first written from a filmmaker's point of view. "The Devil's Workshop" department was the place we first learned about that seemingly magical substance called liquid latex. Mold making, miniature construction and photography, prop building. It was all there! And the people who worked on these projects—Bob Burns and Paul Blaisdell—sounded like they were having fun. We began to feel we somehow knew these guys all those miles away. Here was a group with similar interests actually doing it all. If the burning desire of these one-time fans had led them to enviable work on real Hollywood features, then it seemed truly possible that our own desires would someday lead us there as well. (And they did!)

Dennis Skotak and his brother, Robert, are Academy Award–winning special effects artists whose work can be seen in *Aliens, Terminator 2, The Abyss, Titanic,* and *The House on Haunted Hill*.

Paul Blaisdell FILMOGRAPHY

1955 **The Beast with 1,000,000 Eyes**
(American Releasing Corporation)

1955 **Oklahoma Woman**
(American Releasing Corporation)

1956 **Day the World Ended**
(American International Pictures)

1956 **Hot Rod Girl**
(American International Pictures)

1956 **It Conquered the World**
(American International Pictures)

1956 **The She-Creature**
(American International Pictures)

1956 **The Undead**
(American International Pictures)

1957 **The Amazing Colossal Man**
(American International Pictures)

1957 **Cat Girl**
(American International Pictures)

1957 **From Hell It Came**
(American International Pictures)

1957 **Invasion of the Saucer Men**
(American International Pictures)

1957 **Monster From Green Hell** (DCA)

1957 **Motorcycle Gang**
(American International Pictures)

1957 **Not of This Earth**
(Allied Artists Pictures Corp.)

1957 **Sorority Girl** a.k.a. **Confessions of a Sorority Girl**
(American International Pictures)

1957 **Voodoo Woman** (American International Pictures)

1958 **Attack of the Puppet People**
a.k.a. **Fantastic Puppet People**
(American International Pictures)

1958 **The Spider** a.k.a. **Earth vs. the Spider**
(James A. Nicholson and Samuel Z. Arkoff Production)

1958 **How to Make a Monster**
(American International Pictures)

1958 **It! The Terror from Beyond Space**
(United Artists)

1958 **War of the Colossal Beast** a.k.a.
The Terror Strikes (American International Pictures)

1959 **The Ghost of Dragstrip Hollow**
(American International Pictures)

1959 **Teenagers from Outer Space** (Warner Bros)

1960 **Goliath and the Dragon** a.k.a. **The Revenge of Hercules** and **The Vengence of Hercules;** *original title* **La Vendetta de Ercole** (American International Pictures)

1962 **Jack the Giant Killer** (United Artists)

FILMLAND MONSTERS

Even if the producers at AIP weren't going to show his creations to their best advantage, Paul got a chance to exploit and improve the features he built into many of his props via a short film, *Filmland Monsters*, offered for sale in the pages of *Fantastic Monsters*. Consisting of trailers and excerpted scenes taken from *Invasion of the Saucer Men*, *The She-Creature*, *Day the World Ended*, and *It Conquered the World*—AIP gave Paul rights to use footage that did not include actors—*Filmland Monsters* was supplemented by new material we shot on our own. "Beulah" from *It Conquered the World*, for example, is shown rolling its eyes and gnashing its teeth; the Saucer Man hand is seen looking this way and that with its single eyeball; and "Cuddles," a.k.a. the She-Creature, is given a close-up.

The *Filmland Monsters* movie, along with "Hollywood Monsters" color slides of Paul's creatures also offered through *FanMo*, sold very well and are now sought-after collector's items.

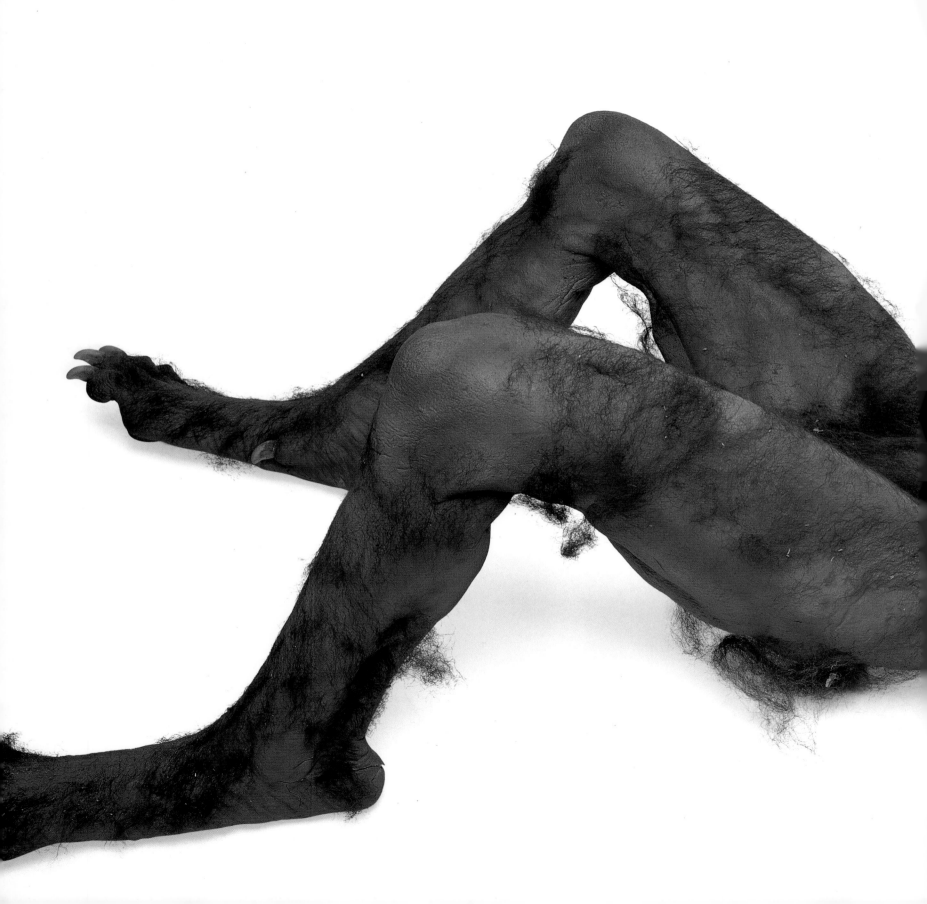

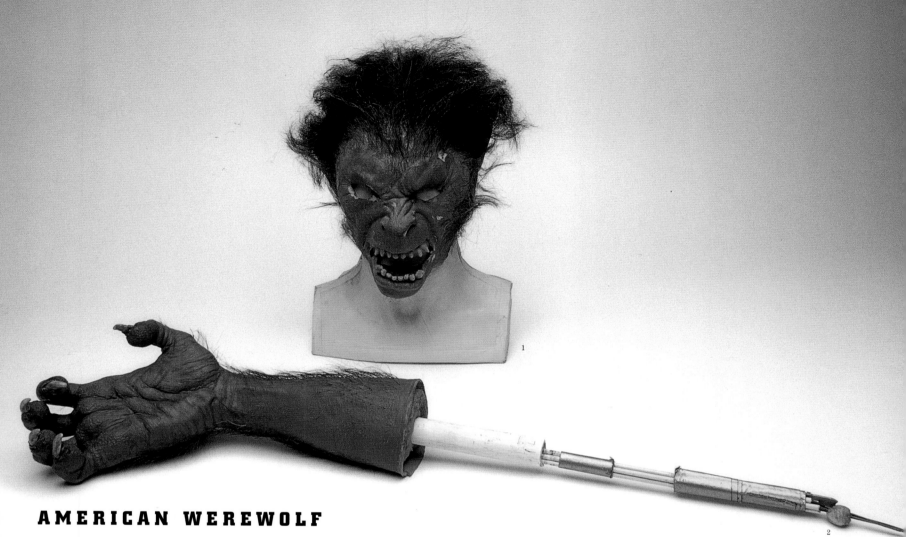

AMERICAN WEREWOLF
IN LONDON

Some of Rick Baker's astounding work for
An American Werewolf in London (1981).

previous spread: **Full-size headless werewolf
body used with human actor in which man
transforms into a werewolf.** (64" long)

1 **Face appliance for werewolf.** (16" tall)

2 **Arm with nail-extending mechanism.** (32" long)

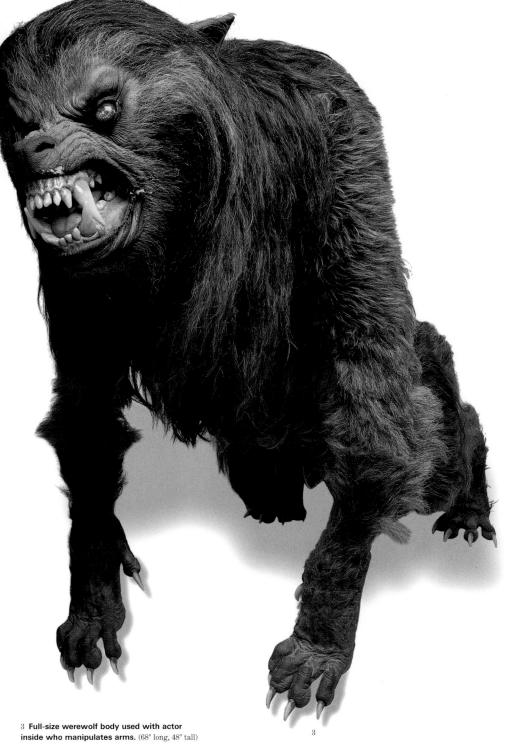

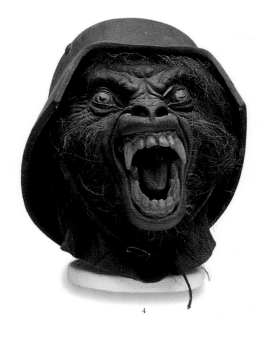

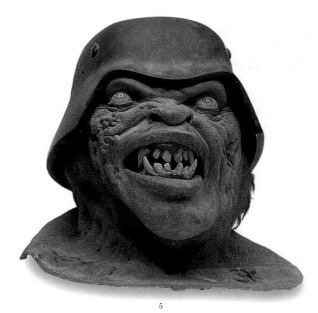

3 **Full-size werewolf body used with actor inside who manipulates arms.** (68" long, 48" tall)

4 **Nazi werewolf.** (13" tall)

5 **Nazi zombie.** (12" tall)

TERMINATOR 2

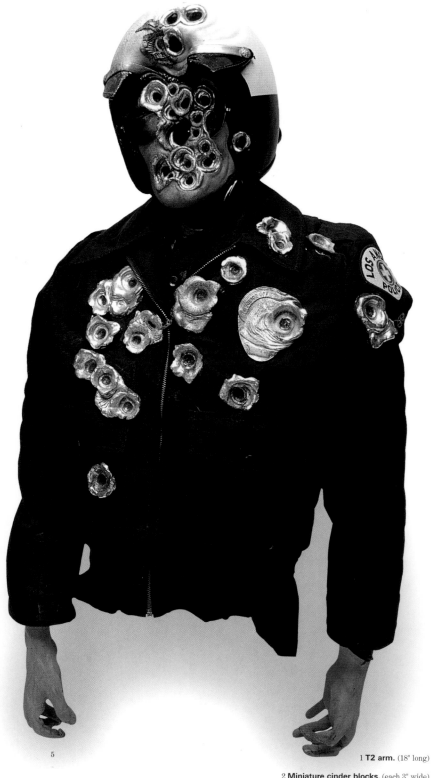

1 **T2 arm.** (18" long)

2 **Miniature cinder blocks.** (each 3" wide)

3 **Miniature skull.** (1")

4 **Hand and forearm with spear finger.** (17")

5 **"Pizza Face" T-1000 torso.** (44" tall)

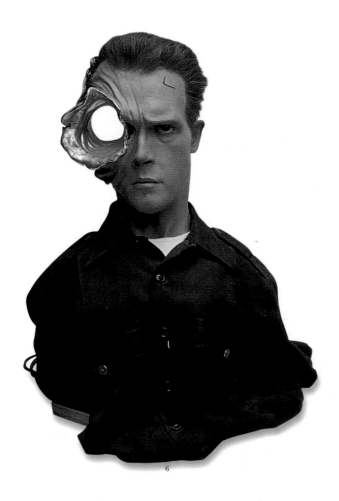

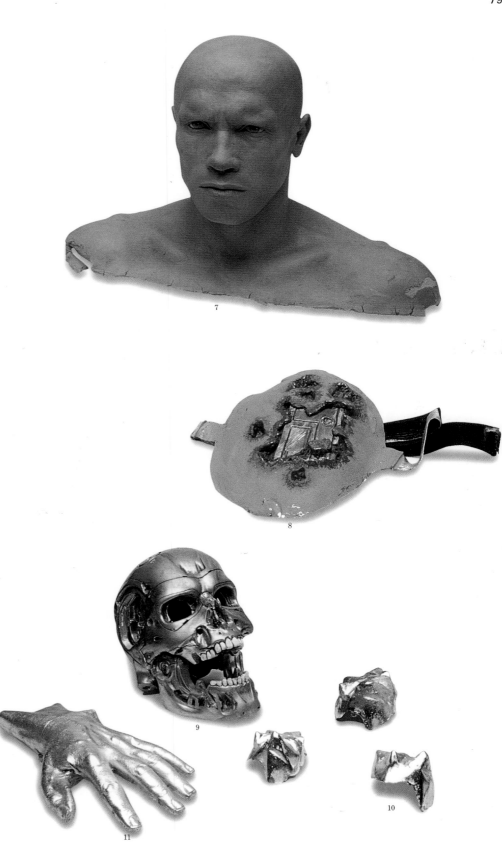

6 "Donut Head" T-1000. (24" tall)

7 Arnold Schwarzenegger bust (not used in film). (14")

8 Leg wound/damage appliance. (7" wide)

9 Terminator skull. (9")

10 Multiple fiberglass shards.

11 Silver rubber hand for stunt Terminator suit. (11" long)

12 Plaster skull made for crushing at beginning of film. (9")

GORILLA MAN

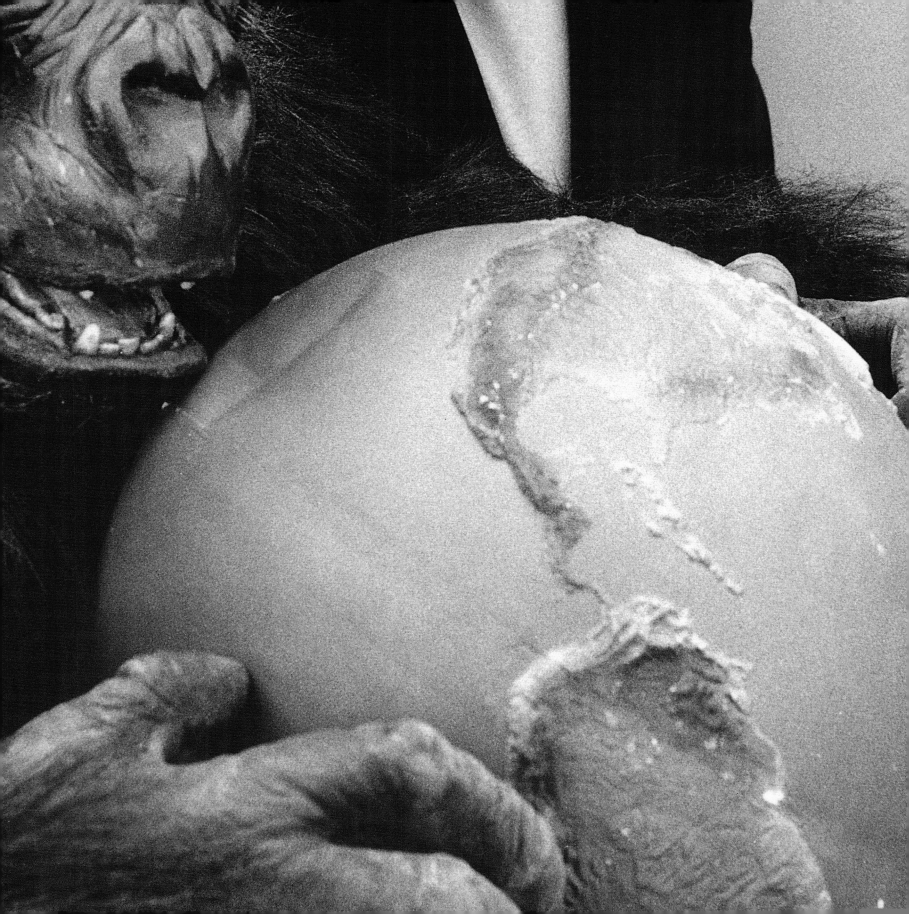

AS I WAS GROWING UP, a lo

of my peers idolized sports figures like Lou Gehri Mickey Mantle, and Joe DiMaggio. There were also starstruck kids who hung posters of Clark Gable, Errol Flynn, and Douglas Fairbanks Jr. on their bedroom walls. For me, however, it was George Barrows, Emil Van Horne, and Charlie Gemora.

Never heard of them? Well, you've certainly seen them; any time a gorilla appears in a movie, comedy short, or vintage television episode, the man in the simian suit is most likely one of a small fraternity of "gorilla men" who made their livings in Hollywood masquerading as primates. In fact, Ray "Crash" Corrigan, who played the deadly alien in *It! The Terror from Beyond Space*, was one of the better-known gorilla men, making more appearances in films than anyone else in the racket.

As a kid, I studied the moves of these furry specialists whenever they appeared onscreen. I was intrigued by the transformation made possible by slipping into a gorilla outfit. A great performer like Charles Gemora could make you forget there was a human inside the suit.

I met Charlie in the late 1950s when a friend took me to Gemora's shop on the Paramount lot. In addition to his great gorilla work, Gemora was head of makeup for Paramount; he built and wore the Martian costume in *War of the Worlds*, created *The Colossus of New York*, and designed and built the title alien in *I Married a Monster from Outer Space*. The generous Gemora invited me to spend an entire day with him. We went over stills I'd brought along and he pointed out features on the pictures. "You can see where the water bladder in the 'stomach' is on this shot," he'd say, explaining how he simulated the heft and movement of actual flesh by installing in his gorilla suits compartments filled with water. He shared with me some of his trade secrets for bringing life to a mask that was limited, mobility-wise, to simply opening and closing its mouth. For example, he explained that if

you wanted to look ferocious you should rear back your head while opening the mouth, which shows the audience more teeth and creates an illusion of facial expression. He also stressed the importance of acting with your eyes, as they are the only exposed part of the wearer. Charlie was so skillful in projecting with his eyes that people who have watched his performances sometimes swear they saw the gorilla's brow and other facial muscles move—even though everything is immobile.

My dream of owning my own gorilla suit caught fire the day Don Post, the famous mask maker, dressed me up in an "economy model" simian outfit of his own design. I'd known Don since I was a kid, and he gave me so many free masks that I tried to return the favor by helping out at his shop on nights and weekends. On this occasion, in 1964, I was acting as human mannequin for a catalog shoot of Post's various costumes. That day I put on, for the very first time, a gorilla suit, and I knew I had to have one of my own. I talked to Kathy about it and she was sure she could make the bodysuit. Don agreed to create the head, hands, chest, and feet.

Kathy worked from a clown suit pattern to create the body, and we ordered the fur through Don Post at a whopping $50 per yard—well worth every penny, though, because this was phenomenal artificial hair. Post imported it from Yugoslavia, and soon afterward it became illegal to buy anything from that communist country. Effects artists all over Hollywood were enormously disappointed.

As Don fashioned my gorilla headpiece, working in clay over a cast of my head, I'd stop by every evening to make sure it was taking shape the way I

The rather homely gorilla suit that Emil Van Horne wore throughout his long career featured extensions in the arms to allow for a four-limbed gait.

Emil Van Horne's metal face armature. (13" tall)

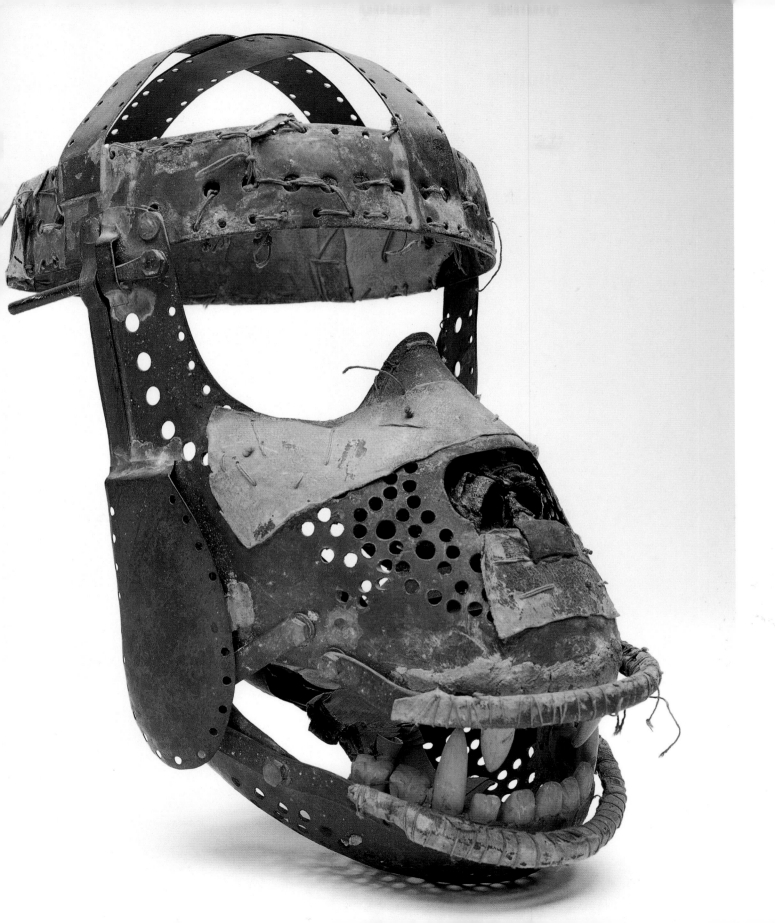

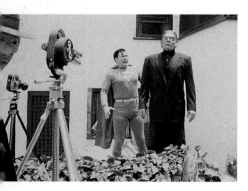

above: **Bob's friend Don Glut, currently an author and well-known dinosaur expert, frequently shot short backyard-features that starred an array of Bob's friends from the golden age of serials and films. At top, Kogar is flanked by B-movie stalwarts Roy Barcroft and Kenne Duncan, with friend John Schuyler behind, in** *Superman vs. the Gorilla Gang* **(1965).**

below: **Glenn Strange reprises his role as Frankenstein, menacing "Superman" Bob in** *The Adventures of the Spirit* **(1965). Glut can be seen in "Spirit" fedora behind his camera.**

wanted it to. While I looked at Charlie Gemora as my inspiration for technique, my visual prototype was Ray Corrigan's "monster gorilla," a vicious-looking caricature that was in vogue at the time. I had Don remove some of the brow, for instance, and make the mouth bigger than his original design. In the end I got a terrific gorilla head that was distinctively my own. I dubbed my creation "Kogar," a nicely guttural name.

Not long after my costume was complete, Lionel Comport's dad secured for me my very first gorilla job. He was working on "The Mickey Rooney Show" at MGM-TV and learned they had planned to hire Janos Prohaska and George Barrows, both well-known gorilla guys. However, Barrows was busy on another project, and they were stuck for a replacement. "Hey, my son's friend has a gorilla outfit," he offered. I didn't even have to suit up; Mickey Rooney took a look at my outfit and Kogar's head and said, "Beautiful." Simple as that, I was in.

My first day as a gorilla man was *not* so simple, though. Janos Prohaska decided to make the rookie sweat it out as much as possible. When I arrived on the set at 7 A.M., he was there with a group of friends who evidently accompanied him on jobs. I was anxious to greet Janos because he was one of the only gorilla men that I hadn't yet met. As I stuck my hand out to introduce myself, he got straight to the point—and let my outstretched hand hang in midair.

"Are you in the stuntman's union?" he asked with his Hungarian accent. I said no; he shook his head. "You have to be in the stuntman's union to do gorilla work. Are you in SAG?"

Again, I had to say no. To apply for the Screen Actors Guild you had to have a screen credit, and this job was to be my qualifying credit. "Oh, this is bad," he said. That ended our "get acquainted" period.

Later, after we'd suited up in our respective trailers, Janos took me aside to impart pearls of wisdom: "When you get your break, be sure to take at least a half hour to get out of your suit. They'll respect you for it."

"But I don't take off the whole suit. I just pop off the head so I'm ready to go," I naively answered. Janos fixed a glare on me that could have peeled paint.

Later, during some downtime, I watched as Janos picked up and closely examined my Kogar headpiece. Without looking up from his inspection, he asked, "What is your mechanism?"

"Well, nothing really," I answered. "Just a spring." He grunted noncommittally. Assuming that we were engaging in "shop talk," I unwisely picked up his headpiece to at least feign interest in what I could see was an inferior mask.

"No, no, no, NO!" he snapped, grabbing back his headpiece. "*Nobody* touches my head!"

"But, Janos, you're looking at mine, and. . ."

He would have none of it. "That's totally different. Completely different," he lectured as he stomped off.

The setup on the show was a variation on the old "oops—I'm-with-a-real-gorilla" scenario. "Hopeful actors" Mickey Rooney and guest star Bobby Van are trying to gain entry into a movie studio, and they see a gorilla (me) and its trainer pass through the gates. They put Bobby in a gorilla suit and try to get in the same way. Of course, a mix-up ensues and Mickey mistakes Janos, playing a "real" gorilla, for Bobby.

It was very instructive watching Mickey Rooney. As a coproducer of "The Mickey Rooney Show," the seemingly tireless star had a hand in all decisions and an eye on the bottom line. He was a wonderful person to work with, and his reputation as the consummate trouper is entirely accurate.

Janos, on the other hand, was taking full advantage of the union-prescribed benefits to which he so dearly clung. I watched from the sidelines as, true to his earlier advice to me, he very slowly shed his entire gorilla costume to begin a break. The crew was obviously irritated when, at break's end, they were ready to go and Janos was still stepping into his costume. The director saw me sitting off-set in full Kogar minus the head. "We're burning time here, boys," he said. "What about this guy? He's ready to go." So we shot my very few scenes while Janos slowly got dressed. This meant, of course, that Janos had to cool his heels a bit waiting for his postponed scenes.

I stayed to watch the crew work after they were finished with me, and when Janos was done with his scenes and left—without so much as a goodbye—Mickey and director Richard Thorpe approached me.

"We know this means staying late, but we can pay you for your time," Mickey said. "I like your suit and your approach much better than Janos's. Anyway, the gag is suffering because he's so much shorter than Bobby Van. If you're game, we'd like to reshoot all of his scenes with you instead." I had no

ROBERT H. BURNS
(Kogar, the Gorilla)
•

T V: LUCY SHOW-MICKEY
TRUTH OR CONSEQUENCES
SHOCK THEATRE

CR-8-0400

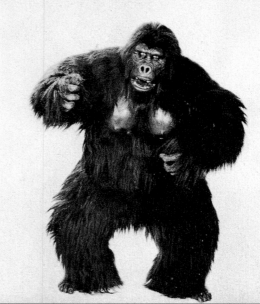

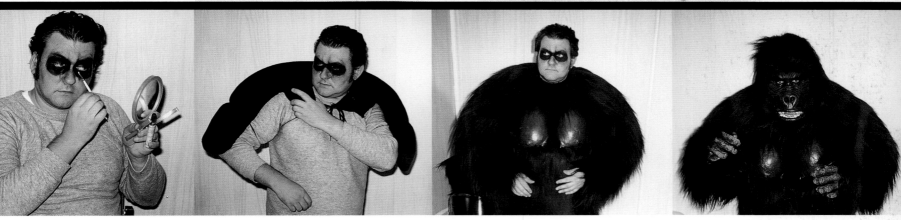

top: **Kogar's calling card.**

below: **A star is born**

problem with that, and Mickey's enthusiasm was infectious. We got everything done in about two hours, and it was great fun.

When I got home I called George Barrows, because I was so concerned about Janos's comments. George reassured me: "Stuntman's union? That's ridiculous. You did the right thing—Janos likes to stir up trouble." And he was right. When Janos found out about the reshoot he had the union insist that they use his footage. It seems he did a "stunt" consisting of a swing on a chandelier that suspended him three feet above the ground, and union rules said he had to be used throughout the show.

I didn't mind. The job got me my SAG card and I was paid for all of the extra time. Whether Janos Prohaska liked it or not, there was another gorilla man in Hollywood!

My next TV job came thanks to an agent that a friend hooked me up with. This particular agent was a very nice older lady who had been a showgirl in her younger days; she still had the pink cheeks and very red lips, only now she was in her seventies. She knew the casting agent at "The Lucy Show" and convinced him to hire me as a werewolf butler for their Halloween episode because I could do my own makeup—this episode featured Gale Gordon as Dracula and Lucille Ball and Vivian Vance as witches, so the crew had their hands full. I auditioned with a Don Post wolfman mask that I'd customized a bit, and I was in. George Barrows had already been hired for the gorilla part.

Make no mistake: Lucy was in charge of her show. It was obvious that she commanded the respect of everyone involved. If I needed further persuasion, all doubt was removed when I watched her

fire a prop man on my first day on the set. It was reassuring to see George there, and he promised he'd watch out for me.

During rehearsals Vivian and Lucy were carrying on a pretty furious argument, sniping at one another constantly and frequently lobbing salty epithets. They were pros and hid any conflict from the studio audience, but their backstage battles made for some tense situations. We were rehearsing a scene where George carries Lucy and I lug Vivian—who was heavier than I—to an examination table. Once there, I was to strap them down, which was Lucy's cue to look at a mummy standing near the apparatus and say, "Please mummy, I'd rather do it myself." (This was a play on a popular commercial tagline of the day.) Vivian was taking out her anger with Lucy on me, being uncooperative and making herself dead weight as I struggled to pick her up. When I placed Vivian on the table she positioned herself so it was impossible for me to get the strap over her and get back in position in time for Lucy's cue.

"Listen, sonny," Lucy said to me. "If you can't get that strap over us on time we'll get someone who will." As I began to say, "But she . . .," I saw George gesturing "No, no" out of the corner of my eye. I stopped myself and said, "Sorry. It won't happen again." Lucy answered, "You bet it won't." Clearly, if I'd given her any excuses I would have been out the door.

Later, George took me aside. "When we do the show you'll have lots more energy and the adrenaline will be flowing. When it comes time to do the bit, you plop Vivian's butt down on that table, and if she's not down you *push* her down." This was a three-camera show filmed live in front of a studio audience—you had to keep going and cut for only the most exceptional circumstances, so I was very, very nervous about the scene. When show time came around, however, I took George's advice and a rather surprised Vivian Vance submitted to the power of the werewolf.

The menacing gaze of Kogar,
sculpted by Don Post Sr. (16" tall x 14" wide)

A barrel of monkeys on "The Mickey Rooney Show."
One of Janos Prohaska's assistants as a chimp; Kogar on the floor;
Rooney, and Bobby Van in a low-rent gorilla suit.

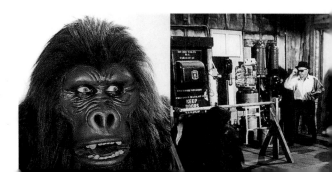

Later in the show we were to have a monster hoe-down and then scatter at the sight of a mouse on the floor, each of us ghouls fleeing in a different direction. There was a gag earlier on where Lucy and Vivian look into a mirror and it breaks along with the wall behind it; that hole was my assigned exit spot. As I moved about the set during filming, though, I could see that a sturdy plank nailed to the back of the breakaway wall to secure it during rehearsals hadn't been removed, and it spanned the opening I was to jump through. We got closer and closer to the time I was to leap out of that hole, and all I could think about was that plank. Should I call "cut" when the time comes? After all, crashing through a nailed-in plank was absolutely work for a stuntman. No—I figured I'd rather take my chances with the laws of physics than incur the wrath of Lucy.

The cue came: "Mouse!" I hurled toward the gap in the wall and went into my best Davey Sharpe leap. In midair I could see that someone had removed the wooden plank—whew! What I *didn't* see was the anchored metal stage brace that stopped me cold in midflight. Kathy was in the audience that night and said I looked like a sack of flour smacking into a brick wall.

The first one over to me was Lucy, asking if I was OK. I was seeing stars and my shoulder was numb, but I got to my feet. Unfortunately, the "hoe-down" fiddle I was carrying was crushed and my tuxedo jacket had been torn up the side. We still had to film inserts that night, so a prop man and costumer had to be roused from bed to provide replacements, and we finished shooting at 2:30 A.M.

A few weeks later I got my check, but instead of the "scale" wage of $150 that I expected, the check was for over $700. I called the studio to tell them about the mistake, but they said Lucy had been so pleased with the fact that I went ahead with the scene rather than yelling "cut" that she made sure I got the stunt adjustment on my pay. I love Lucy.

The far more benevolent Tracy, created by Rick Baker.
The beanie is from the "Ghost Busters" wardrobe department. (16" tall x 14" wide)

An episode of "The Lucy Show."
Lucille Ball, Vivian Vance, Bob, and Gale Gordon prepare for Halloween high jinks.

In 1966, Kogar was booked on "My Three Sons" through agent Mary Grady, mother of one of the titular sons, Don Grady. Though people have talked about how aloof Fred MacMurray could be on the set of that show, I found him to be quite outgoing and friendly to me, a schmo in a gorilla outfit. He brought up the name Charlie Gemora and we ended up talking for quite a long time about the techniques Charlie had shared with me and how I'd patterned my suit after his. Fred was very interested in the mechanics of the whole thing, so he went to the director, James V. Kern, and suggested expanding my very small bit in a dream sequence. He and Kern worked out a very funny bit and Kogar ended up with a quite substantial part.

Mary Grady also represented Butch Patrick, who played Eddie Munster of "The Munsters," and there was talk of giving Eddie an appropriately bizarre pet—like a housebroken gorilla, for instance. It looked like I'd get the gig, so Butch and I were booked for a personal appearance at a mall opening in Phoenix, Arizona. We were up on a small stage, Butch signing autographs, with me at the end of a leash. Occasionally I'd venture to the edge of the stage and give a big snort and the kids would all scream and scatter—that was fun, no doubt about it. Toward the end of our appearance I could see a little commotion out in the crowd out of the corner of my eye but didn't give it too much thought. When we walked back to the dressing room, we were met by a group of security guards and police officers.

"Do you want to press charges?"

"What? Why?" I replied.

"Well, we grabbed up a kid with a spray bottle filled with lye. He was planning to squirt it in your eyes."

The kid was about twelve years old and said he "just wanted to see what the gorilla would do." I didn't press charges, but the mall did.

Unfortunately, "The Munsters" was cancelled a week later, so Kogar's big break would have to wait. Still, I kept busy throughout the balance of the 1960s and into the 1970s with television appearances as Kogar on "Rowan and Martin's Laugh-In" and "Truth or Consequences," and improvisational promos with the master for "The Wacky World of Jonathan Winters," among other gigs.

left: **Metal Robot costume used in Gene Autry's *Phantom Empire*
(1935) and TV's "Captain Video" (1951). Originally built as part of a
large production number in a 1930s musical, for which many
cardboard copies were made. Bob wore it for three years to deliver
mail on "Captain Jet," a local afternoon kid's show.** (6' tall)

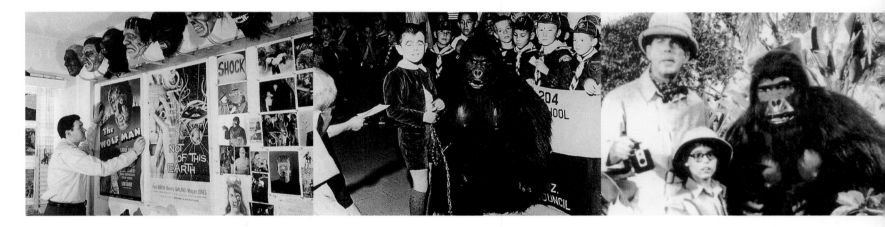

In 1971 I was part of a strolling gorilla act at the newly opened Magic Mountain in Los Angeles. Art Laing was a wonderful performer who played Kogar's trainer, and we worked out an act in which Kogar would be hauled around the park in a cage pulled behind an electric car. We'd stop at various areas where people were gathered, at which point Art—decked out in a complete "great explorer" ensemble—would begin his spiel: "Ladies and gentlemen, I want you to go ahead and look closely at the fierce creature in this solid steel cage. He is perhaps the most vicious animal in nature, but we have absolutely nothing to fear because I wield this authority stick." Art would brandish a rubber hose at me and I'd cower in the corner of the cage. As he continued his speech, spectators would get closer and closer for a better look, and I'd suddenly grab at the "authority stick." "Oh no! He's never done that before!" Art would exclaim. "This has never happened before! I don't know what's the matter with him!" I'd begin raging

around and shake the cage just so—and the rigged door would suddenly swing open.

Art and I would simultaneously "notice" the open door, and I'd begin striding toward it. Pandemonium! "Oh no! Let's get him back to the compound! The beast is getting loose! Drive!" Art would prod me back through the open door with the stick, and then the guy behind the wheel of the electric car hauling Kogar's cage would hit the gas and we'd speed away. We really frightened people; you could tell where we'd been by the half-eaten corn dogs and spilled sodas scattered on the ground. Sometimes you'd see babies in their strollers left all alone as the parents streaked away. Once a guy leapt into a nearby fountain. He claimed he knew for a fact that gorillas are afraid of water.

Kogar had served me well for many years, but by the mid-1970s I was ready for a change. It seemed to me that the trend was moving toward more cartoonish gorillas, and I was in serious danger of underemployment if I didn't keep up with the times.

above left: **By 1962, Bob's budding
collection of horror and fantasy film
memorabilia was already beginning
to take over the house.**

above center: **Butch Patrick and Kogar.**

above right: **Kogar in the jungle with
Fred MacMurray and Barry Livingston.**

One of Bob's heroes, Jonathan Winters, had Kogar presented to him as a "prop" during shooting of improvisational promotional spots for his television special.

Enter an extremely talented—and very shy—young man named Rick Baker. I met Rick after he'd read about me in *Famous Monsters of Filmland* and somehow figured out that I had friends at Don Post Studios. Rick was so shy that he had his dad, Ralph, call Don Post Studios to pass a message along to me. I called him and invited the family up to my place.

Rick was interested in becoming a makeup artist, and on that first visit he brought along some masks he'd created. I was completely taken aback by what this kid could do—the results he was achieving, with no outside instruction, were as good as or better than those of many pros. That day I showed him how to do a scar and we concluded a fun visit with the promise to get together again soon.

The Bakers visited again the next weekend, and Rick brought along some scars he'd done on his own. He had deconstructed the samples I'd made for him and created new scars from scratch that absolutely put mine to shame. If his first visit assured me that Rick was talented, his second convinced me he was a budding genius. Kathy and I began a relationship with Rick and his parents, Ralph and Doris, that we treasure to this day.

Rick's dream was to work as a Hollywood makeup artist, and I tried to do whatever I could to help him along. In those days there really was no formal way to learn makeup skills, but I'd picked up a lot of what I knew by acting as a "test head" over the course of many years for artists who were experimenting with new techniques for upcoming films. I would also sit for exams given by the make-up artists union. Applicants who'd made it through pre-screening and written tests would then be tested for their ability to create—on me—a skull cap, bruise, wrinkle, or other feature. I conveyed to Rick the knowledge I'd accumulated.

Grant Wilson, CBS's makeup artist, was nice enough to provide guidance and practical tips to Rick. Grant was a through-and-through union man, so when Rick turned eighteen he got us a meeting with a representative who could evaluate his abilities and, we hoped, place him in an apprenticeship. We showed up at the appointed time with some of Rick's samples, and, after a negligible period spent looking over Rick's work, the guy basically blew us off: "Nice try. Keep at it."

I was furious. The union was known as a closed shop, but I couldn't believe they were so afraid of competition that they would try to dissuade a person so obviously gifted. Many years before I'd met with a union rep and was told I simply didn't have what it takes; I believed him. Rick, however, took his response in stride as one man's opinion and simply worked harder. A few years later he showed his work to Dick Smith, the legendary makeup genius who aged Dustin Hoffman so convincingly in *Little Big Man*. Dick was so taken with Rick and his work—he said he saw something in Rick that he'd never seen before in his long career—that he invited him to work as an assistant on *The Exorcist*. The rest, as they say, is history. Rick has since become one of the pre-eminent artists in the business, and has so far won five Academy Awards for his work.

In 1973 I mentioned to Rick that I'd like to over-haul Kogar, and he volunteered to do a new head-piece that reflected the direction I wanted to go. He was beginning a lifelong fascination with gorillas that would culminate in his incredible creations for films like the 1976 remake of *King Kong*, *Greystoke*, *Gorillas in the Mist*, and *Mighty Joe Young*.

The finished product was perfect. Where Kogar promised menace, Rick's creation was mischievous and friendly in a childlike way. It was a face designed to instill chuckles rather than fear. Kathy and Rick also revamped the suit, and Kogar II was born.

It wasn't long before my new simian partner would get his lucky break. While attending a night course on television production, a colleague of mine from CBS struck up a conversation with guest lecturer and television producer Lou Scheimer.

"Oh my god, what a day!" he moaned, head in hands. "We've got this show with Forrest Tucker and Larry Storch, and we had a guy lined up to star as the gorilla sidekick, Tracy. But at the last minute this guy's agent started jerking us around, and all of the replacements we've looked at are pitiful. We might have to cancel the whole show." My friend told Lou his troubles were over.

Scheimer had me in his office the very next morning for an audition in front of various writers and

right: **Now regarded by many as the finest make-up artist in Hollywood, Rick Baker used Bob as a practice palette as he learned and perfected his craft.**

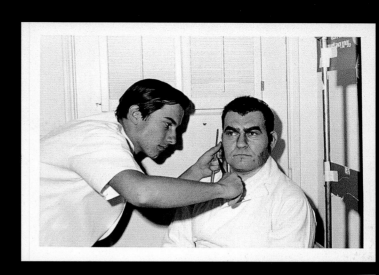

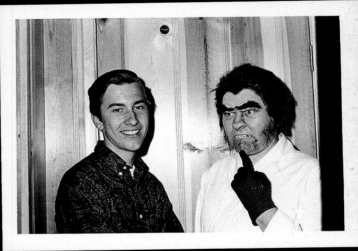

Actor Glenn Strange, whose monster credentials included *Abbott and Costello Meet Frankenstein* (1948), is remembered by Bob as his "second father."

directors for the series. I could see an immediate positive reaction to my suit. Mark Richards, the creator and writer of the show, filled me in on the role.

"The character is called Tracy the gorilla," he said. "He's a real gorilla, but he'd love to be a human. He's restricted insofar as he can't talk, but through gestures and pantomime he can emulate humans." Then he asked, "If you were Tracy, what would you do?"

I thought for a moment as all eyes in the room studied me. I walked over to a nearby desk, picked up a copy of *Variety*, and sat down, legs crossed, to read it. They all said, "There's Tracy the gorilla!"

Three days later I was doing Filmation's "Ghost Busters" with the legendary duo of Larry Storch and Forrest Tucker. They were, of course, very comfortable together after years of honing their act on "F-Troop." As the rookie and odd man out, I was a bit worried. I'd heard Forrest, who was known to one and all as "Tuck," could be pretty gruff. On the first day of rehearsals I did all of my schtick as Tracy, but I throttled back noticeably when we actually started to shoot.

The director, Norm Abbott (nephew of Abbott and Costello's Bud Abbott), called a break and took me aside. "Bob, you were doing great stuff during rehearsals, but when the camera rolls you're not giving me the broad action I need."

It was clear to me what was holding me back.

"Norm," I said, "I've got a problem. I'm worried about Tuck and Larry."

He responded, "Man, you better take care of it because we've got fifteen shows to do!"

I screwed up my courage and approached Larry and Tuck. "Guys, can I talk to you for a minute? I've got a problem."

Tuck fixed me with a sinister glare and said, "What could *possibly* be your problem?"

At that point, had there been a shovel handy I would have dug and crawled into a hole in the ground. I pressed ahead, however. "Norm's telling me that I'm not doing the outrageous schtick he wants, and, frankly, I'm concerned about offending you guys by upstaging you. You're the stars; I'm just the new guy in the gorilla suit."

Tuck's stern expression did not change. "*That's* your problem?" He looked at Larry and then back at me. "Listen, I'm too old to worry about that ego crap, and Larry's too stupid."

Larry chimed in with "Yep, yep."

"We're here to make people laugh," Tuck continued. "That's the whole reason for the show. If you can run around behind me and make faces, then do it! You're going to walk off with this show anyway—let it fly!"

Tuck turned out to be craggy on the outside but sweet on the inside, a very generous and funny person to work with. The day we met he called me Bob; after that I was "Trace," "Tracy," or "the kid." He and Larry made me feel like I was a valuable part of the team, and in no time we were all buddies. Larry didn't drive, so Tuck brought him to the lot in the morning and I'd give him a lift home at night. He did voices for Filmation cartoons, so we'd spend the ride home having conversations as barnyard animals and space creatures. If anyone had overheard us, they would have thought we were nuts.

Tuck was also my protector on the set. We were behind schedule from the get-go, so we churned out a show every two days to make our 15-episode slate. One day I passed out from the heat and exertion—I was just too enthusiastic about the role, really, to notice exhaustion creeping up on me. Tuck was the first one over to see if I was all right.

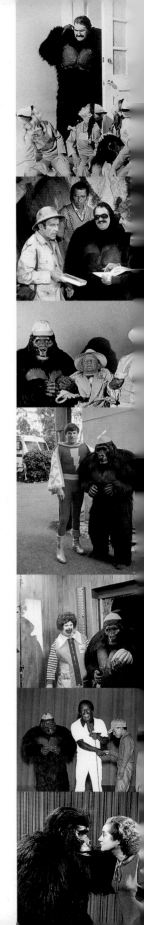

top to bottom: **Brushes with fame—Mickey Mouse Club; Paul Lynde and director Art Fisher on the set of a Donny and Marie Osmond TV special; Billy Barty and Johnny Brown; John Davey as Filmation's Captain Marvel; Ronald McDonald; Flip Wilson; Elsa Lanchester.**

opposite page: **The original "Ghost Busters," Larry Storch, Forrest Tucker, and Tracy.**

"Hey kid," he said. "Aren't you supposed to be getting breaks so you can take the suit off and get some air?"

"Yeah, I guess so."

"You're overdoing it. I'm going to lay down some new ground rules." He gathered the director and crew. "Now here's what we're going to do: When I think the kid's tired, we're going to take a break. I'll go off to my trailer and have a little drink, and you pop the gorilla head off the kid and give him some water and air and whatever he needs. Remember, if we kill him we don't have a show!"

From then on, Tuck would look at me every now and then and ask, "Are you tired?" and I'd say, "Well," and he'd repeat, *"Are you tired yet?"*—and off he'd go to his trailer while I doffed the head. In fifteen minutes he'd be back, making sure I was OK, and we'd get back to work.

Without a doubt, the time I spent as Tracy on "Ghost Busters" was the happiest in my life. I was being paid to work daily doing comedy while portraying a gorilla—a perfect synthesis of my favorite things in the world. We worked hard, but the camaraderie was tremendous.

Naturally, it couldn't last long. While CBS wanted a second season of "Ghost Busters" for 1975–76, the production house, Filmation, felt that they faced a budgetary choice between our show and "The Shazam/Isis Hour." We ranked number two among new Saturday-morning programming and "Shazam/Isis" ranked number one; Filmation chose to put all their eggs into one basket, and our budget was given to the number-one show. As I noted to Lou Scheimer after the cancellation, it seemed strange to have your horses place first and second, then shoot the second-place finisher! After "Shazam/Isis" tanked six months later, I might have appeared prescient.

In another unfortunate circumstance, Filmation sold the videotape masters of all fifteen episodes of "Ghost Busters" to Westinghouse, and they in turn sold them to another party, who erased them. Ten shows have been released for sale on video, but the other five may be lost.

A bit of "Ghost Busters" lives on, though. Tracy became so indelible as my gorilla identity that the name stuck.

right: **Action-packed stills from** *The Further Adventures of Major Mars.*

MAJOR MARS RETURNS

You can't keep a good major down.

One day in 1973, my friend Tom Scherman, a special-effects professional, and I spent an afternoon reminiscing about the old days of matinees and Republic serials. Tommy reminded me of my Major Mars stint and suggested the character would make a great hero in the tradition of Spy Smasher and Rocket Man. Why not make a Major Mars movie?

I picked up the thread immediately. While my original Major Mars was very mysterious and only partially goofy—I would, for instance, step in a bucket on my way onstage and do the rest of the show with the bucket on my foot—I thought a new version should take advantage of the fact that I was older and heavier. I suggested that we actually show his face and make him comedic, a cross between the arrogance of Oliver Hardy and the bumbling of Inspector Clouseau. The sort of person who creates chaos wherever he goes. Tommy agreed. "But let's make his past and motivations a closed book," he said. "We'll just jump in as if he's always existed."

Scherman and I shared the idea with mutual friend Glenn Johnson, a film editor and actor. We spent many afternoons and evenings brainstorming ideas and developing the loose outline of a script for the spoof. Soon Tommy began to cobble together financing for production of *The Further Adventures of Major Mars*, and word got around the Hollywood production community that fun was afoot. Many of the guys I'd befriended when they were just entering the business were now sought-after effects artists, and they wanted in.

We benefited enormously from the fact that so many professional special-effects people were excited about creating a funny homage to the old Republic serials. One by one the talent came aboard—animators Jon Berg, David Allen, Jim Danforth, Joe Musso, and Douglas Beswick, artist Mike Minor, model builders Greg Jein and Bill Malone, pyrotechnics expert Joe Viskocil, and on and on. These were craftsmen that we could never dream of affording on our budget, but they did it for the pure fun—and they could do magic with very little in the way of materials and money.

Tom Scherman created all of the detailed miniature landscapes and model spaceships for the production, using as his template the familiar "model on a wire" constructs seen in Flash Gordon and Buck Rogers films. Major Mars himself "flew" with a helmet device influenced by Republic Pictures' Rocket Man. For the streamlined headgear, Tommy found a set of fiberglass cowls used to cover airplane engines for the winter. He customized three of them: one for Major Mars; one for his sidekick, Sparky; and a stunt helmet for Major Mar's big entrance through the closed window of his headquarters.

The production started and stopped as our finances permitted. A portion of the live-action material was shot in 1973, while special effects and the remaining studio material were completed in 1976 when more money became available. I have an especially vivid recollection of a shot in the cockpit of Major

Mars's spacecraft during which Joe Viskocil—who went on to demolish the Death Star in *Star Wars* as well as the White House and the Empire State Building in *Independence Day*—nearly added Bob Burns to his résumé under "Things I Blew Up."

It was a scene where I'm holding a space weapon in the cockpit, and they'd rigged the head of the gun with a reflective flood lamp, or "Chinese hat." The effect was simple enough; a wire ran down from the flood lamp and through my jacket to an off-set switch, where a powder charge in the lamp could be set off on cue. Joe packed the end of the gun with powder, and as we got closer and closer to the take he'd keep adding more and more powder. I was getting nervous, but he kept telling me to relax.

What none of us remembered were the little heat-dispersal holes at the bottom of the Chinese hat. When the piece was appended to the end of my "space gun," the holes were left uncovered. I played the scene, and the gag was that I get so flustered at the thought of Dr. Evil kidnapping Marcia that I pull the trigger of the weapon prematurely. At the moment the charge went off, the business end of the gun was right next to my head; the powder ignited and flames escaped from the little holes in the lamp-piece. I felt some heat but didn't know anything was wrong until Tommy walked up to me and said, "Geez, Bob—your eyebrows are kind of gone!" We were fortunate that this particular shot was saved for last.

To this day, when I see Joe Viskocil I call him by a nickname no one else is allowed to use: "Boom Boom"—one for each eyebrow.

Tommy and I insisted that the feature be shot on professional-format 35mm film, and the talent deployed on everything from set design to stunt work gives *The Further Adventures of Major Mars* an expensive sheen—the film's final look belies its minuscule $10,000 budget. Kicking off with appropriately sonorous narration, courtesy of a perfect one-take reading by Charlie Dugdale, my co-worker at CBS KNXT-TV, and concluding with a surprise ending that "breaks the fourth wall" both literally and symbolically, *Major Mars* clocks in at a crisp, well-paced seven minutes that plays well even today. I portray the Major as blissfully unaware of his shortcomings, and Glenn Johnson as Sparky makes the perfect straight man.

A typical exchange occurs after Major Mars crashes headlong through the closed window of his Rocky Mountain Headquarters:

SPARKY: Gee whiz, Major Mars! Are you okay?

MAJOR MARS: Sparky—who left the window to the headquarters closed? I could have been hurt real bad!

SPARKY: Gosh, Major Mars, I think *you* did.

MAJOR MARS: Well, it really doesn't matter who left it closed. The important thing is I could have been killed—see that it doesn't happen again!

Though we had no luck selling the character to any of the major TV networks—ABC, CBS, and NBC all made offers that butchered our original intent in one way or another—I've regularly screened *The Further Adventures of Major Mars* in the intervening years as part of my presentation as guest speaker at many genre conventions. Consequently, Major Mars has become somewhat beloved by fans of serials and sci-fi films. Statuettes, model kits, paintings, and action figures have been produced in the Major's image, and his fan-produced merchandise shares space on convention exhibitors' tables next to that of *The Lone Ranger, Captain Marvel*, and *Superman*. What could be more flattering?

Alumni of the 1976 Major Mars feature—many of whom now have multiple Academy Awards under their belts—regularly approach me with dreams of producing another "episode" of the hero's adventures for the new millennium. I just laugh; Major Mars is a very old man, and I doubt he'd have the strength to fire up his helmet rockets, much less battle bad guys.

Still, with special effects so advanced today there may be a way for my alter ego to swing back into action. Will Major Mars don his trusty rocket helmet once again to continue his fight against the forces of evil? What sort of new technology could he bring to the struggle? Is the lease on his secret Rocky Mountain Headquarters paid up? *Will his uniform pants still fit?*

Tune in next week.

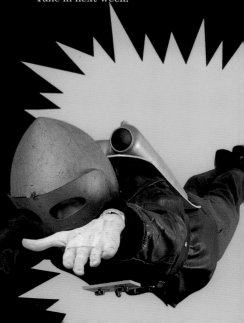

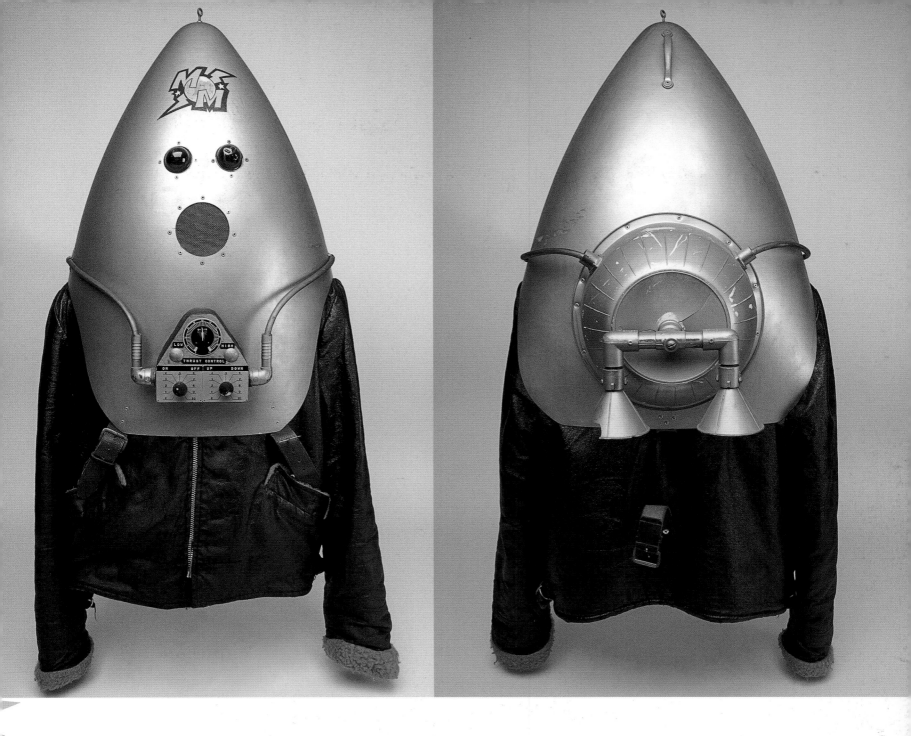

above: **The Major Mars flying suit. Major Mars logo by Mike Minor.**

left: **A major influence on the look of Major Mars was Rocket Man, a Republic serials fixture since his introduction in 1949's** *King of the Rocket Men***. This particular suit was worn by Dave Sharpe for stunt sequences, with refurbished front panel and tanks by prop maker Don Coleman.**

HELMETS

1

2

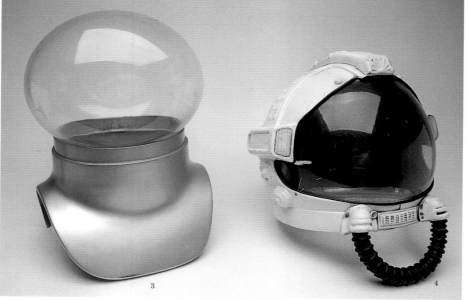

3

4

1 **Helmet worn by George Barrows for** *Robot Monster* **(1953), found at Western Costume for the presentation of the film in 1982.** (15" tall without antenna)

2 **Bob with the co-host of** *Robot Monster.*

3 *The Andromeda Strain* **(1971).** (19" tall)

4 *Outland* **(1981).** (16" tall)

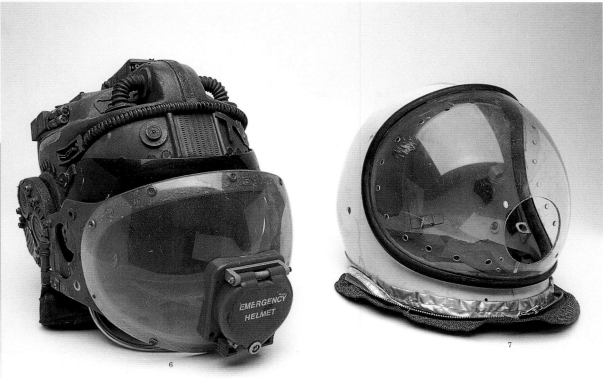

5 *20,000 Leagues Under the Sea* (1954) diving helmet. (19" tall)

6 *Alien* emergency helmet used in the "wake-up" sequence at the beginning of the film. (11" tall)

7 *X-15* flight helmet with hole cut in Plexiglas for subsequent use as a costume in an ice show. (11" tall)

8 *The Fly II* (1989) helmet for boy-scientist, by Chris Walas. (16" tall)

9 *Rollerball* (1975) helmet. (10" tall)

APES/GORILLAS

1 *The Thing with Two Heads* (1972) gorilla face made and worn by Rick Baker. (11" tall)

2 Rick Baker's first professional gorilla film project, the ape face from *Schlock* (1971), worn in the film by director John Landis. (8" tall)

3 *Harry and the Hendersons* (1987) solid
head from dummy, by Rick Baker. (15" tall)

4 *Gorillas in the Mist* (1988)
Digit "amputated" hands and head by
Rick Baker. The head is from the original
mold and hands are props from the film.
(Head: 14" tall; hands: 14" long)

I REALIZE THAT I stand in the minority when I say that my favorite holiday isn' one of the gift-giving events or even one that grants us a four-day weekend. For me, the center of the year has always been October 31–Halloween.

By this point in the book I'm sure that doesn't surprise you. After all, Halloween is a one-day license for make-believe. For the period surrounding "All Hallows' Eve," everyone is interested in the same things that I am every other day of the year!

When I was little, Halloween was a joyous event. My friends and I planned our costumes weeks—even months—in advance, and the neighborhoods would swarm with candy-seeking ghouls and goblins on the appointed night.

I can also remember attending school on costume day our first year in California, wearing a store-bought Mickey Mouse outfit. For some reason that costume was the hit of the day; kids followed me everywhere I went, and when we had our grand costume parade I was put at the head of the line. For a guy who was used to being ostracized (my "Okie" accent was the source of incessant teasing), it was quite an experience to be that popular, even temporarily.

The glory days of Halloween were before warnings about razors in apples and the necessity of daylight trick-or-treating. It was a simpler time that is perhaps gone forever. Since becoming a "grown-up," I've tried to bring back a bit of the fun I remember for the kids in our neighborhood. At first, it was just a matter of answering the door as Frankenstein's monster or Dracula; the kids who stood their ground rather than fleeing got candy. In 1967, Kathy and I decorated our entire living room in a Frankenstein's lab motif, complete with test tubes and a crackling Jacob's-ladder electrical apparatus (which played havoc with the television reception of my neighbors). When kids rang the bell at the front porch, the door would open slowly to reveal a huge portrait of Bela Lugosi and a dummy of Glenn Strange as the monster on an operating table. Kathy, dressed in a ghoulish white shroud, handed out the candy. When everyone had gotten his or her goodies, I'd leap out from behind a door in a Mr. Hyde mask and the kids would scatter in all directions. We noticed that many of them would come back for "seconds" with their uninitiated friends.

My friends Tommy Scherman and Dennis Muren, both visual-effects aces, had seen my little tableaux and offered to help me create something a bit more elaborate. We decided on a takeoff of *This Island Earth*, with my living room becoming the interior of a spaceship with a porthole overlooking the surface of Metaluna. Trick-or-treaters were menaced by our reproduction of that film's mutant. The kids loved it, and Tommy and Dennis thought it was so much fun that we followed up the next year with a giant, tentacled "Goombah" alien on my house's roof. The creature had two puppeteers inside who controlled a moving eye and mouth. When a kid on the sidewalk would point or say something, the Goombah would roll his eye in that direction. Our living room was rigged to appear as though one of the alien's tentacles had burrowed inside and claimed a victim, which was a dummy controlled by modelmaker David Allen. It was fantastic.

The crew for the "Jekyll and Hyde" show take a breather. Left to right: Jon Berg (in Glenn Strange's Frankenstein boots), Bob, Bill Hedge, Tom Scherman, and Dennis Muren.

top right: **1975's Halloween production, "War of the Worlds," featured an awe-inspiring set that made it appear that an alien spaceship had crashed into Bob's house.**

bottom left: **A peek at the back of the "War of the Worlds" set.**

bottom center: **A neighborhood menace, the Goombah.**

bottom right: **Bob's Jekyll-Hyde transformation in his 1971 show was done "live" using a trick also seen in the film version: a light filter revealed previously hidden makeup that made it seem as though Bob's entire appearance had magically changed.**

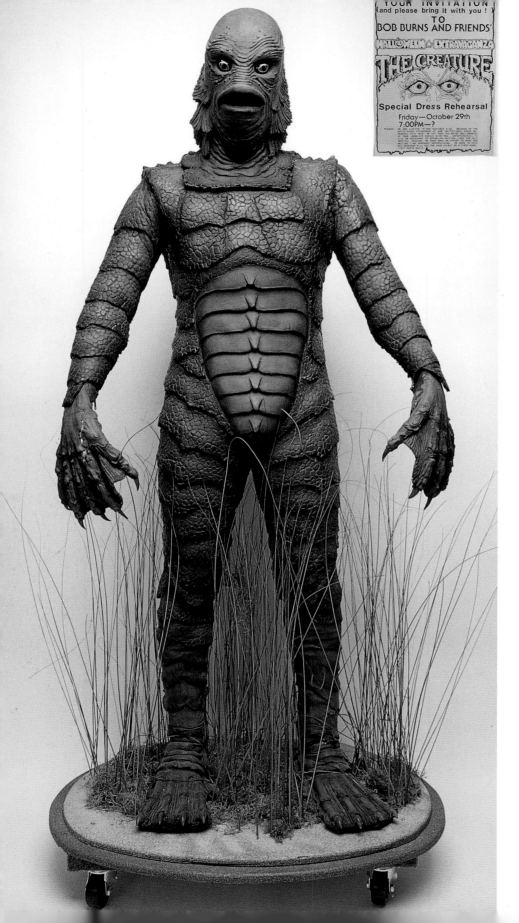

Thus began a decade-plus escalation of Halloween shows with a growing crew of Hollywood effects experts doing their best to scare my neighborhood and surrounding community to death. After a *Dr. Jekyll and Mr. Hyde*–themed show in 1971, the crowds and setups had reached the point where Kathy kicked us out of the house—which only expanded our ambition. With the whole backyard and driveway to work with, we could get even more outrageous. One year visitors had to pass through the mouth of a giant gorilla head at the front of my driveway, painted by Mike Minor, in order to experience a reprise of the "Kogar Escapes" routine Art Laing and I had performed so often at Magic Mountain. Rick Baker had recently built his first gorilla costume and shared the role of Kogar with me. This show, like most of our productions since 1971, had a small plot line that led to a "boo" moment designed to clear the show for the next group.

Our Halloween antics quickly got the attention of local news affiliates, and a cover story in *Starlog* magazine entitled "Hollywood Halloween" made our little shows notorious across the country. In 1979 actors from the new movie *Alien* were at CBS doing publicity for the film, and I asked the 20th Century Fox PR person accompanying them whom to approach in order to do an *Alien*-themed show. To my surprise, I got a call within the week from a Fox representative. They'd heard of us and thought the idea of getting press for *Alien* through our event was a good one. Since the film had just been released, he explained, Fox had a few guidelines that we had to observe—all of which seemed very reasonable. Then he dropped the real bombshell.

"We just got a shipment of *Alien* props from Shepperton Studios in England," he said. "We don't usually do this sort of thing, but why don't you come down and see if there's something you could use for the show?"

I was at the 20th Century Fox offices in the blink of an eye. My contact took me to a warehouse area where all of this amazing stuff was laid out. "Take whatever you need," he said.

above center: **Flyer for the 1982 "Creature" show.**

left: **"Creature from the Black Lagoon" costume created for the 1982 Halloween show, sculpted by Bill Malone. The head piece was the last pulled from an original mold from the Universal film. Stand and mannequin by Greg Nicotero.** (6' tall)

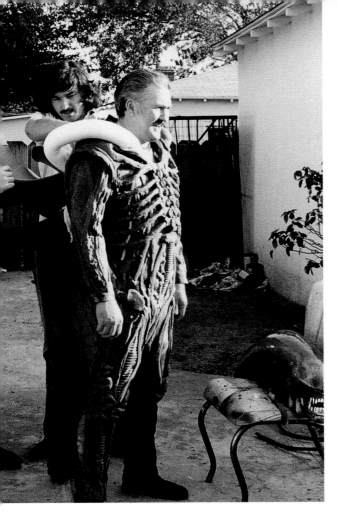

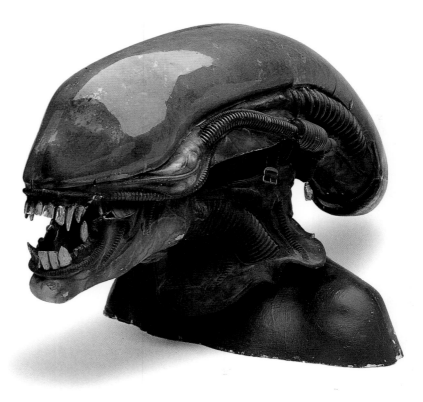

Not wanting to appear greedy, I tried to limit myself to the absolute essentials: a jacket, some weapons, and a really nifty "alien detector" that had lights and sound. I was about to gratefully leave with my booty when the guy stopped me, asking, "Don't you want the mechanical 'face hugger'?"

Well—if you insist.

The set we built for "Alien" was amazing. My driveway became an enclosed corridor that led to a larger space wherein our actor—Walter Koenig of "Star Trek" fame—would portray a menaced space explorer. The small space vividly recreated the sense of claustrophobia that pervades *Alien*, the movie.

"Star Trek" and "Star Trek: The Next Generation" writer Dorothy (D. C.) Fontana, whom I'd met when we were both guests at a local science fiction convention, was on the crew of many of my Halloween shows. The "Alien" show holds special memories for her:

On "Alien," Mike Minor designed an extremely complex and "nurny"-filled set of corridors and main area that depicted the Nostromo ship. And everything had to be painted black. I noticed one of the guys working on the Alien suit had a terrific t-shirt I had never seen before. It featured the Id Monster from *Forbidden Planet* (one of my all-time favorite sci-fi movies), and I complimented him on it. And thought no more about it. Another day, I had finished painting everything black that I had been assigned and was looking around for something else to do. Kathy Burns suggested I help out the guys working on the Alien suit. I wandered back and asked one of them what I could do to help. One of them, who introduced himself as Dennis Skotak, said I could cut out some foam rubber which would constitute the basic material of the Alien backbone and that led to our starting to date and our getting married two years later. In October. Close to Halloween—our favorite season.

The designer of the Alien creature, H. R. Giger, may be glad to know that he can add matchmaking to his creature's long list of survival and death-dealing abilities.

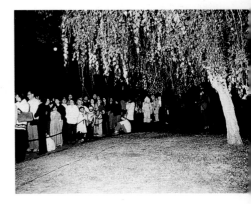

above left: **Bob suits up for his turn as the alien.**

above right: **Alien headpiece worn by an actor in** *Alien*. **It was loaned to Don Post Studios for use as a model for an alien mask that was never produced, then given to Bob for use in the 1979 "Alien" Halloween show.** (36" long from nose to back of head)

above: **The "Alien" Halloween show in 1979 attracted people in droves.**

top: **This actual prop from the *Alien* (1979) film caused screeches of delight when it would suddenly spring to life.**

bottom: **Walter Koenig portrays a doomed astronaut stalked by the bloodthirsty alien.**

The storyline for our "Alien" show was one of our creepiest: A group is led down the long, dimly lit "spaceship corridor" to a larger "junction space." We placed the mechanical "face hugger" in a clear case set into the corridor wall, looking to our unsuspecting visitors like a static display. When one or more people would move closer to investigate, we'd make it suddenly wriggle violently—always good for a jolt. Once the group is assembled at the end of the corridor, a door opens and Walter enters, guided by the "alien detector" he carries and disembodied "voice link" communications with crewmates (the voices of Kathy Burns and Dorothy Fontana). He starts up a ladder and is suddenly attacked by a face hugger, which he throws off. While he regains his composure back on the ground, voices on his radio warn that the creature is getting closer. Suddenly, a *screech*—he has accidentally stepped on the cat. As Walter, and the audience, breathe a sigh of relief, a crewmate's voice breaks in on the intercom: "It's still registering!" We hear a *crash* behind Walter, and he walks away to investigate. Shadows appear in the direction he's heading; as he gets farther and farther away from the audience he rechecks his alien detector apparatus and it swings him back around to face the spectators. Then, with unerring timing, Walter looks just over the heads of the assembled "victims" and shouts, "Oh my God!" Immediately, a very loud alien *screech* blasts from above and behind the audience and they turn in time to see lights illuminate the Alien himself, mere feet above and moving toward them. Then— lights out! During the moments of darkness, hidden crew members spray atomizers of warm water into the crowd.

After a suitable period—usually five seconds—the lights come back up and Walter thanks the audience. Most are pressed up against the walls of the corridor, and many are certain they were slimed by the monster as he passed—an illusion created by the warm-water

atomizers. The Alien had actually retreated into a secret alcove when the lights went out.

A group of 20th Century Fox executives showed up to take in the show—and, I'm certain, to make sure we'd adhered to their guidelines. They were mightily impressed with what they saw and showered compliments on our little assemblage. One of the men noted sourly that they had multi-million-dollar films in production where the sets didn't look as good as our backyard setup. I simply told him, "You hired the wrong crew!"

After striking the "Alien" set, I called my new friend at 20th Century Fox to arrange to return the props they'd loaned us.

"We heard you have a collection of movie props and plan to open a museum someday. Is that true?" he asked.

"Sure," I answered. "That's my goal."

"You know what, your Halloween show was amazing. You did everything we asked of you and really helped promote the film. As long as you sign some papers that assure us that you won't sell or reuse the props in another film, why don't you keep the stuff for your collection? In fact, if you want, we have some other stuff you can have as well."

Wow! I took the day off from work when the props were scheduled to arrive so I could accept delivery of what I thought would be a few boxes.

It turned out I'd vastly underestimated what "some other stuff" meant. First, an enormous crane pulled up in front of my house, followed by two semi-trailers filled with very large crates. The shipment was truly overwhelming—I had to call Kathy so she could see the crane hoisting giant boxes over our house and depositing them into the backyard. Alien invasion indeed!

right: **The props from *Alien* arrive at their new home.**

far right: **The Alien queen small animated puppet that did the majority of the "power loader" fight scenes in *Aliens*. (42" tall)**

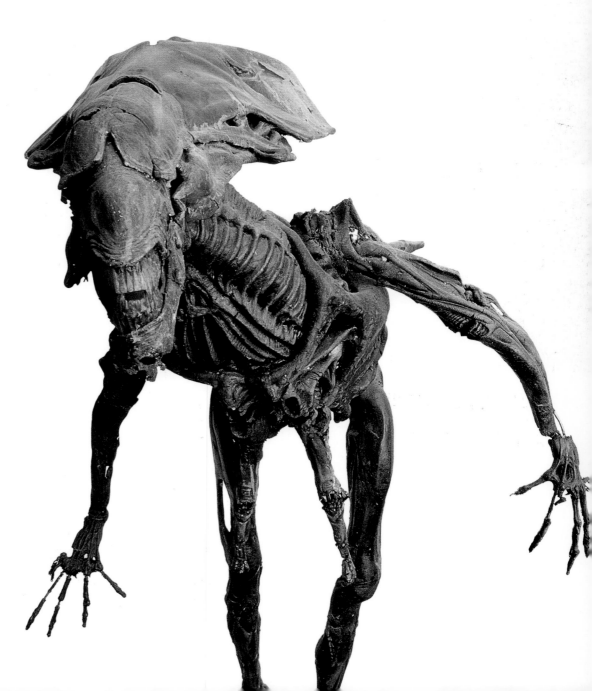

ALIEN

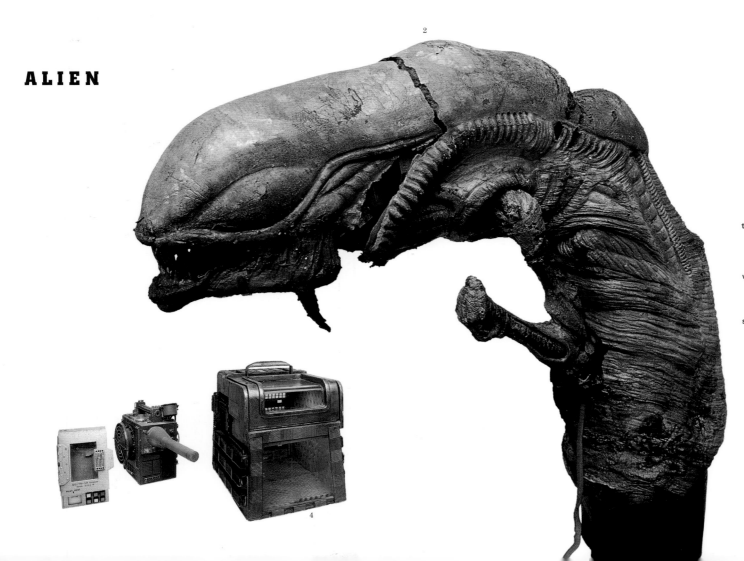

1 *Alien* (1979) Face Hugger on the left is built on garden glove, for puppet movement; the other was created to clamp onto Kane's face and pulsate via two air tubes.

2 *Aliens* (1986) chestburster with actuation devices. (45" tall)

3 H.R. Giger-designed *Alien* "space jockey" study model showing one-wall construction. The alien pilot section rotated so scenes could be shot from all angles and simulate an enclosed space. (36" x 36" x 18" tall)

4 left to right: **M.U.T.H.E.R.** keyboard used to gain access to the Nostromo's main computer; an "alien detector;" Ripley's cat box.

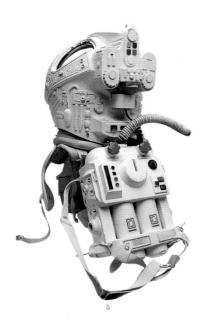

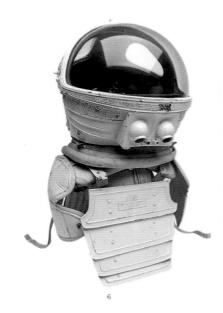

5

6

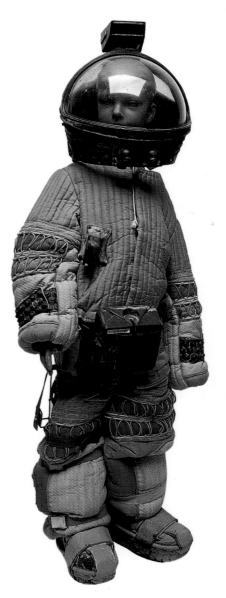

7

5-6 **Front and rear views of Ripley's helmet and tank apparatus from** *Alien*, **featuring smaller tanks also used on miniature "kid-sized" spacesuits elsewhere in the film. The helmet, with a light attached, is also used in earlier scene with the "Lambert" character.** (30" tall)

7 The *Alien* director used child actors for certain shots on the "space jockey" set to make the environment seem more immense, necessitating child-size spacesuits like the one shown here. (4" tall)

8 *Aliens* **Drop Ship.** One side is painted "01" and the other is painted "02" to simulate two different ships. (82" long)

9 **Mannequin used for the Bishop android's demise in** *Aliens*. (30" long)

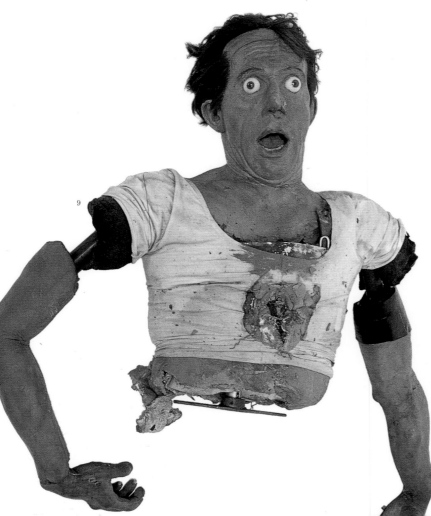

9

8

THE TIME MACHINE

The most star-crossed prop in my collection, and the one most precious to so many visitors, is the Time Machine.

Around 1951, two years after first meeting George Pal on the set of *Destination Moon*, I saw the director at a screening and got up the nerve to reintroduce myself. To my surprise, he remembered me and the circumstances of our first encounter. We chatted for a bit, and I told him that I'd love to talk to him sometime at length about his great work. Again Pal surprised me: "Well, here's my number at the studio. Give me a call."

We talked for at least half an hour during my first phone call. Pal told me about his next film, *War of the Worlds*, and flattered me immensely by asking my opinion of some ideas he had for the project. We kept in touch from that point on, speaking on the phone about once a week.

In the early 1970s, MGM had an auction of their props. I attended with $1,000 I'd scraped together and every intention of going home with my Holy Grail, the Time Machine. Immediately the price shot up to $4,000, way out of my league. I was absolutely heartsick and left before the final bid. I heard later that it was sold to a traveling show for between $8,000 and $10,000. When we spoke on the phone after the auction, however, George was his usual optimistic self; "Someday you will own the Time Machine," he said matter-of-factly. "Don't give up hope."

In 1975, a friend was in an Orange, California, thrift shop looking for interesting items when he caught sight of the familiar big dish of the machine in the back of the store. It was in rough condition and the chair was gone, but I made an offer to the owner of the store. When I called George to tell him I finally had the Time Machine, he simply said, "Of course you do—don't ever doubt me."

George had given me a set of the Time Machine's plans years earlier, so, with the help of Dennis Muren, Tom Scherman, Mike Minor, Dorothy Fontana, TV producer Mark Richards, and Lynn Barker, we completely rebuilt the prop in time to produce a Halloween show entitled "The Return of the Time Machine." David Gerrold—most famous as the writer of "The Trouble with Tribbles" for "Star Trek"—scripted the show in exchange for getting to play the Time Traveler along with Charlie Dugdale.

It was a special treat for all of us when George Pal came by to see our show and the refurbished Time Machine. We asked him to take a seat behind the controls for a picture or two, and he admitted that he'd never sat in the Time Machine before—he was too busy to do so during production of the movie. To this day, one of my favorite pictures is the one we took that night of George seated in his brainchild, pulling the control lever and smiling a huge smile.

right: *The Time Machine* early concept sketch. (14" x 12")

below: **Pal in Time Machine.**

photo by: **Joe Viskocil**

1 **The restored Time Machine.** (75" long)

2 **Created by makeup artist Terry Smith.** (2-1/4")

3 **Tiny model by Steve Stockbarger—about the size of a housefly.** (3/8")

4 **Model by Harvey Mayo.** (7")

5 **Built by Mike Minor from memory at age 18.** (9")

6 **Built by Tom Scherman as a possible set-piece for Bob's museum.** (10" square)

7 *The Time Machine* matte painting by Bill Brace, Great Hall exterior. (24" x 36")

8 *The Time Machine* matte painting by Bill Brace, Great Hall interior. (24" x 36")

MAGIC PENCILS

I've met many creative souls in my life, but none more vital and vibrant than Mike Minor.

We met in 1960, when Mike sought me out after reading that I was a big fan of George Pal's work. On his first visit he brought over armloads of drawings, paintings, and models inspired by images in Pal films; he'd created everything from memory, and I was shocked at how perfect the designs were. After a great visit filled with animated exchanges he insisted on leaving all of that artwork with me, saying nonchalantly that he could always do them again.

Our friendship spanned twenty-eight years. Mike contributed to our ill-fated magazine, *Fantastic Monsters of the Films*, and became a real driving force behind some of my best Halloween shows. His concepts and designs made the magic.

In fact, Mike's ability to communicate astounding visions via black paper and colored pencils—his "magic pencils," I called them—was almost supernatural. That was the way he did his conceptualizing and sketching; for Mike it was all about coaxing colors through a black void

sional work of art appeared. I remember one particular evening we spent listening to audiotapes of movie soundtracks. Mike was intently sketching on his black paper, the magic pencils hard at work. In a matter of minutes he'd recreated three scenes from three movies: *War of the Worlds, The Day the Earth Stood Still,* and *Destination Moon.*

"Tape boxes need colorful sleeves just like record sleeves," he said. Before the night was over he'd completed twenty scenes and mounted them with black tape on the boxes.

Mike's vision found expression through his work for dozens of television and movie projects, but he made perhaps his most indelible mark as art director for *Star Trek II: The Wrath of Khan.* It was Mike who conceived the Genesis Planet effect, and his carefully plotted nebula space battle between the Enterprise and Reliant—inspired by the tense submarine combat in films like *Run Silent, Run Deep*—represents arguably the most memorable sequence in the Trek franchise's history. His storyboards for these and the rest of the special effects scenes in *Khan* were so incredibly detailed and precise that Industrial Light and Magic was able to deliver the effects shots in record time.

When Mike Minor died in 1988, Kathy and I were devastated. His enthusiasm and energy were so much a part of our lives that we wondered whether there were a way to fill the space he left.

But then something wonderful occurred. My birthday happened to fall eight days after Mike died, and the occasion merely reminded me how much I missed him; he was big on birthdays and always made them special for his friends. I was ready to mark the day by feeling sorry for myself, but Kathy insisted that I spend time with our friends. On the drive to the restaurant we could see broken dark gray clouds in a sky of rich cobalt blue that faded into soft velvet. The clouds seemed to be ringed with silver, and the sun was a huge orange ball, right out of *When Worlds Collide.* Rays of light emanated in all directions as ribbons of pink. It was breathtaking, a once-in-a-lifetime sight. Kathy said, "You see! Mike didn't forget your birthday."

And I'll never forget Mike and his magic pencils.

top left: **Concept acrylic painting of travel pod and docking station for *Star Trek: The Motion Picture.*** (15" x 30")

far left: ***Enterprise* hallway concept.** (11" x 26")

center left: **Transporter room concept art for aborted "Star Trek" television relaunch circa 1977.** (15" x 20")

left: **Painting of the *Enterprise,* from *Star Trek: The Motion Picture,* based on a design by Matt Jefferies. Minor painted over details as the project evolved from a planned TV series to actual theatrical release.** (60" x 26")

right: ***V'Ger* concept for *Star Trek: The Motion Picture.*** (16" x 27")

CHRIS WALAS

Academy Award–winning special effects artist Chris Walas met Bob in the early 1980s on an airplane flight, and they've been close friends ever since.

"I was glad to give Bob my 'souvenirs' when I finally closed my effects shop," Walas said. "The reasons were simple. Of course, seeing Bob begging and whimpering for them on the floor helped, but I knew he'd keep these memories together and that they would actually be seen and enjoyed rather than just sit somewhere in storage."

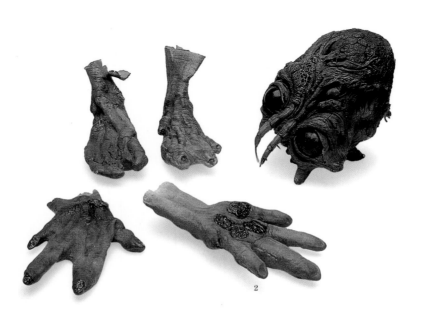

1 **Never-before-revealed "body,"** seen encased in a cocoon in *The Fly II*. (52" long)

2 **Puppet head, feet, and hands from *The Fly*.** (Head: 14" tall; feet and hands: 12" long)

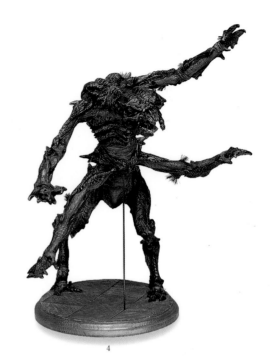

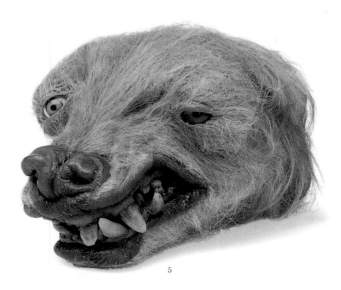

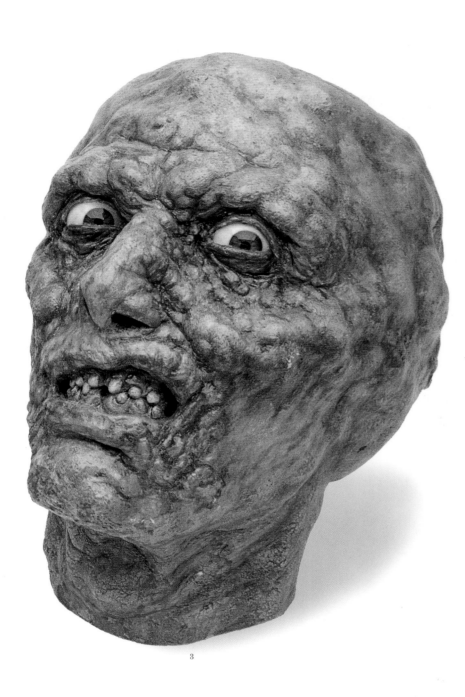

3

4

5

3 Jeff Goldblum fiberglass transitional head
from *The Fly*. (Bust: 15" tall; fly head: 10" tall)

4 "Final transformation," sculpted by Chris Walas
for *The Fly II*. (12" tall)

5 Dog head puppet used for close-ups in
The Fly II. (14" long)

MASKS

1

1 Perhaps the only surviving piece of makeup-man Jack
Pierce's work, the mask made for *The Mummy's Curse*
(1944) after Lon Chaney, Jr., complained that he wanted no
more cotton and colodian (a.k.a. "newskin") makeup
applied to his face. Eye and mouth openings were made by
Pierce so his nephew could wear the mask on Halloween.
Restored by Jim McPherson. (15" tall)

2 *Man From Planet X* (1951) headpiece made of rigid
mannequin rubber. (16" tall)

3 Martian in globe from *Invaders from Mars* (1953).

4–7 *Star Wars* cantina masks.

left to right: **By Doug Beswick,** (18" tall) **By Rick Baker,** (15" tall)
By Rick Baker, (12" tall) **By Rick Baker,** (14" tall)

2

The WEIRDEST Visitor the
Earth has ever seen!

The MAN from
PLANET X

Presented by SHERRILL CORWIN
starring ROBERT CLARKE • MARGARET FIELD
WILLIAM SCHALLERT and the Strange Man from Planet X!
Directed by Edgar G. Ulmer. Written and Produced by Aubrey Wisberg and Jack Pollexfen.
Released thru United Artists

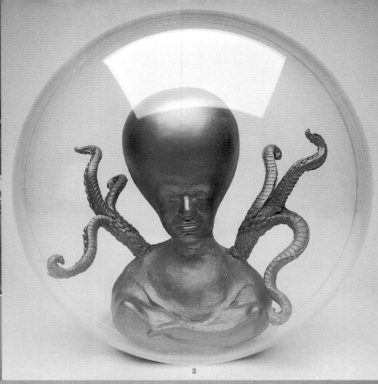

3

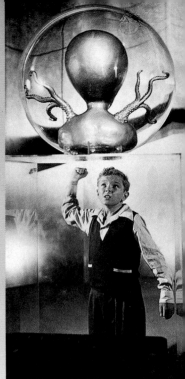

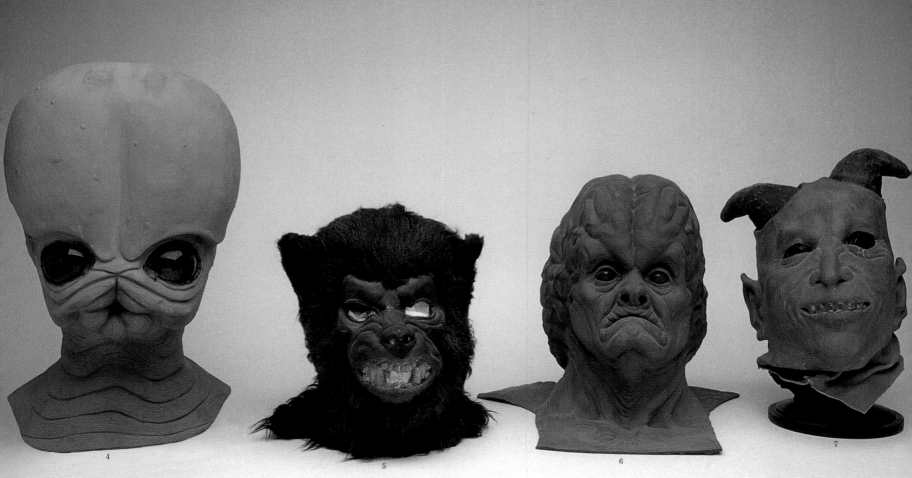

4 5 6 7

CHAPTER SEVEN

KONG

AS A PERSON who once made a living portraying apes, I naturally look up to the greatest of them all, King Kong. (But, then again, who doesn't look up to a forty-foot-tall gorilla?)

The first time I saw *King Kong* was during its third re-release in 1947, when I was twelve years old. I sat there with my jaw dropping to the floor. It was thrilling—the music, the overblown 1930s-style acting, and, of course, the sight of a giant gorilla wrestling with prehistoric beasts. I'd never seen anything like it in my life.

Released in 1933, *King Kong* virtually redefined what was possible in a fantasy film and inspired countless aspiring effects technicians to get involved in filmmaking. So much was done so effectively with miniatures and optically enhanced sets that *Kong* can be seen as the grandfather of all fantasy films, establishing a visual standard that stimulated every effects-driven film produced afterward. It truly was—and is—film art.

The central breakthrough in the production of *King Kong* is, of course, the stop-motion animation that brought the giant ape and his prehistoric peers to life. The concept is deceptively simple: Onscreen motion is simulated by photographing, frame by frame, the incremental movements of small articulated models. The animator poses his figure, shoots a frame, then makes tiny adjustments to the figure's limbs and expression, then shoots another frame, and repeats this over and over and over again. When all of these still frames are played back, "persistence of vision" creates the illusion of movement. Even with modern video playback to gauge exact placements and provide instant footage of work as it's happening, stop-motion animation is an incredibly meticulous and complex process—you can imagine how much harder it was to create realistic footage in the early 1930s. At the beginning of each animation scene, the technicians working on *King Kong* had to replace each light on the miniature set; if one were to burn out, all work would have to start over because the intensity of a replacement would not match. In fact, it was necessary to animate entire scenes without a break—no matter how long it took—because continuity would be ruined by lights that reignited at different brightnesses or plants that withered or bloomed on the miniature sets. These seemingly imperceptible changes would be jarringly obvious when the footage was later screened.

Because of the laborious nature of stop-motion animation, it was impossible to eliminate all visual errors. *Kong* is full of scenes where you can see some of the animator's tools and aids in the frame. If you freeze-frame the sequence where Kong fights the T. Rex, you can clearly see metal rods holding the puppets in position. Of course, in a movie house these frames would be going by at twenty-four per second—pretty fast—so small errors were unnoticeable by audiences of the day.

The final production of *King Kong* uses two distinctly different heads for its title character (three, if you count the full-scale head-and-chest constructed for close-ups and native-chomping). One of the puppet heads has a longer face and was used in the two key Skull Island sequences: when Kong confronts the explorers trapped on a log bridge, and when he wrestles the T. Rex. The other head, with a rounder face and bigger brow, was used in the balance of the Skull Island scenes and all of the New York scenes.

The difference in head shape is due to the fact that, as a cost-saving measure, stop-motion pioneer

previous spread: **Willis O'Brien sketch showing mechanical detail in armature for** *The Giant Behemoth* **(1959).** (30" x 20")

Willis O'Brien poses next to his most famous creation.

executives. It's believed that producer Merian C. Cooper thought the earlier long-faced Kong looked too human and instructed Marcel to sculpt the round-faced version for use in the rest of the film.

Small continuity inconsistencies did nothing to lessen the enormous visual impact of *King Kong*. The key to making all of the magic happen was Willis O'Brien—or "Obie," as he was more commonly called. Though people had done simple animation before him, Obie is regarded as the pioneer. He had an uncanny knack of making his stop-motion characters appear to be living, breathing animals. He was extremely meticulous and demanded the same quality from all of the animators who worked for him. (One of his most famous and gifted pupils is Ray Harryhausen, who began his career working with Obie on the first *Mighty Joe Young*.)

In 1956, I was able to gain great insight into Obie's meticulous methods by spending a fascinating afternoon in the workshop he shared with his associate, Pete Peterson, watching as he animated a train-attack sequence for *The Black Scorpion*. The small train model he was working with had teeny little paper "people" cutouts in the windows, and he explained to me that he was actually animating those as well as the attacking scorpions.

Although there has been much speculation as to how many models were made for production of *King Kong*, it's the conviction of persons I've spoken to who were involved in the film's production that Kong was portrayed by two 18-inch armatures, or puppets, created by Marcel Delgado. I suspect much of the confusion regarding just how many Kong puppets were created for the film springs from the fact that Willis O'Brien and Delgado also worked together on another giant-ape picture in 1949, *Mighty Joe Young*. For that film, six puppets were used: four 16-inch, one 6-inch, and one bust.

When constructing Kong and the other beasts used in the film, Marcel started with a metal skeleton that was engineered to allow maximum articulation

top left: **Test still showing Kong on building with miniature "victim."**

bottom left: **Willis O'Brien with triceratops from his aborted production entitled "Creation." Many models constructed for the project were used in *King Kong*.**

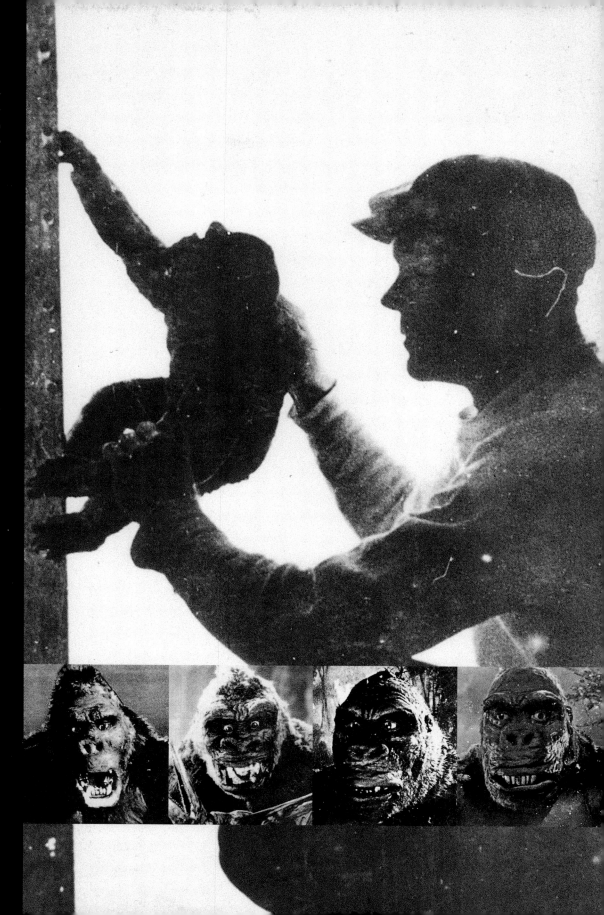

for the animators. These skeletons had to be enormously sturdy in order to withstand the rigors of constant manipulation on the miniature sets. He then covered the metal framework with sponge rubber to form muscle structure, and, in the case of Kong, covered that with rabbit fur. The face was sculpted using latex rubber over other materials. Part of Marcel's job was to do daily maintenance on the joints of all the armatures, tightening and adjusting everything through small slits in the hides.

Very few *King Kong* animation puppets have survived, simply because they were thought of as tools and regularly cannibalized for other projects. One of the Kong puppets was dismantled for parts soon after the film wrapped. The armature in my collection survived because it was re-covered and re-used as the titular character in *Son of Kong*, which began production very soon after *King Kong* was released.

Kong evidently resided at RKO undisturbed for many years until 1962. During the production of *Jack the Giant Killer*, animator Jim Danforth was faced with a scene where the two-headed monster has to pick up an anchor. Needing two good fingers for the grasping action on the model, he simply took two digits from Kong's left hand.

The puppet most likely would have disappeared slowly in that manner, piece by piece, had it not been for a friend of Willis O'Brien, animator Phil Kellison, who became the custodian of the armature soon afterward. The *Son of Kong* latex, rubber, and fur covering was deteriorating and rotting, and it smelled terrible. A chemist examined it and warned that the decomposing rubber was actually eating into the underlying metal parts, so Phil had it steam-cleaned to its present condition. In the early 1970s, Phil loaned the puppet to a museum called Movie World, of Buena Park, California. When the place went belly-up, Kong just sort of . . . disappeared. I used to pester Phil about it, and he contacted the owner only to get evasive answers to the effect of, "I think he's lost."

top: **Buzz Gibson animates Kong's climb to the top of the Empire State Building.**

left and left center: **Kong's face changed subtly from scene to scene.**

right center and right: **Two earlier versions of the Kong puppet were created for the picture by master sculptor Marcel Delgado. One early rendition made Kong look more human, and another made him appear to be an evolutionary "missing link." Both were scrapped in favor of a final design that borrows elements of both approaches.**

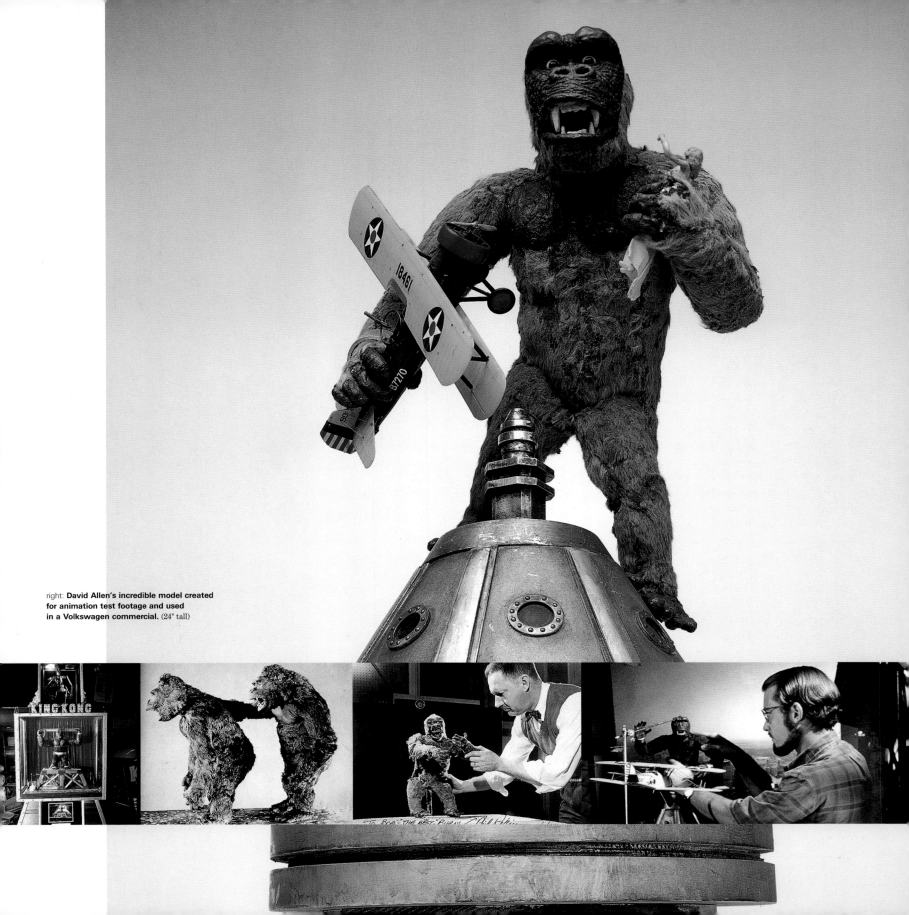

right: **David Allen's incredible model created for animation test footage and used in a Volkswagen commercial.** (24" tall)

As luck would have it, in 1975 I accompanied my friend Bill Malone to the warehouse where all of the Movie World material was stored. Bill had bought Robby the Robot, which I was going to help him take home. While we were in this big storage room waiting for Robby, I spied the Kong puppet standing on a box way back in a corner! I immediately contacted Phil, and, once he got it back, he shocked me by asking, "Bob, can you take this guy off my hands for your collection?"

Several years ago a man who said he represented the Smithsonian contacted me about the possibility of including Kong in the museum's traveling exhibition. As the custodian of the artifact, I didn't want to chance losing it, so I declined. He assured me that their insurance company would pay for a reconstruction if anything happened to the armature—which misses the point entirely, of course. When I still said no, the guy got so mad that he said he'd make his own model. "That's fraud," I warned. "I don't care," he said. Incredibly, the Smithsonian employee had a full body copy made and began to exhibit it as "The Model Used in the Movie *King Kong*."

A news crew filmed the fake Kong at one of the exhibit's stops, believing that they were seeing the real deal, and the story reached CBS, where I was working at the time. The reproduction had sort-of orange fur and had even been made to look old and beat up. Everyone at the network knew I had the real Kong, so we did our own cut-in with the actual Kong in time for Dan Rather to make a correction. The Smithsonian was very embarrassed.

Still, the fake Kong remained on the tour with a plaque that was amended to read, "This may have been the model." Its current whereabouts are unknown, but don't be surprised—or fooled—if it turns up in the near future.

My chance to portray the greatest ape of them all came in the mid-1970s, when Universal Pictures was competing with Paramount to create a remake of

King Kong. I got involved because my friend Chris Mueller (a sculptor who created, among other great work, the *Creature from the Black Lagoon* beast) was working at Universal at the time and had heard that they were interested in using a man in an ape suit. He recommended me, and I got the call to come down to the studio to shoot some tests. If I'd had any idea what I was about to get involved with, I would have told them I was busy washing my hair that day.

I decided to use the opportunity to make a pitch for stop-motion animation. A few years earlier, in 1971, I had helped animator David Allen put together a very short test reel showing King Kong battling biplanes atop the Empire State Building. Allen was a brilliant artist and animator—he did, for example, the Pillsbury Doughboy commercials—and he created a dead-on rendition of Kong for the test. Being an old film editor, I was able to cut in excerpts from the original *Kong* soundtrack so the appropriate roars and airplane buzzes were cued nicely. Since David had used his employer's studio facilities for the work, he allowed them to include the test footage on their promotional reel. The folks from Volkswagen took one look at it and said, "We have to have Kong in our commercial!"

David had given me the gorgeous test Kong for my collection, and I took the puppet with me to Universal—which is a good illustration of my career sense, since I was, in effect, trying to get myself replaced. I showed the model to the "suits" and they thought it was amazing. And, of course, far too costly. "It'll be much better to do it with a guy in an ape outfit," they decreed. What I didn't know at the time was that Universal had animator Jim Danforth on the payroll as a consultant, and he was getting the same response as I.

So I showed up on the set at the appointed time, ready to do my finest Kong impression. Right away there were indications that I was in for a strange experience. First of all, they decided they didn't want to use my gorilla outfit, so they dressed me in the Bigfoot costume from "The Six Million Dollar Man." Since it had been made for wrestler Andre the Giant, they had to fold up the arms and legs—it really looked awful.

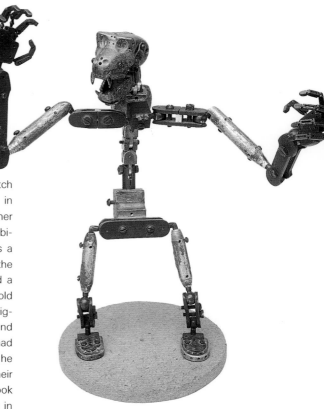

above: **The metal skeleton of King Kong.**
(18" tall x 10" wide)

But that was nothing compared to the mask situation. Since Universal wouldn't expend the money to do a cast of my head, the makeup man was forced to sculpt an ape on an existing head cast of actor Joe Don Baker. He's a big guy; I'm big rotund, but Baker is big *giant*. The mask was way too large and kept popping loose. But they had a solution: A new kind of adhesive—the kind of stuff made for holding artificial limbs in place—was slathered on my face to hold the mask securely. At the end of the day they had to destroy the mask to get it off, and my face looked like hamburger for weeks.

Once suited up, I was led to a miniature jungle and beach set where we ran through some takes. I was to walk through the waist-high "trees" to a clearing and pick up a Barbie doll that represented Ann

Darrow. I thought I did pretty well, but the director came over after my first attempt to offer some insight into my approach.

"That was fine," he said. "But on this next take can you kind of shake and jiggle a lot so it looks like animation?" Honest—he actually said that.

I laughed under that mask the majority of both days I was on set. The crew had all kinds of wacky ideas. They considered, for instance, hiring an amputee actor to allow for shorter gorilla legs. While that particular brainstorm never came to be, an art director had decided that they could save some money by building their miniature sets at an even smaller scale, so they hired a little person in a small ape suit to alternate takes with me as King Kong. Unfortunately, the "trees" that made up the soundstage jungle, waist-high on me, towered over the little person and he was invisible as he rumbled through the underbrush. All the camera captured was the occasional rustling branch and stirring bush until mini-Kong emerged in the clearing. As I stood off to the side waiting my turn, I overheard Clifford Stein, who was Universal's head effects cinematographer for many years, mutter under his breath, "I don't know why I ever came out of retirement to do this piece of crap."

I never saw any of the stuff that we shot on the two days I worked, and I'm sure everyone involved made certain every foot of film was destroyed. I learned later that Universal and Paramount were in a dead heat to get competing versions of *King Kong* onscreen. Universal seemed to have the better script, a period piece written by Bo Goldman, and enjoyed the support of *Kong* aficionados who lobbied for a version evocative of the original. However, after much legal back-and-forth, Universal aborted its *Kong* production as Paramount's ballyhooed version went forward.

For my friend Rick Baker, who designed and acted in the amazing gorilla suit used in Paramount's film, the experience was a combination nightmare and career boost. As goofy as certain elements of Paramount's *Kong* were—was there ever an onscreen monster more ineffectual than the forty-foot robot they used?—Rick's work in his gorilla outfit was outstanding and foreshadowed his triumphant accomplishments in *Gorillas in the Mist* and the 1999 *Mighty Joe Young* remake.

Nearly seven decades after its release, the original *King Kong* still reigns as a timeless classic. It's a tribute to the skills of Willis O'Brien, Marcel Delgado, and the army of artists and technicians who labored on the film that no amount of modern technology has been able to overshadow their accomplishment.

upper left: **Closeup of Kong's hand.**

below from left: **Bob suits up as Kong for test footage at Universal Studios.**

Werner Keppler adjusts Bob's mask.

Holding mask: Werner Keppler. Right: Chris Mueller Jr.

right: **Study model created for construction of the giant Skull Island wall and gate set. The set itself was burned as part of the "Atlanta ablaze" sequence in *Gone with the Wind* (1939).**
(16" wide x 14 1/4" tall x 10 1/4" deep

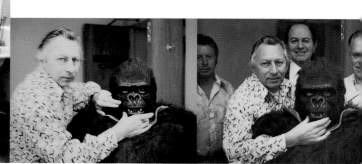

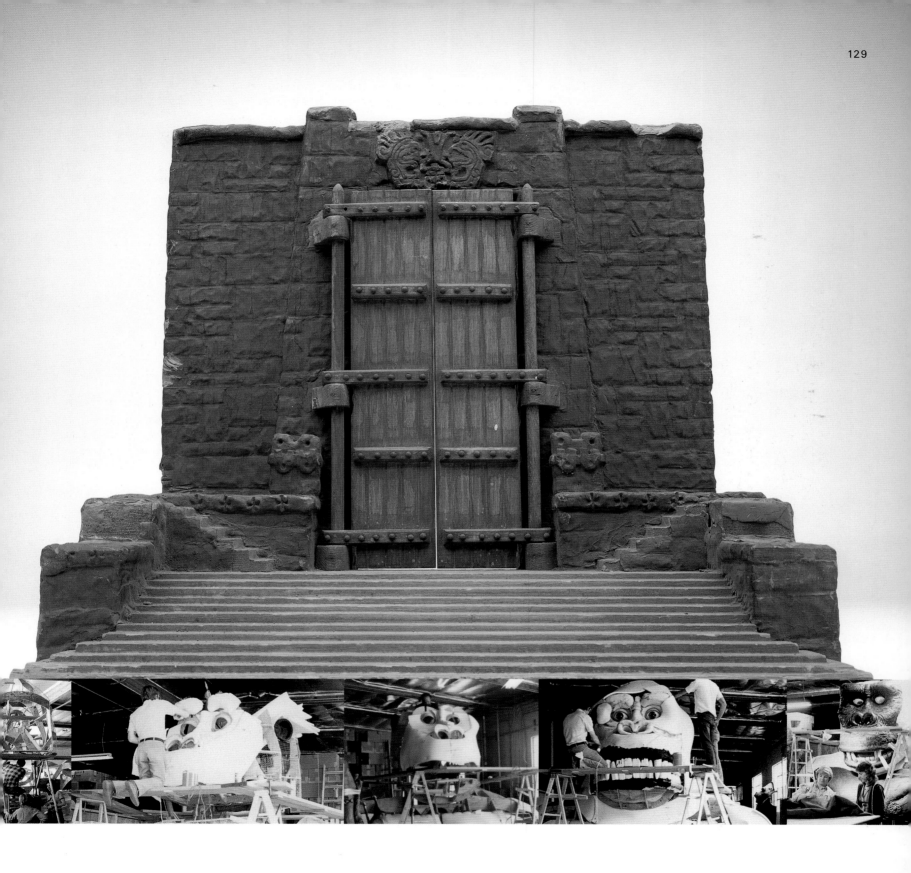

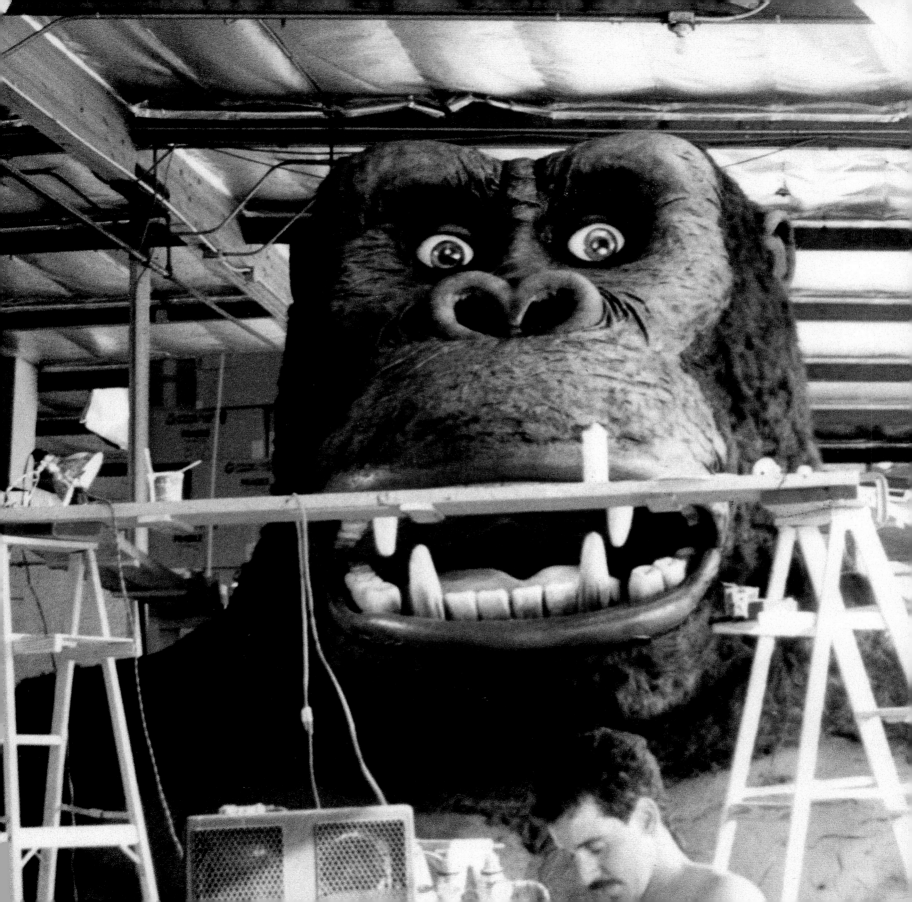

For Hollywood's Golden Anniversary Celebration of *King Kong* in 1983, Bob, Kathy, and a team of effects experts, including animator Jim Danforth, Tommy Scherman, Bill Hedge, and the Chiodo brothers, assembled a stunning reproduction of the giant Kong bust prop used in the 1933 film.

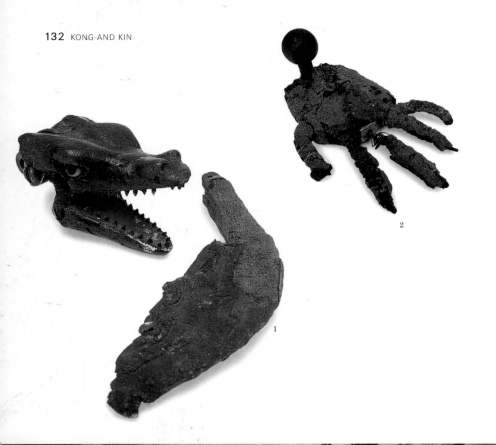

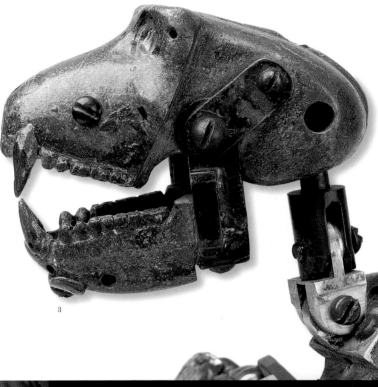

1

2

3

A King Kong Reunion

I'm happy to say that I've been able to meet nearly all of the artists and technicians who brought life to Kong. One such occasion was the Telluride Film Festival Tribute to *King Kong* in 1976, where many of the principals involved in the original production were reunited. I brought for the occasion the Kong model that David Allen had constructed. Kong made his initial appearance to great fanfare as music from the original soundtrack swelled throughout the grand theater wherein a print of *King Kong* was scheduled to be screened. The curtains parted, an announcer intoned, "Ladies and gentlemen, the Eighth Wonder of the World," and a spotlight revealed . . . my little Kong, safely "chained" as he was in the film. It brought down the house—fortunately not in the way the movie Kong did!

left to right: **Linwood Dunn, Mario Larrinaga, Mrs. Cooper, Fay Wray, Zoe Porter (Cooper's secretary), Archie Marshek, and Orville Goldner at the Telluride Film Festival.**

1 **Elasmasaurous head and flipper.**
(both 2" long)

2 **This foot from another Kong armature shows remnants of the rubber and fur covering.** (4" long x 3" wide)

3 **Close-up of Kong's "skull."**

4 *King Kong* and *Mighty Joe Young* **producer Merian C. Cooper examines an animated model of Mighty Joe at a home screening of** *King Kong* **in 1964. It's likely that this particular model is the one in Bob's collection.**

5 **Cover of pressbook for the 1957 re-release of** *Mighty Joe Young.*

6 **Always dissatisfied with how his lead character was rendered by other hands, Willis O'Brien penciled Mighty Joe Young's face for the poster concept, painted by an unknown artist.**
Painted on masonite. (36" x 24")

7 **The final poster featured Mighty Joe rescuing a single child from the burning orphanage.**

4

5

above left: **Molded hard-rubber horse head used for animation models in** *Mighty Joe Young,* **sculpted by Marcel Delgado.** (2 ¹/₂" long)

below left: **Lion head from** *Mighty Joe Young,* **a resin casting by Marcel Delgado.** (2 ¹/₂" long)

right: **The Mighty Joe armature has withstood the test of time very well. In fact, when Phil Tippett and his crew needed to create stop-motion models for** *The Empire Strikes Back* **(1980), they borrowed the Joe Young "skeleton" to study before Tom St. Amand built their "Tauntauns."**

far right: **Matte study created by Willis O'Brien for the opening sequence of** *Mighty Joe Young* **(1949).** (16"x 10")

above: **When animator Ray Harryhausen, who made stop-motion epics like** *Jason and the Argonauts* **(1963) and** *Golden Voyage of Sinbad* **(1974), saw Bob's Mighty Joe Young armature, he immediately said, "Oh my God, you've got Jennifer!" Of the four puppets made for the film, this was the one Ray used, and he'd affectionately named it after his favorite actress at the time, Jennifer Jones.** (16" tall)

One of Willis O'Brien's many scrapbooks. (14" x 20")

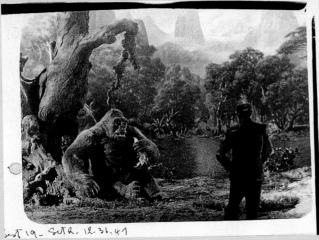

Test 19 - Set 2 - 12-31-41

SET #1 TEST #20 1-28-48

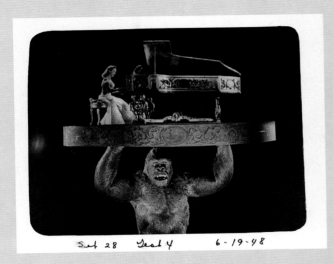

Set 28 Test 4 6-19-48

Set 22 A. Set 3. 4-19

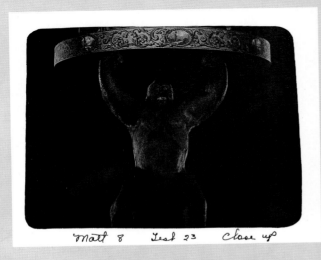

Matt 8 Test 23 Close up

Mighty Joe Young (1949) test frame blow-ups with
handwritten notes, from O'Brien's scrapbook. (5" x 7")

THE CURATOR

Still a child in the land of dreams

IT'S A WARM, windy September day, and a throng of onlookers cheer as the She-Creature flies above the La Brea tar pits.

The event is a promotional soiree for the American Movie Classics cable channel's "Monsterfest," a series of vintage horror films—including *The She-Creature, Day the World Ended,* and *It Conquered the World*—scheduled for the month of October. I've been invited to the event for a reunion of sorts with "Cuddles," now immortalized as an eighty-foot-tall hot-air balloon. A big, big star.

I'm doing what I've done for decades, telling the story of Paul Blaisdell to the many news outfits and fans that approach me. Their interest is gratifying and by no means anomalous in this day and age. Since the release of *Star Wars* in 1977, enthusiasm for fantastic films has built steadily. In fact, my Halloween show crew dissolved in 1982 because everyone was simply too busy meeting the new demand, making movie after movie.

It's been sixteen years since Paul Blaisdell died. We'd been estranged ever since 1963, when our magazine went up in smoke under sinister circumstances and Paul soured completely on the entertainment business, retreating with his wife, Jackie, to their home in the woods of Topanga. We spoke briefly in 1969 at the funeral of Lionel Comport, but Paul was so obviously hurt and frustrated by what he perceived as the industry's low regard for his work that our few interactions were strained. He felt—despite my admonitions to the contrary—that the public had already forgotten everything he'd created.

The cancer that eventually killed him was degenerative, and Jackie had to care for his every need as it spread throughout his body. Kathy and I had no idea Paul was ill; his pride wouldn't allow him to be seen in a weakened state. That same pride kept him from telling me, as Jackie did after his death, that he'd

Bob prepares to take to the sky with an old friend.

previous page: **art by James Hong.**

been following my career with delight and watched me on "The Ghost Busters" every Saturday morning. I took some comfort in discovering that my "older brother" approved of me, but I will forever regret that he couldn't shake his despondency. He wasn't someone who wanted to be well known or famous. He just wanted his work to be appreciated.

I wish Paul could have lived to see how far things have come. Of the ten top-grossing movies of all time, seven are science-fiction films. (Come to think of it, the top grosser, *Titanic,* owes so much to visual effects that it might as well be lumped in too.) There is now an entire cable network, The Sci-Fi Channel, devoted to the genre once relegated to drive-ins and matinees. It's been my pleasure to work with their producers on specials celebrating the work of my friends Dennis Muren, Ray Harryhausen, Rick Baker, George Pal, and, of course, Paul Blaisdell. From 1994 to 1997 we even did regular "Bob's Basement" segments from my museum on their "Sci-Fi Buzz" show. Fans love to hear about the artifacts and the people behind them, a far cry from the days when visual effects artists were lucky to get a screen credit.

Perhaps the most wonderful benchmark of how far behind-the-scenes artists have come in terms of recognition and prestige is Dennis Muren's star on the Hollywood Walk of Fame—the first special-effects person to be so recognized. George Lucas, in the middle of the publicity whirlwind surrounding the release of *The Phantom Menace,* flew in from Japan for the ceremony, not wanting to miss his collaborator's special day. Even C-3PO was there. I was so proud I could have burst.

The passage of time has turned me into a sort of curator for the treasures and stories of hundreds of

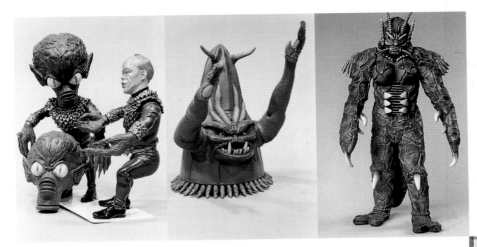

above: **The monsters of Paul Blaisdell have been memorialized in model kits like these from Billiken, a Japanese company. From left to right, Saucer Man actor; "Beulah" from** It Conquered the World**; and the She-Creature.**

right: **In 1993, Bob's friends in the film industry honored him with a surprise testimonial dinner.**

fantastic films and their creators, and people from all over the world have examined the props and artwork of which I am custodian. While my collection is by no means a public attraction—I've been trying as long as I can remember to fund a museum that people can visit—I've endeavored to make the contents available to anyone curious about fantasy movies and the creative minds behind them. My enjoyment of these treasures is quadrupled because I get to see them again and again through the eyes of people who are as thunderstruck as I was when I walked onto the set of *Destination Moon* so many years ago. I've seen people literally tremble with excitement when touring the collection, and I still understand how they feel. And what a true pleasure it is to be able to help shine the spotlight on these talented friends of mine!

I'm shaken from my daydreaming and into the present by the voice of my friend John Goodwin; it's my turn to ride the "Cuddles" balloon. In no time at all I'm in the basket with the pilot and other brave passengers, and we begin our gentle ascent with a whooosh of the overhead jets. The ground falls away—we're aloft. I look down upon an ocean of miniature She-Creatures. Kids—and adults—are wearing cardboard "Cuddles" masks, waving at me as the balloon rises. Does Paul look down from where he is and see what I see?

It's not a star on the Walk of Fame, but it's exactly what he would have wanted.

art work by: **John Eaves**

INDEX

BIBLIOGRAPHY

Del Vecchio, Carl. "Blaisdell Remembers!" *Filmfax*, October/November, 1986.

Goldner, Orville, and George E. Turner. *The Making of King Kong*. New York: Ballantine Books. 1975.

Henderson, Jan Alan. "Bob Burns: Fantastic Film Fandom's Goodwill Ambassador." *Filmfax*, June/July, August/September, October/November, 1998 (three-part series).

Hutchison, David. "Mike Minor: Illustrating the Future." *Starlog*, August, 1979.

Kinnard, Roy. "The She-Creature: Up From the Depths of a Primordial, Hypnotic Nightmare." *Filmfax*, October/November, 1986.

Monsterscene "Special Bob Burns Issue." Summer/Fall, 1995. Gogo Entertainment Publishing.

Okuda, Ted. "The Paul Blaisdell Story." *Filmfax*, October/November, 1986.

Palmer, Randy. *Paul Blaisdell: Monster Maker*. Jefferson, North Carolina: McFarland & Company, Inc., 1997.

Palmer, Randy. "The Paul Blaisdell Story: Hollywood's Forgotten Monster-Maker." *Cinefantastique*, May, 1990.

Wright, Bruce Lanier. *Yesterday's Tomorrows: The Golden Age of Science Fiction Movie Posters*. Dallas, TX: Taylor Publishing Company. 1993.

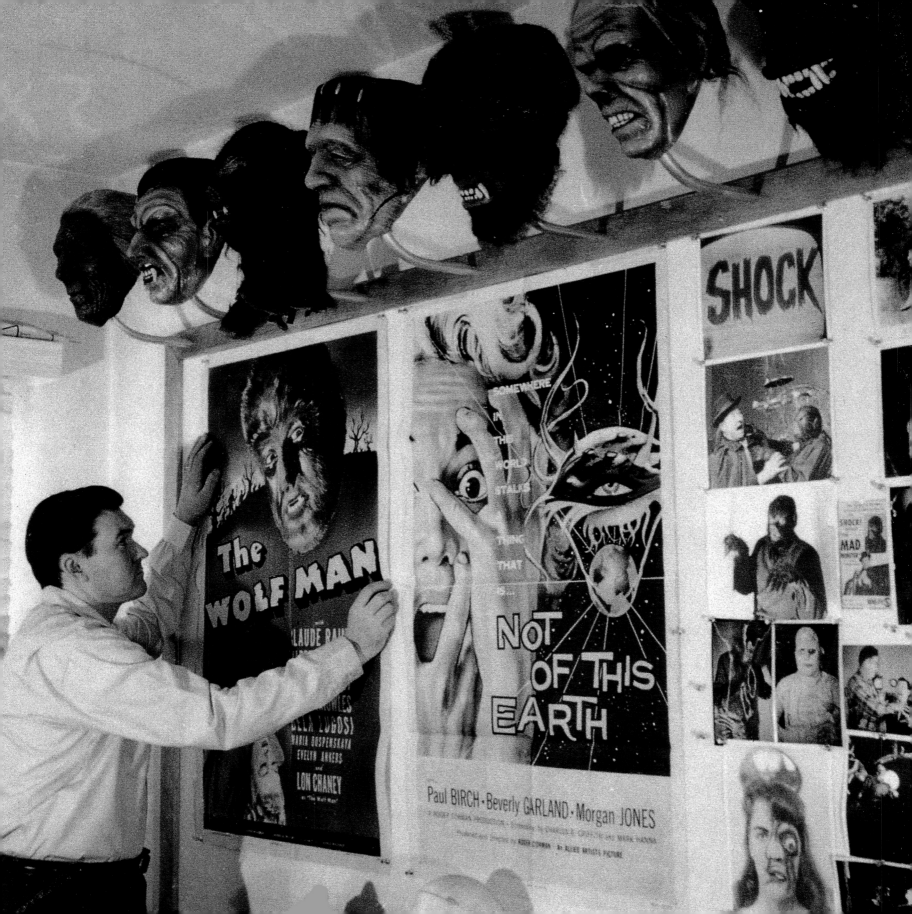